THE DRAWINGS OF
PHILIP GUSTON

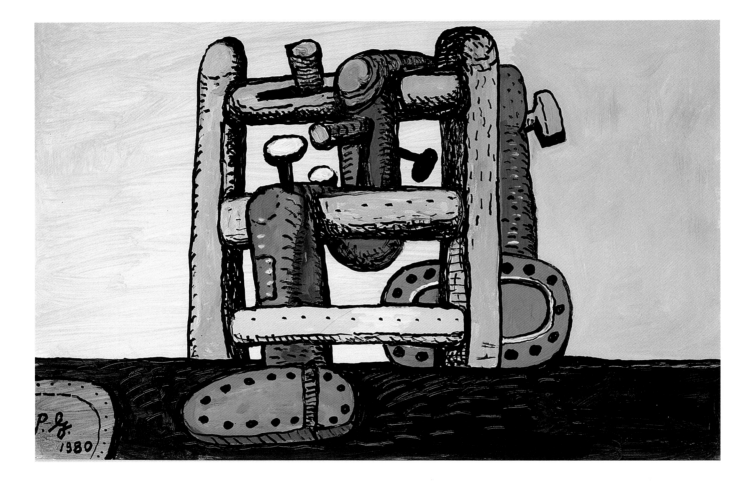

THE DRAWINGS OF PHILIP GUSTON

MAGDALENA DABROWSKI

THE MUSEUM OF MODERN ART, NEW YORK

Published on the occasion of the exhibition
"The Drawings of Philip Guston," September 8–November 1, 1988,
directed by Magdalena Dabrowski, Associate Curator,
Department of Drawings, The Museum of Modern Art

The exhibition is made possible by generous grants from the
National Endowment for the Arts and The International Council
of The Museum of Modern Art. Additional funding has been
provided by the New York State Council on the Arts.

This publication has been supported in part by grants from
Jeanne C. Thayer and Edward R. Broida.

Edited by James Leggio
Designed by Joel Avirom
Production by Daniel Frank
Set in type by Concept Typographic Services, New York
Color separations by Spectra II Separations, New York
Printed by Eastern Press, New Haven, Connecticut
Bound by Horowitz/Rae, Inc., Fairfield, New Jersey

Distributed outside the United States and Canada by
Thames and Hudson Ltd., London

The Museum of Modern Art
11 West 53 Street, New York, New York 10019

Frontispiece: *Untitled.* 1980 (CAT. 146)

The photographers and sources of the illustrations in this book are listed alphabetically below. Illustrations in the plate section are cited by catalogue number.

Acquavella Contemporary Art, Inc.: cat. 112. Alinari/Art Resource, New York: fig. 5. Art Gallery of New South Wales, Sydney: cat. 122. Rudolph Burckhardt: cat. 42. Bevan Davies: cats. 84, 138, 140, 143, 146, 147. D. James Dee: cats. 11, 13, 14, 51. The Detroit Institute of Arts: fig. 11. © Virginia Dortch: p. 46. M. Lee Fatherree: fig. 9 (courtesy San Francisco Museum of Modern Art); cats. 22, 91, 145. Gamma One Conversions: cat. 137. © Denise Browne Hare: p. 8. Bill Jacobson: cats. 46, 107. Kate Keller, Chief Fine Arts Photographer, The Museum of Modern Art: cats. 3, 15, 36, 55, 152. Kibby Laboratories, Inc.: cat. 104. Kunsthalle Bremen: fig. 15. Robert E. Mates, courtesy David McKee Gallery, New York: fig. 1; cats. 5, 7–10, 20, 25, 31, 33, 37, 50, 59, 66, 68, 75, 78, 90, 93, 105, 108, 111, 116, 123, 126, 129, 130, 134, 135, 142, 144, 146, 148–51, 153. Robert E. Mates and Mary Donlon, courtesy The Solomon R. Guggenheim Museum, New York: cat. 32. Robert E. Mates and Paul Katz: cat. 45. James Mathews: figs. 6, 12. Munson-Williams-Proctor Institute, Utica, New York: fig. 7. Hans Namuth: cat. 28. National Museum of American Art, Smithsonian Institution, Washington, D.C.: cat. 133. Otto E. Nelson: cats. 4, 17–19, 21, 24, 26, 40, 49, 89, 94, 96, 115, 124, 125. Mali Olatunji, Fine Arts Photographer, The Museum of Modern Art: figs. 13, 14; cats. 4, 6, 39, 43, 47, 53, 58, 92, 106, 136. Douglas M. Parker Studio, courtesy Paule Anglim Gallery, San Francisco: cats. 16, 41, 48, 52, 54, 56, 64, 73, 86, 113, 117. Philadelphia Museum of Art: figs. 2, 3. Pollitzer, Strong & Meyer: cats. 70, 98, 101. San Francisco Museum of Modern Art: figs. 8, 10; cat. 81. Schopplein Studio, courtesy Paule Anglim Gallery, San Francisco: cat. 29. Steven Sloman: cats. 12, 23, 30, 38, 57, 60–63, 65, 67, 69, 71, 72, 74, 76, 79, 80, 82, 83, 85, 87, 88, 95, 97, 99, 100, 102, 103, 109, 110, 114, 116, 118–21, 127, 128, 131, 132. Sotheby's, Inc.: cat. 35. Whitney Museum of American Art, New York: cat. 1. Zindman/Fremont: cat. 139.

CONTENTS

This book is published on the occasion of the exhibition "The Drawings of Philip Guston," the first major retrospective of drawings by this important artist. On behalf of the Trustees of The Museum of Modern Art, I wish to express our special gratitude to the artist's widow, Musa Guston, for her assistance and continuing interest in this project.

Support for the exhibition has been provided by grants from the National Endowment for the Arts and from the International Council of The Museum of Modern Art, for which we are most appreciative. Our thanks are also due to Jeanne C. Thayer, Edward R. Broida, Donald M. Blinken, and an anonymous donor for their generous support of this publication.

The exhibition was directed by Magdalena Dabrowski, Associate Curator in the Department of Drawings, who also wrote this book. The quality of both is a tribute to the dedication and professionalism she has brought to this undertaking, and she deserves our thanks and admiration.

Finally, we are deeply grateful to all the lenders, whose gracious cooperation made this exhibition and publication possible.

Richard E. Oldenburg, *Director*
The Museum of Modern Art

The reputation of Philip Guston as an eminent artist is founded primarily on his paintings. But to fully understand the rich complexity of what Guston achieved, we should study another, less familiar aspect of his work, namely his drawings, which often more pointedly elucidate his innovations and creative development. Despite the fact that he rarely followed study drawings closely in his painted compositions, his drawings have much to tell us about the nature of his style and his sensibility as an artist.

The activity of drawing seems to pervade his art-making. Guston was an unusually prolific draftsman; even though he discarded many drawings, a large number are still extant. Inevitably, they vary in quality. Yet over the decades Guston produced an extraordinary body of drawings, encompassing the full span of his development—from the early figurative works of the thirties and semi-figurative ones of the early forties, to the abstractions of the fifties and early sixties, the "pure" drawings of the later sixties, and finally the new figurative works of 1968–80. But notwithstanding an exhibition at The Metropolitan Museum of Art in 1973 and some presentations at the David McKee Gallery in New York, there has never been a full retrospective of the drawings, which would permit a thorough evaluation of this aspect of his oeuvre.

This catalogue and the exhibition it accompanies are intended to demonstrate the vital role of drawing in Guston's art. The works assembled here were chosen primarily for their individual strength and beauty, within the overall purpose of illustrating the various phases of the artist's career. The selection emphasizes drawings per se—that is to say, black-and-white linear images (whether figurative or abstract) as well as colored-pencil drawings—and also includes works on paper or board executed in watercolor, gouache, oil, or acrylic which, in their compositional organization, are

structurally dependent on drawing, and which the artist himself considered to be drawings. Taken together, they allow for a synoptic overview of Guston's restless explorations of form, space, and pictorial structure. It is hoped that a broader appreciation of the artist will result, and that we will see, more clearly than before, the innovative spirit of his later figurative idiom, which foreshadowed the neo-figurative tendencies of younger artists in the late seventies and early eighties.

An exhibition can come about only through the enthusiasm, generosity, and cooperation of many people. To Musa Guston, the artist's widow, and Musa Jane Mayer, his daughter, I would like to extend special thanks for their cooperation and unfailing interest throughout the project. And David McKee deserves warm expressions of appreciation; his enthusiasm and advice have been invaluable, and his help in tracing many of the works proved crucial to the exhibition. I thank also Renée McKee and the members of the staff of the David McKee Gallery for dealing with a number of vexing technical matters. Many friends of Philip Guston shared with me information about him; among them, I particularly appreciate the help of Dore Ashton, Mercedes Matter, Michèle Cone, and the photographer Denise Hare. My research on the artist could not have been completed without the cooperation of the Archives of American Art and I thank its director, Bill McNaught, for facilitating my work.

In the Department of Drawings of The Museum of Modern Art I would like to thank John Elderfield, Director of the Department, for his support and advice. My main debt is to two individuals who tirelessly assisted me throughout this endeavor. Mary Saunders, Program Assistant, gave unsparingly of her time and energy, through all the intricacies of the exhibition and its catalogue; Mary Chan efficiently helped with the manuscript and many other daunting aspects of preparing the exhibition and publication. In addition, Bryn Jayes was always of great help with the physical preparations and provided expert handling of the works.

Many other members of the Museum staff contributed to the realization of the project. I am most grateful to Waldo Rasmussen, Director of the Museum's International Program, for his indefatigable assistance in raising funds for both exhibition and catalogue. In the Department of Publications I would like to thank William Edwards, Nancy Kranz, Harriet Bee, and Maura Walsh. Tim McDonough and Daniel Frank deserve special thanks for overseeing the production of this book under a very tight schedule. Most of all I owe a great debt of gratitude to Jim Leggio, who has edited the catalogue text patiently and skillfully, offering many valuable suggestions that helped to make this a better book. I am very grateful to Joel Avirom, the book's designer, for his professionalism in meeting impossible deadlines. Thanks are also due to Antoinette King and the Conservation staff; to Richard Tooke, Kate Keller, and Mali Olatunji of Rights and Reproductions; to Rona Roob, the Museum's archivist; to Sarah Tappen of the Registrar's Office, for her efficient coordination of the loans; to Lacy Doyle of the Department of Development; to Richard Palmer and Betsy Jablow of the Exhibition Program; to Jerome Neuner and Fred Coxen in Exhibition Production, and Ashley Diaz and John Martin in the frame shop. The help of all of these individuals was invaluable.

Particular thanks are owed to the lenders to the exhibition. For their generosity in consenting to share these works with the public, I am more grateful than I can say.

M.D.

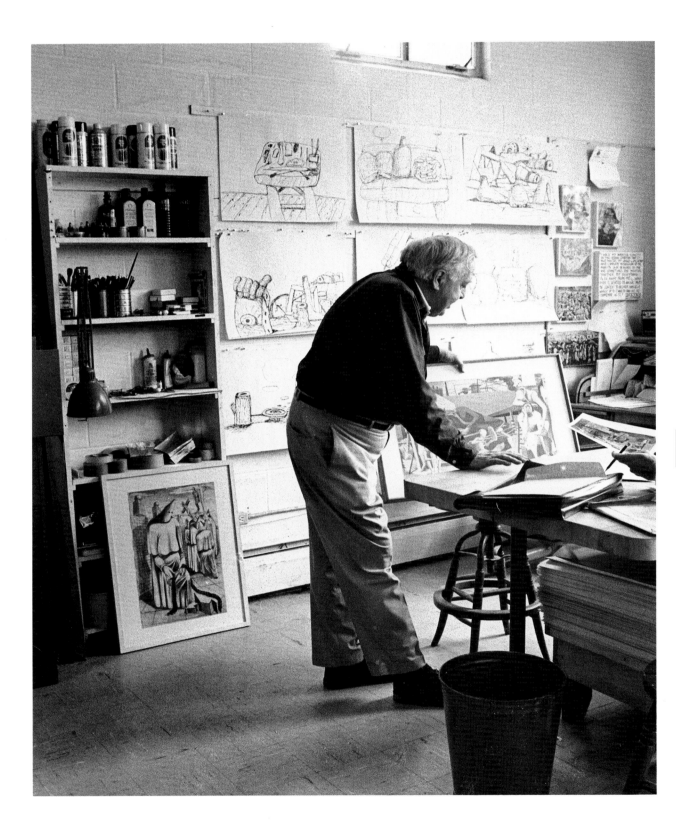

THE DRAWINGS OF PHILIP GUSTON

When Philip Guston died, in June of 1980, a major retrospective of his work had just opened at the San Francisco Museum of Modern Art. It was a summation of fifty years of creative life, and the ninety-eight works it included (seventy-two paintings and twenty-six drawings) revealed the range and complexity of the artist's development. But even though he had been recognized since the early fifties as one of the seminal figures among the Abstract Expressionists, Guston was never as highly praised as Pollock, de Kooning, Rothko, Still, or Kline; especially during the last decade of his life, critical acclaim eluded him. As a result, the full breadth of his artistic achievement is still imperfectly known.

This is particularly true with regard to his drawings. Even though Guston is one of the few painters whose drawings are in quality clearly on a par with their painted works, constituting an essential part of the oeuvre, appreciation of Guston's ability as a draftsman remains for the most part restricted to aficionados. Yet his drawing was of critical importance, both for his paintings and as an independent activity pursued for itself.

Guston himself assigned to drawing a place of preeminent importance in his work. He told an interviewer in 1957 that he had "always drawn as far as I can remember," and that he initially intended to become a cartoonist, "a comic strip artist."[1] In 1973 he commented:

> It is the bareness of drawing that I like. The act of drawing is what locates, suggests, discovers. At times it seems enough to draw, without the distractions of color and mass. Yet, it is an old ambition to make drawing and painting one.
> Usually, I draw in relation to my painting, what I am working on at the time. On a lucky day a surprising balance of forms and spaces will appear and I feel the drawing making itself, the image taking hold. This in turn moves me towards painting—anxious to get to the same place, with the actuality of paint and light.[2]

By the very nature of the medium, drawing is the most direct expression of the artist's thought; it shows him at his most rigorously intellectual while also at his most intimate, most immediate, and most revealing. That is, on the one hand its

Opposite: Philip Guston in his studio, Woodstock, New York, 1976

"bareness" delineates the essence, the bare bones, of the artist's initial idea, organizing a basic conceptual structure of lines and tone "without the distractions of color and mass." Yet on the other hand, the very directness of the medium gives access to the more emotional and subjective side of the artist; drawing can represent an unadulterated, often deeply searching or troubling, manifestation of his state of mind, as well as a way of organizing visual experience. In other words, drawing can be an activity that arises out of instinct, even before reason comes into play to impose its own order. All this is especially true of Guston's drawings, which, often executed in large series, have a certain almost obsessive quality of trying to come to grips with an unmanageable profusion of thoughts and images. Looking at them, we do not simply contemplate the results of this process but instead are forced to reenact the artist's struggle to create.

Guston began to draw at the age of twelve, and throughout his fifty-year artistic career relied on drawing as a means of exploration and regeneration. It sustained him by playing multiple roles in his work: as a notation of ideas, as a working drawing, as a study for painting, and as a final work of art in itself. But overall, his career shows an interesting alternation of painting and drawing such as the one Guston described, regarding his day-by-day working habits, in the passage just quoted. Periods of intense drawing activity alternated with periods of intense painting activity. His drawing development was therefore rather episodic in nature, since there were years when he only drew, and others when he only painted and did not draw at all. Often, after he exhausted his energy painting—having thoroughly explored, in his opinion, whatever style he had been pursuing, to the point of becoming dissatisfied with it—he would turn to drawing, as if to exercise his hand anew. He would then draw for a long period of time, until again he felt the need to paint, "anxious to get to the same place, with the actuality of paint and light." Drawing became his "problem-solving" medium; whether quickly noting a fresh thought, or elaborating a developing sequence of thoughts, it helped him to work out new formal and pictorial solutions. The small size of a sheet of paper and the relatively simple material character of the medium itself (whether brush or pen and ink, charcoal or pencil) made it physically possible to develop new concepts with greater ease and rapidity than allowed by the larger scale and the more elaborate and time-consuming medium of painting. Drawing thus eased his transition into a new stylistic phase; it catalyzed discontent into new creativity.

Such an overview of Guston's career highlights a few especially concentrated periods of drawing, and these clearly also mark the major stylistic turning points. The first such episode occurred between 1947 and 1949, when Guston also made his first trip to Italy; his drawings of Italian landscapes engendered his abstract idiom of the following few years. In 1952–54 another intense period of drawing produced the lyrical, "Mondrianesque" compositions that gained him his reputation at that time as an "Abstract Impressionist." Then, in 1958–62, Guston again turned to drawing as a way out of a creative impasse and evolved a new style, based on the use of flowing, unshaded line which now increasingly began to describe forms. In a subsequent episode, during the years 1966–68, he focused exclusively on drawing, and as a result his new—figurative—style emerged, wherein drawing assumed paramount importance.

When these late figurative works were first shown, in 1970, in an exhibition at the Marlborough Gallery in New York, they aroused great critical animosity. In part this was because at the time, most of the critics, as well as his fellow artists and the public, saw them as a complete break with his earlier work. Yet analyzed in retrospect, Guston's oeuvre does yield a certain, almost cyclical, conceptual continuity from the early to late works. It becomes clear that what was seen as discontinuity resulted from his giving emphasis at different moments to different aspects of what were, nonetheless, constantly returning subjects and formal preoccupations. (On one level this is seen in his cyclical iconography, with the same motifs reappearing throughout, under different stylistic guises.) One should remember that Guston's lifelong ambition was to create an art of constant rediscovery, and in this process of continuous renewal drawing served him well. His different phases could of course be summarized in a way that sees nothing but contradiction: early figurative period versus abstraction, and then abstraction versus new figuration. But it would be truer to the nature of Guston's creative imagination to recognize these transformations as successive stages of the same emerging cycle. Clearly it is not a straightforward, linear progression, with each thing coming directly out of the one before. It is more troubled and erratic, a development by fits and starts, but always returning, in its anxious exploration, to the same points of reference.

In his article on Piero della Francesca, published in 1965, Guston tried to summarize these recurring concerns in the form of a two-fold question: "Where can everything be located and in what condition can everything exist?"[3] In other words, where, and how, do the compositional elements exist in pictorial space? How do they relate to each other, and how does this relationship produce the expressive power of the composition? And finally, how does one find that optimal point where space and form, form and content, are perfectly balanced? Whether on a stylistic or interpretative level, he inevitably attempts to answer these elusive yet crucial questions.

In all his transitional phases and periods of doubt, drawing always came to Guston as the proper medium in which to address such questions. When he needed to reconsider the "condition" in which things can exist, he did so by reconsidering the condition of line. For example, when in the mid-forties he was disillusioned with figuration, he searched for a meaningful solution in drawing, eliminating the form and experimenting with the rhythm of line, at first tentatively, but then with growing expressive power. In the subsequent stage, his abstract work of the fifties, line became the armature of his compositions. Or when, toward the end of the fifties, Guston's faith in his abstract work began slipping away, and it seemed to be "too easy" and "too simple," line helped him to find again his role as an image-maker. A few years later, about 1961–62, Guston felt what he called "the urge for images" (that is, the need to make increasingly object-related forms) and then painted a group of pictures in black and white—essentially a series of drawings in paint—in which impastoed brushstrokes were translations of his lines in drawing.

To cite a further example of this sort of transition, in the late sixties Guston's "enclosure" drawing often comes to share the uninflected condition of line seen in cartoon drawing, even as it grows out of the basic, abstract linear marks of what he called his "pure" drawings of 1966–68. But here we also encounter the other aspect of Guston's question, "Where can everything be located"—the "locational" quality of

a drawn mark, its establishing of a position in space. For in enclosure drawing, line is used as a contour or outline which encloses part of the field of the support: the area contained within becomes the figure, while the area outside of the contour line conveys the illusion of the surrounding space. The uninflected line at once unifies and divides the pictorial field. This visual ambiguity forces the viewer into more active perceptual participation, engaging the eye and the intellect in the process of distinguishing between abstraction and figuration. In terms of spatial structure, the ambiguous space resulting from enclosure drawing—the sometimes unclear relationship between positive and negative space or between form and background—prompted further experiment. So the thick, uninflected line of the drawings that marked Guston's initial return to figuration in 1968–70 gives way in the mid-seventies to a thin, nervous, wispy, often unshaded (subsequently shaded) line, describing more volumetric forms and implying spatial recession. He would now explore different spatial configurations suggested by the possibilities inherent in shaded line, whose varying thickness and inflection can create the illusion of depth.

In his last twelve years, it is the return of iconographic motifs from the early decades that is most striking. Hooded figures reappear from a drawing of 1930. The floating and partially submerged heads of the "deluge" series of 1975–76 derive from a drawing for Navy training, executed by Guston during World War II. A similar recurrence can be found in the late series of landscapes, whose formal configurations seem to look back to a 1939 landscape drawing.

This iconographic, conceptual, and stylistic "cycle" in Guston's development is a major characteristic of his work. It particularly comes to the fore in his late drawings, as the ring begins to close and he almost obsessively uses and reuses the same elements. But it had been a defining aspect of his art-making all along. Understanding such creative processes—which surface most clearly in drawings—is the key to a fuller appreciation of Guston's achievement as a whole.

**THE EARLY
FIGURATIVE DRAWINGS:
1930–49**

The earliest extant fully developed drawing by Guston is a study from 1930 (p. 50), executed by the artist at the age of seventeen as a preparatory drawing for a now lost painting, *Conspirators* (fig. 1). Already encompassing a number of his artistic interests—Renaissance art, for example, and de Chirico—as well as his awakening social conscience, the drawing sums up many of the forces at work in the emergence of his early figurative idiom.

To fully understand how the various forces come into play, it is important to recognize that Guston belongs among those artists whose life and art show an exceptionally close interdependence. Every change, whether of surroundings or of psychological atmosphere—the books he read, the intellectual exchanges he had with friends at a given moment—all immediately affected the character of his creativity. Conversely, every period of intense creativity, or lack of it, sharply affected his overall psychological state and often prompted a change in where, or how, he lived. And after he had become a well-known artist, the shifting critical reception of his work brought yet another unpredictable element into the equation. But even at this early point in his

life, biographical events and personal influences illuminate the development of Guston's artistic personality. Reviewing them can be helpful before looking more closely at this important early drawing.

At the point of executing the study for *Conspirators,* Guston had been drawing for about four years, although with very little formal instruction. An early interest in drawing and a desire to become a cartoonist had been encouraged by his mother's gift, for his thirteenth birthday, of a correspondence course from the Cleveland School of Cartooning. But within a few months he had become disillusioned with the routine, facile drawing required to excel in this commercial idiom. After he entered Manual Arts High School in Los Angeles in 1927, his interest in art broadened, under the tutelage of Frederick John de St. Vrain Schwankovsky, one of his teachers. Schwankovsky, who encouraged Guston to draw, introduced him—and his friend Jackson Pollock—to modern European painting, particularly Cubism; to contemporary art periodicals, such as *The Dial* and *The Arts*; as well as to Oriental philosophy, especially the teachings of Krishnamurti and of the Russian mystic and philosopher Peter D. Ouspensky. But, in 1929, Guston (along with Pollock) was expelled from the school for disorderly behavior and for drawing cartoons ridiculing the academic program. Except for one more brief period of formal art education, at the Otis Art Institute in Los Angeles, in 1930, he remained primarily self-taught.

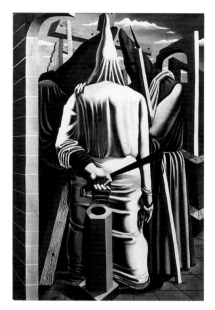

FIG. 1. Philip Guston. *Conspirators.* 1932

Around the time he was at Otis, through his friend Reuben Kadish he met a Los Angeles artist with whom Kadish had been studying—Lorser Feitelson. And it was through Feitelson that Guston for the first time came into direct contact with modern European art—"real" works of art (rather than reproductions)—in the distinguished collection of Walter and Louise Arensberg. This was Guston's first personal encounter with the work of Picasso, Braque, Léger, Miró, and de Chirico. As he later recalled, particularly de Chirico's canvases were a revelation to him.[4] The experience prompted Guston to leave Otis, where he felt restricted by traditional academic training, especially the endless drawing from plaster casts. He found such methods oppressive and too limiting for true artistic development. As he recalled, his enthusiastic response to modern painting, to Surrealism and Surrealist poets, was related to his reaction against formal education, for both reflected an attitude of rebellion—"a rebellion against everything. A desire, as I see it now, to find myself."[5]

He had found a new mentor in Feitelson. An erudite man, Feitelson was especially knowledgeable about Renaissance painting, and under his influence Guston's interest shifted from modern to Renaissance painting. As a result he began drawing from the figure and looking at reproductions of drawings by the Renaissance masters. He was fascinated by the art of Mantegna, Uccello, and Piero della Francesca; further, he developed an admiration for Masaccio, Giotto, Michelangelo, and later, Tintoretto and Raphael. Since none of their work was available in Los Angeles firsthand, he was limited to studying from art books found at the Los Angeles Public Library as well as from art magazines and reproductions. He became completely immersed in fifteenth- and sixteenth-century Italian painting. After leaving Otis he concentrated on drawing and avidly copied reproductions of drawings by Michelangelo, frescoes by Giotto and Masaccio, the prints and paintings by Mantegna. But always the focus of his main interest, the main figure in what he referred to later as his "pantheon" of Renaissance artists, remained Piero della Francesca.

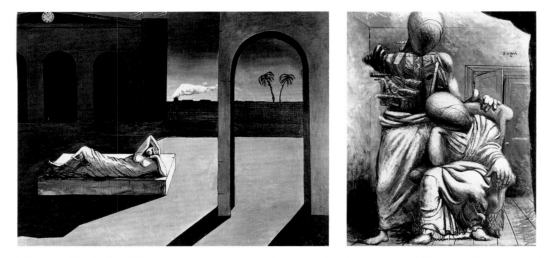

Left: FIG. 2. Giorgio de Chirico.
The Soothsayer's Recompense. 1913

Right: FIG. 3. Giorgio de Chirico.
The Poet and His Muse. c. 1925

It was probably because of his own deep appreciation of Renaissance art that Guston found de Chirico's work to be such a revelation. The deserted plazas, such as that in the Arensbergs' *The Soothsayer's Recompense* (fig. 2), and the monumental, draped figures of *The Poet and His Muse* (fig. 3) manifested de Chirico's debt to Renaissance art, and for that reason would hold a special attraction for Guston, who recognized their shared bond with the same tradition. In fact de Chirico's influence as much as that of Piero would remain a stimulating resource for Guston in the years to come.

Guston's self-education was not limited to studying the Renaissance; his interests were very broad. Like many of his young contemporaries, he was reading the "little magazines" and art journals such as *Transition* and *Cahiers d'art*. He also followed closely the latest innovations and theories of such filmmakers as Dovzhenko and Eisenstein. He admired the music of Stravinsky, and he read incessantly: Russian classics—Chekhov, Dostoyevsky, Gogol, Tolstoy; eighteenth- and nineteenth-century French literature; works by Isaac Babel, Kafka, and Kierkegaard; as well as twentieth-century American writers. Yet at the same time he was attracted to such forms of popular culture as the comic strip, particularly the *Krazy Kat* cartoons by George Herriman, which then enjoyed great popularity.

Besides pursuing artistic and literary interests, he became increasingly aware of the harder realities of everyday life, especially as experienced by working people. Now forced to earn his living, he shared their problems. And as the thirties began to unfold, he witnessed the spreading social unrest of the deepening Depression. His social conscience was troubled by the religious and racial atrocities of the Ku Klux Klan, then on the rampage in the Los Angeles area. Politically, he began to veer to the left, and this inevitably affected his attitude toward art. He came to feel that the artist's role was not to paint private and appealing subjects but to produce public art, art with a social message, which would comment on vital issues and engage a large public. His work of the thirties is informed by a powerful belief that art should be a vehicle for social comment, and should not merely constitute "art for art's sake."

His 1930 drawing for *Conspirators* highlights the beginning of his figurative idiom and of the socially engaged art that he would pursue until the early forties,

earning his first critical praise. The subject of the drawing reflects his concern with the larger reality of racial repression, not just the specific activities of the Klan (the next year he would begin painting, with Reuben Kadish, a series of fresco panels based on the highly publicized Scottsboro Case). Here, several Ku Klux Klan figures attend some nameless ritual beneath the hanged figure of a black man and a falling cross. The composition exudes a threatening yet strangely poised mood, arising from the monumentality of the bulky figures, the looming black shadow on the wall, the incongruity of scale and distance, and the stillness and silence of the narrative moment. And thus the massive, isolated figure of the Klansman in the foreground seems to be depicted in an ambiguously half-kneeling—almost penitent—position, fingering a hangman's rope so thickly corded that it suggests a blasphemous string of rosary beads.

Stylistically, the work combines elements of the realistic rendition characteristic of the Regionalists and Magic Realists with the influence of other sources important to him, such as Italian Quattrocento painting, especially Piero della Francesca, and de Chirico. (One wonders whether he might have also been looking to the work of Zurbarán, with its frequent motif of hooded monks.) The monumental bulk of the hooded figures echoes Piero; indeed, as Dore Ashton has pointed out, the foremost figure, although clearly a Klansman, might relate subconsciously to the hooded, kneeling penitent embraced by the mantel of the Virgin in Piero's *Madonna della Misericordia* (fig. 4).[6] Yet it also suggests the robed, faceless figures with oversize hands in de Chirico's *The Poet and His Muse,* which Guston knew from the Arensberg collection. The bare, threatening architecture against which the drama takes place also brings to mind the timeless, vacant, melancholy spaces of de Chirico's paintings, while the color scheme, with darkly delineated figures placed against pastel pink, yellow, and orange surroundings, evokes the palette of Quattrocento frescoes, such as those by Piero at Borgo San Sepolcro.

Yet for all the obvious references, it is a beautifully rendered, powerful, and personal statement, its forcefulness remarkable, even unique, among Guston's early works. It is not merely precocious but a truly mature work from the seventeen-year-old artist and a significant milestone in the early phase of his development. It is significant for the future as well: this is the first appearance of the motif of the hooded figure, which in modified form would return, along with figuration itself, in the works of the years 1968–70. And the figures, strongly modeled in chiaroscuro, are here delineated with black contour line, which would also return in Guston's late figurative work, as enclosure drawing, defining the forms.

While the study for *Conspirators* addresses social, public issues, Guston's work of this early period has also another, more personal and intimate, side. A small drawing of Punchinello (p. 51) exemplifies this impulse toward more private expression. Taken together, the two early drawings—the *Conspirators* study and the Punchinello—mark an unresolved ambivalence that will persist throughout his life.

The small Punchinello drawing from 1933 brings out Guston's interest in eighteenth-century French and Italian art (he was at this time avidly studying art history on his own). It portrays the famous character from the popular imagination who by the eighteenth century was a ubiquitous presence in the commedia dell'arte, the subject of many Italian genre pictures, and the hero of a well-known series of drawings by Domenico Tiepolo. The character was also spiritually akin to the Gilles by

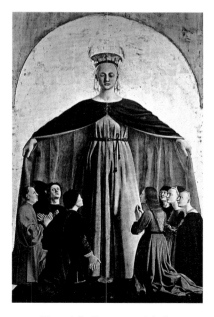

FIG. 4. Piero della Francesca. *Madonna della Misericordia.* c. 1445

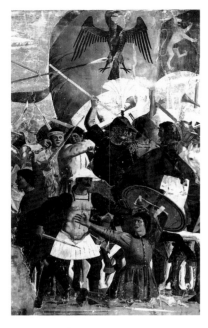

Watteau, another artist whose work Guston studied and admired. At once funny and tragic, Punchinello was generally limited to the grotesque personification of various, mostly negative, human traits, both physical and psychological. But Tiepolo's drawings, in a long Venetian tradition of fantasy, employed exciting narrative and exotic adventures, expressing a wider range of emotions and a fuller sense of the drama of life. Yet their great energy veiled a certain melancholy. For Guston, whose restless psychology moved within a wide compass of shifting moods, the Punchinello series would understandably hold fascination, and would perhaps invite identification with the character; in fact, he often expressed his admiration for the Tiepolo drawings.[7]

Guston depicts the figures of Harlequin and Punchinello playing musical instruments in a very de Chirico–like interior, not dissimilar to the one in *The Poet and His Muse.* Compositionally, the reference to de Chirico is quite obvious—the placement of the two figures in relation to each other being reminiscent of such de Chirico works as the drawing *The Mathematicians* (The Museum of Modern Art, New York) and the painting *The Prodigal Son* (Collezione Nazionale d'Arte Moderna, Rome)—but the solidity and robustness of the figures are very much Guston's own. Among less obvious connections, it is interesting to note that one of the many artists drawn to the subject of Punchinello was Picasso, who between 1918 and 1920 made drawings of Pierrot and Harlequin (the same two figures depicted by Guston), as well as a Cubist version of the subject in gouache (1919) and the costume designs for the ballet *Pulcinella,* produced in 1920. Considering Guston's early interest in Picasso, it is conceivable that he might have been familiar with the latter's Punchinello works, too, and felt that he also wanted to tackle the subject.

In these early years, drawing for Guston served primarily as a means of developing his own idiom, a way of finding a personal vocabulary to express his vision. But it is important to remember that since his main occupation as an artist in the thirties was mural painting, drawing also served as an essential technical tool, a preparatory medium. Between 1932 and 1941, Guston—who in 1935 joined the mural division of the WPA—executed a number of mural commissions in such places as Morelia, Mexico; Duarte, California; New York City; Commerce, Georgia; and Laconia, New Hampshire, among others. They manifest his belief in socially conscious art, a conviction shared by many other American artists and reflected in the increasing attention given by artists and public to the work of the Mexican mural painters: Orozco, Rivera, Siqueiros. Although Guston would not see their works first-hand until well into the decade, he became familiar with them earlier, through the reproductions that could be found, for instance, in an issue of *Creative Art* in 1929.

Few drawings survive from this period, but those that do allow us to trace the changes of Guston's style. Among them belong *Boys Fighting* (p. 52), representing a motif for a section of a mural; a study for a section of a 1939 mural for the lobby of the community center in the Queensbridge Housing Project in New York (p. 53); and a study for a mural, *Maintaining America's Skills,* for the WPA pavilion at the New York World's Fair in 1939 (p. 55). The three drawings address, each in its own way, new pictorial issues that Guston found challenging at the time in the treatment of form and space as well as compositional organization. There is an obvious dialogue with both the Renaissance tradition and the European modernist idiom. In *Boys Fighting,* for example, a reference to Piero's *Defeat of Chosroes*—to the central section of the

fresco, with the figure holding a shield above his head (fig. 5)—is integrated into a Cubist-derived space, and the piling up of interlocking shapes shows the influence of Picasso's *Guernica* (fig. 6). The solid wall in the background returns to de Chirico.

The Queensbridge Housing Project study is a presentation drawing for the central portion of a large mural on the subject Work and Play. Through both its content and form, the work addresses the social issues of city life. In its iconography the drawing incorporates some of Guston's earlier motifs: the central group of children is a restatement of *Boys Fighting*; the monumental seated female figure is a rephrasing, in a more flattened, stylized form, of Guston's early painting *Mother and Child* of 1930 (estate of the artist). But their treatment here makes them eloquent comments on the dreariness of everyday urban existence. On the compositional level, the organization of space is again a combination of de Chirico and the Renaissance, modified by the influence of Synthetic Cubist structure derived from Picasso and Léger. It was particularly Picasso's *Three Musicians* and Léger's *The City* (both Philadelphia Museum of Art) that impressed Guston deeply when he saw them in the A. E. Gallatin collection, shortly after moving to New York in the winter of 1935–36, and he tried to assimilate their lesson. Here, he incorporated flattened, generalized forms into the layered structure of the composition, creating depth by the overlapping of elements and thus exploring the ambiguity of Renaissance versus Cubist space. As with his 1930 drawing for *Conspirators,* there is here a sense of stillness, the arrangement of figures suggesting an almost Surrealistic moment frozen in time. The figures are encapsulated in their own separate registers, their deployment as well as their postures conveying the weariness and hopelessness of urban life. But unlike the spatial organization, the rhythm of line that dominates the composition is still indebted to the muralists of the thirties and particularly the Mexicans.

By comparison, the study for *Maintaining America's Skills* (which, unlike the presentation drawing for the Queensbridge Housing Project, is only a working drawing for a small part of the mural) announces what was emerging as his new phase: the simplification and stylization of the protagonists are pushed much further, almost making the figures into geometric forms. Forms and motifs used previously, such as the hooded figure at the right or, adjoining it, the figure with a hand raised (again reminiscent of *Boys Fighting*), are here recapitulated in a more schematic form.

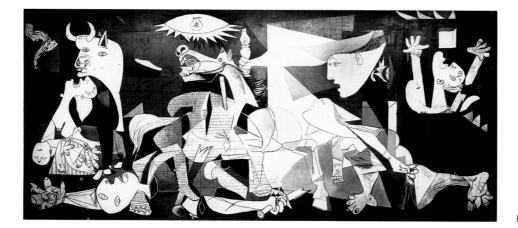

FIG. 6. Pablo Picasso. *Guernica*. 1937

17

In these drawings Guston seems to be searching for his own style while continuously maintaining contact with his initial sources: the Renaissance and the European modernist tradition of Picasso, Léger, and de Chirico, with an accent of American realism. After 1939, an additional influence sets in, that of Max Beckmann, whose work Guston discovered in New York.

Although he was a successful mural painter, in 1940 Guston resigned from the WPA, feeling the constraints of the fresco technique and the limitations imposed by architecture. In 1941 he completed his first mature canvas in a distinctively personal style, *Martial Memory* (St. Louis Art Museum), and decided to concentrate on easel painting. (The same year, he moved to Iowa City to become an art instructor at the State University of Iowa.) This composition—once again depicting a group of boys battling in the street, wearing paper helmets and wielding pretend weapons such as trashcan lids and wooden bats—initiated a group of paintings of 1941–45 with masked and unmasked children, fighting or playing in an urban setting composed of dilapidated tenements and Renaissance-like, heavy, arcaded brick walls. These paintings further explored, now in a more personal idiom, the lessons of Piero, Uccello, Watteau, de Chirico, and Picasso, while also bringing to mind James Ensor. They culminated in 1945 in a large canvas, *If This Be Not I* (Washington University Gallery of Art, St. Louis). All made use of bold, volumetric forms and complex spatial configurations which together were principal carriers of a complex narrative. There are practically no drawings in existence from that period, other than those on pre-flight training for the Navy and for a war-related article for *Fortune* magazine (pp. 56, 57). In style and execution such drawings, executed on commission, still relate directly to his earlier mural commissions and are much less advanced stylistically than some of the paintings.

A change begins to be felt only with the appearance of drawings in which, although the subject remains related to the playing-children paintings, the treatment of it is different, especially the spatial organization (p. 58). Space is flattened, and the whole pictorial structure is connected to the relational design of Cubism: space is defined through the use of flat forms arranged on a pictorial plane in relation to each other and not depicted in illusionistic depth. Other drawings (p. 59), although still dominated by a figurative element, are essentially semi-figurative and begin to show a dissolution of forms into a more abstract structure. Direct reference to specific objects or figures becomes less and less visible, and will in fact shortly disintegrate into an overall non-figurative field. Line takes over as an organizing agent of the pictorial field. The modeled form is "removed" from the contour line, which remains as an often open-ended outline (pp. 60, 61 [bottom]).

As the figurative element begins to be questioned, one should pause to take note of the iconographic motifs which appeared during this figurative period of Guston's work, for they will return later in the new figurative idiom of the seventies. The floating heads in the 1943 drawing (p. 56) done for the Navy will reappear in the mid-seventies, as will a number of other motifs: reclining heads, intertwined legs, nail-studded soles of shoes, and flatiron shapes (pp. 58, 59). The same holds true for certain compositional devices, such as the "layered" configuration, as in the drawing for the Queensbridge mural, with objects arranged within horizontal bands placed above one another to create the illusion of depth. Present also in a 1939 landscape drawing (p. 54) which combined the influence of landscapes by Grant Wood with that

of Paolo Uccello's background in the *Battle of San Romano,* the configuration will return later in the series of landscape-like drawings of 1980.

It is clear that around the mid-forties, despite winning a First Prize for Painting from the Carnegie Institute in Pittsburgh and having his first one-artist exhibition in New York (both in 1945), Guston had begun to feel dissatisfied with his figurative work, which now seemed too easy, too predictable. He sensed a need to somehow change his artistic frame of reference. Consequently, he very keenly felt his isolation from any artistically stimulating environment. Having accepted in 1945, for financial reasons, a position as art instructor at Washington University, in St. Louis, he felt cut off from all that was important to him. A deep creative depression set in.

The possibility of relief arrived with the award of a Guggenheim Fellowship in 1947, and in the spring of that year he took a leave of absence to begin his grant. He decided to move to Woodstock, New York (about two hours' drive from New York City), which allowed him the freedom of choice of either being in contact with the art scene in New York or distancing himself from it and remaining shut in his studio. While living in New York in the late thirties, Guston had come to know most of the younger artists whose work soon came to dominate American art. He now renewed his friendships with some of them—Mark Rothko, Adolph Gottlieb, Willem de Kooning, as well as Pollock, a friend of his youth—and came into contact with Peggy Guggenheim's gallery, Art of This Century. In Woodstock his closest friends were the painter Bradley Walker Tomlin and a young writer, Robert Phelps, and Phelps's wife, Rosemary Beck, a painter, with both of whom he had long literary discussions. In fact, such exchanges of ideas with other artists and, particularly, writers were always for Guston an important, almost indispensable, stimulus to his creativity.

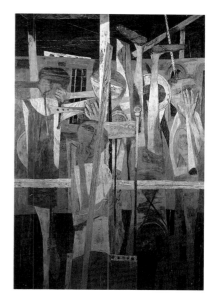

FIG. 7. Philip Guston. *Porch II.* 1947

Nonetheless, his melancholy did not subside; a deep awareness of creative impasse persisted. During the winter of 1947–48 he painted the last two of his semi-figurative paintings: *Porch II* (fig. 7) and *Tormentors* (San Francisco Museum of Modern Art). The pages from his sketchbooks at that time (p. 61) indicate that he was drawing obsessively, recomposing the motifs of his earlier paintings such as *Martial Memory* (1941) or *If This Be Not I* (1945). Line became more schematic and forms less exactly defined, which subsequently allowed line to become "disembodied" from form. This process is quite evident in the study for *Tormentors* (p. 59) of 1947, in which the figurative elements—a human face supported on the right hand, with an outstretched, pointing left hand, and two shoe soles studded with nails—are incorporated into a virtually abstract linear composition whose unshaded line and flattened space clearly anticipate non-objective works of 1950 (pp. 64, 65). Guston was no longer interested in narrative (little of which remains in *Tormentors,* except in the title), but rather in finding a new form that would be emotionally expressive yet not remain tied to figuration.

In 1948 Guston won the Prix de Rome from the American Academy in Rome and a grant from the American Academy of Arts and Letters in New York. This finally enabled him to travel to Italy to study first-hand the frescoes by the Renaissance masters, until then known only from books and reproductions. During that year-long stay in Europe he traveled extensively in Italy, also visiting Spain and France. He drew continuously (but did not retain many drawings), making sketches of scenery, such as *Forio, Ischia* and *Ischia* (p. 63), pen-and-ink drawings in the tradition of the traveler's

sketchbook. Here, as previously in the study for *Tormentors,* the fragile, spidery line describing forms (such as cubes of buildings, and arches) begins to be released from contour and acquires, although still in a tentative way, its own identity as an organizer of the surface composition. The emphasis on the independence of line will subsequently increase, leading to the grid-like compositions of the early fifties.

While traveling and drawing, Guston zealously studied the Old Masters. He went to Arezzo, Orvieto, Florence, and Siena, spending hours contemplating the frescoes by Giotto, Piero della Francesca, and Luca Signorelli, and admiring the works at the Uffizi. He saw the Venetians Titian and Tintoretto as if for the first time. In Spain, El Greco and Goya captured his attention completely; in France, Cézanne and Manet. When he returned to the United States in the autumn of 1949, his imagination was charged.

THE EVOLUTION OF ABSTRACTION: 1950—54

In his travels of 1948—49, besides exploring the European artistic heritage Guston had also discovered a new, European view of life, the Existentialist philosophy then becoming widely disseminated in France through the writings of Jean-Paul Sartre. It struck a chord in Guston, who was already a devoted reader of Kierkegaard, its spiritual father. He immersed himself again in Kierkegaard, whose thought was now amplified for him by his reading of Sartre and, particularly, the works of Albert Camus, with their calm acceptance of the absurd.

These encounters prompted Guston to look at his art from a new vantage point, and made him feel again the need for an urban environment and an art community, to reinvigorate his creative energies. He decided to resettle permanently in New York City and, in the autumn of 1950, took up a teaching post at New York University—becoming, at his request, instructor of the freshman drawing class. With a studio on Tenth Street, Guston was at the center of the intellectual and artistic circle later known as the New York School. His creativity was always fueled by intellectual exchanges with his friends, and this was particularly true of the early fifties: he had found a sounding board for his ideas.

Interestingly, most of his truly close friends were not painters but writers, poets, composers. In the early fifties his friends among writers included the critics Harold Rosenberg and Thomas B. Hess and the poets Stanley Kunitz and Frank O'Hara. At the same time, the composers Morton Feldman and, to a lesser degree, John Cage were important spiritual kin. Guston shared an interest in Zen Buddhism with Cage, accompanying him to Daisetsu Suzuki's lectures at Columbia University. And with Morton Feldman, Guston believed that Feldman's music and his own pictorial work attempted to convey analogous ideas and feelings; both of them were, as Guston put it, interested in "everything," in a universal yet deeply personal experience of the world. Indeed, Guston always felt that it was Feldman who most perfectly understood what he was trying to achieve in the work of the first half of the fifties, rather than his painter friends, even though among the latter he counted Bradley Walker Tomlin, Mercedes Matter, James Brooks, Jack Tworkov, Willem de Kooning, Franz Kline, Barnett Newman, and Mark Rothko.

An active member of the Eighth Street Club, Guston spent many hours there discussing his artistic ideals and the nature of creativity. The Cedar Bar and the Artists' Club were inevitable stops in his nightly wanderings. Guston was then very much part of a group, yet, as he later recalled, by the time he settled in New York, most of the artists of the New York School had already developed their individual styles.[8] He therefore felt a certain peer pressure to catch up.

But even though Guston, like Kline, was a latecomer, he shared with Rothko, Gottlieb, Motherwell, and Pollock a sense of adventure and excitement at doing something new, of having broken a fundamental link with European art (despite the fact that the initial impulse for their work came from Surrealism, through contact with the French Surrealists who, during the war, had fled to this country). Gathered around Peggy Guggenheim's Art of This Century gallery, and later the Betty Parsons Gallery, they all had a sense of liberating American art from the hegemony of Paris and the Cubist-derived tradition. Their art was a reaction against the dominance of Matisse and Picasso. They wanted to achieve a new freedom—from politics, from tradition, from objectivity—in order to reinvest art with more subjective, spiritual values. The artists' personal vocabularies of abstract painting therefore not only expressed their revolt but articulated an independent creative position: they strove to create an original, truly American school of painting that would be characterized by a new consciousness—a new attitude toward the artwork and the process of its creation. Harold Rosenberg, who coined for this endeavor the controversial term "action painting," spoke of its philosophy, in 1952, in a now famous statement that redefined painting as an existential act:

> At a certain moment the canvas began to appear to one American painter after another as an arena in which to act—rather than as a space in which to reproduce, re-design, analyze or "express" an object, actual or imagined. What was to go on the canvas was not a picture but an event.
> The painter no longer approached his easel with an image in his mind; he went up to it with material in his hand to do something to that other piece of material in front of him. The image would be the result of this encounter.[9]

The Abstract Expressionists considered this process of creation to be a solitary struggle haunted by anxiety and a continuous sense of being in an ambiguous situation. By understanding the artist as one who reveals his authentic identity through the act of painting, they were in accord with a basic premise of Existentialism, the idea that the anxious confrontation with a blank universe of possibilities is essential to the realization of the self. As Irving Sandler points out, both artists and critics often borrowed Existentialist terminology to describe the philosophy behind their work.[10] The artist Robert Motherwell and the critics Rosenberg and Meyer Schapiro adopted Existentialist propositions in their theories on art. Rosenberg, in particular, insisted on existential experience as the origin of action painting, emphasizing the crucial importance of the artist's internal experience in the process of creation, which became a process of self-definition. Action painting was understood as a means of furthering self-knowledge, of enlarging internal experience. The works thus executed evoked a multitude of responses, and were not concerned so much to achieve an aesthetic whole as an open-ended "sum of possible suggestions."[11]

FIG. 8. Philip Guston. *Untitled.* 1952

The Existentialist philosophy in which Abstract Expressionism was rooted, and the attitudes it produced, were particularly suited to Guston's mental outlook, and he embraced them passionately as he tried to understand, and resolve, the creative impasse at which he had arrived by the end of the forties. Having joined the ranks of those practicing action painting, the work he embarked on in the early fifties represented one of the manifold expressions of gestural abstraction. In search of a new idiom, it would be for him an intensive period of drawing.

Guston's drawings of about 1950–51 are already completely abstract. They are mostly simple line compositions, done in quill pen and ink. The thickness of their line resulted from the varying amount of pressure on the quill, while a differentiation of color and density of line caused by the fullness or dryness of the quill gave a chiaroscuro-like effect. These delicate drawings probe the possibilities of the picture surface, in its ambivalent role as flat support and yet as open, evocative space (p. 65), a preoccupation which was at that time a focal point of his investigations (and those of other Abstract Expressionists). His line had a quality of controlled gesture: in pursuing his surface explorations, the gesture became increasingly controlled and localized, forming a network of sharp, rapid strokes or groups of strokes that in final effect created compositions hovering in front of the picture plane, such as *Autumn* (p. 66) and *Loft II* (p. 69).

He was searching for a new freedom in which the traditional compositional relationship between form and space would be dislocated, liberating both elements to become parts of some new system. The space of his early fifties drawings was not a palpable, physical one, but rather a mental dimension open to his searching mind. As Dore Ashton has pointed out, "In his ink drawings, copiously produced in the early 1950s, Guston explored spaces that were not bound by systems of perspective but rather corresponded to the vast dislocations that occur in dreamlike mental conditions."[12] At that point the lines were totally disembodied, freed from form and serving to mark position within complex relationships. They are nervous, fragmentary signs, quick but purposeful notations building up into an integrated whole. Guston appears in them to be experimenting with different systems of organizing his marks into compositions. There is an explicit emphasis on structure that will continue to dominate his works throughout the fifties. Some drawings (pp. 67, 71) are centralized, but essentially all-over, compositions; others show distinct concentrations at either the top or bottom (fig. 8; p. 70), creating the effect of a composition bursting upward or spilling down.

Guston's intention in these drawings is to create a self-contained universe, strongly structured and energized by the interaction of vigorous marks, wherein thick brush-areas (sometimes very heavily worked over) are played off or complemented by thin, wispy, nervous lines, creating a shimmering film in front of the plane. Making a large series of drawings—working and reworking the multiple possibilities afforded by a free, disembodied sign—allowed Guston to achieve the long-sought creative freedom that culminated, during the summer of 1951, in *White Painting I* (fig. 9), the picture he himself considered one of the crucial works in his entire artistic development.

Trying to understand exactly what he was striving for in this large series of drawings, one might turn again to Guston's article on Piero della Francesca. There he asked, "Where can everything be located and in what condition can everything exist?"

FIG. 9. Philip Guston. *White Painting I.* 1951

He continued, with regard to Piero's *Baptism,* "One cannot determine if the rhythms of his spaces substitute themselves as forms, or the forms as rhythms."[13] His drawings (pp. 67, 71) seek to make manifest these elusive principles, discerned in Piero. He has focused on the fact that the two elements—line and space—remain in a symbiotic relationship, in which the existence of lines determines space and the space in turn affects the rhythm of line. What he values is the sense of every compositional element firmly retaining its own well-defined place within that composition despite the ambiguous interaction between the mark that fixes its location in space and the surrounding space itself. In Piero's work, figures are massive and monumental, solidly planted in their clearly assigned location; they are depicted in an even, calm light, which makes them stand out against the background, producing an ideal fusion of compositional elements, enhanced by the rhythm of forms. To arrive at such a perfect fusion of elements seemed to remain a preoccupation throughout Guston's life, as in some notes he jotted down in June 1972, under the heading THEORY:

> Regarding the two rhythms in painting—the movement of forms coming together, and forms separating, I worry about what states and in what conditions they can be represented.
> At times individual forms will appear and exist as if they are independent from their source and have a life of their own. But this is a necessary disguise, for they come from an invisible core and can magnetically return to their source.[14]

The artist for him was only a catalyst for the materialization of these forms—an accomplice, who should help that rhythm to surface without constraining its movement. As he further elaborated:

> At times the forms are seen bunched together, closely affecting each other. They can cause each other to shrink, enlarge, absorb, repel, or seem to swallow one another. In intimate contact, they determine the shape of their existence, a mutual feeding is going on, before they move apart.
> The locations of the forms in space must give the sensation of existing only temporarily. . . .[15]

Although these notes refer specifically to painting, they articulate pervasive, fundamental principles, particularly evident in Guston's drawings of the early fifties and those of the late seventies.

Creation for Guston required avoiding a fall into "immobility," actively following out the implications of the artist's constant doubt about what he described as "a final destiny of forms."[16] Doubt was the motivating force behind each gesture of his hand. His primary objective, distinctly evident in the early fifties drawings, and best expressed in his own words, was to pursue "the enigma of the clear and visible rhythm of the role of forms in space."[17] Certainly drawing, in its rapid execution, allowed the artist the looked-for freedom of exploration. Guston emphasized the importance of this exploratory quality when in a 1964 interview he observed that "in drawing everything surfaces more quickly than in painting."[18] Sequential drawings play the part of erasures in painting: ". . . the discards are the erasures. At one time, I wanted to make drawing more like painting—no contour. Those were drawings with masses,

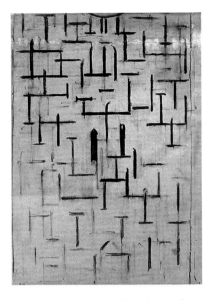

FIG. 10. Piet Mondrian. *Church Façade (Church at Domburg).* 1914

accumulated strokes."[19] Those were the drawings of the early and mid-fifties, and they were highly praised by the critics. Lyrical, evocative, spiritual, they expressed the formal and philosophical aspirations of Abstract Expressionism. Some critics, such as Sam Hunter and Robert Rosenblum, saw the shimmering quality of the pictorial masses and the subtle tonal relationships as reminiscent of the late works of Monet as well as having the atmospheric, spiritual quality of Abstract Expressionism, and therefore called his work "Abstract Impressionism."[20]

The drawings, which at that time were structurally very close indeed to his paintings, exhibited a calligraphic quality, evoking Oriental painting, an affinity that is probably not completely accidental, since Guston was always fascinated with Oriental, especially Chinese Sung, painting. He admired the economy of expressive means and skill of execution that produced the quiet beauty of its compositions. His own works attempting to incorporate these aspects were arrangements of quick, short, sinuous signs moving across the picture plane. They were self-contained explorations of a linear mode that showed resolute control of the free, gestural sign. Guston created compositions in which a process of continuous revelation of line and open form was played out through the size, intensity, and thickness of the strokes.

Guston's emphasis on "the mark"—the stroke, the gesture of brush or pen—was part of a more general dialectic within Abstract Expressionism, and an aspect widely seen as being of extreme importance in the early fifties. The mark was understood as the ultimate realization of an artist's personal and spontaneous gesture; it conveyed his determination to individualize his artistic vocabulary, the very goal that Guston had been relentlessly pursuing. He did in fact personalize the mark and achieved great dexterity in manipulating it to expressive effect. In the drawings of 1952–53, Guston seems to bring small signs together, making them of more uniform thickness (p. 74) or building them up into larger forms (p. 79), thus creating an apparent synthesis of texture and atmosphere.

It should be clear that during the early fifties drawing as a medium played a very important part in Guston's oeuvre, not only allowing him to work and rework his marks but also to master the compositional process itself. In other words, drawing—by virtue of the small size of the support and the medium he used (generally brush and ink)—allowed a close, bodily control of execution, through the supple gesture of the hand across the sheet. It also made possible something that Guston wanted to achieve in his paintings as well: finishing a work without any interruptions in the process.

Guston's drawings from this period were often referred to as "Mondrianesque," in the manner of Mondrian's "plus-and-minus" compositions of the Pier and Ocean series and the Church Façade series of the years 1911–15. While unquestionably they differ from Mondrian's works both in execution and intention (Guston, unlike Mondrian, did not seek a system of universal signs underlying all creation), nonetheless Guston was reportedly very interested in the plus-and-minus compositions, and for hours used to contemplate a drawing from the Church Façade series (fig. 10) which then hung in the living room of his close friends Herbert and Mercedes Matter.[21] Comparing it with Guston's works (pp. 69, 75), and particularly with *Drawing* from 1954 (p. 82), one easily detects the parentage—in the all-over composition, the strong relationships of verticals and horizontals, and the sense of flowing rhythm. And although Guston's surfaces are much more agitated and the marks more nervous, the

same element of giving equal importance to the marks and the spaces between them remains manifest.

In 1953 and throughout 1954 Guston began to restrict the expressive handling so evident in the earlier fifties and introduced more rigorous structure (pp. 80, 82). His concentration shifted from the mark itself to space, or rather to the location of the mark in space. The individual mark became larger, more open and airy, while the total number of marks diminished. As a result, the whole composition showed a more open structure, dominated by the emphasis on space rather than marks, exemplified by *Fall* (p. 78) and the drawing related to *Zone* (p. 81). Compared with drawings of the previous three years, these compositions were more "spare," since it is only the mark itself, through its size and intensity of its blackness, that conveys texture and mass. But its different intensity and density of color also signal different points in space, not on a single plane but as if in depth. Space becomes an active part of the composition, modifying the relation of figure and ground.

YEARS OF EXPERIMENT: 1955–65

Between 1955 and 1958, black-and-white drawing temporarily lost its predominant importance in Guston's work as he focused on paintings and painterly gouaches (p. 86). When the little strokes of the early fifties drawings began to build up into larger, textured forms, and the heavy black mark from the "spare" drawings gained increasing texture and size, beginning to form solid volumes, they engendered the desire for a more solid medium. Paintings like *Beggar's Joy* of 1954–55 (private collection) and *To Fellini* (fig. 11) fulfill that desire, as a textured mass of clustered brushstrokes is played against a looser but nonetheless still fairly compact background. His subtle control of tonal masses becomes the structuring agent of the composition. Guston in such paintings enjoys a mastery of close-value nuances within each color. As Dore Ashton has pointed out, the works reflect a state of reverie.[22]

Paintings of this type were first shown in 1958. Paradoxically, as often happened with Guston when his works were as well received as these, the exhibition was followed by a period of unease and a feeling of exasperation. His palette changed, becoming progressively darker. His brushwork changed as well: the signs grew knotty, contorted, and Guston again opened up a period of drawing.

This process of experimentation with mark and line and their relationship is quite evident in *Head—Double View* and *Forms in Change* of 1958. Both are composed around knotty, thick marks, which send out wispy, unshaded lines that tentatively begin again to describe anonymous forms. *Head—Double View* (p. 84) shows the heavy "locational" mark connected with a line, becoming increasingly descriptive in function. This is the most figuratively developed drawing in the entire series. Guston himself considered it a very important expression of his changing state of mind, the beginning of his disaffection from abstraction.[23] At this point Guston was growing dissatisfied with high modernism, and with abstraction as its expression, because he found it "too well-settled"—too conformist, sterile, devoid of new inventive possibilities. He partook of the sentiment of contemporaries such as de Kooning and Pollock as well as some younger artists (like Helen Frankenthaler) who began in the early fifties to

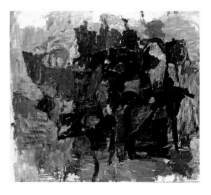

FIG. 11. Philip Guston. *To Fellini*. 1958

react against the absolute non-objectivity of Abstract Expressionism. As in the late forties, when Guston had disavowed figuration in the first place, he again needed to change his frame of reference. On the iconographic level, *Head—Double View* suggests as much, being the first manifestation of the head motif, which would become prominent later. The possibilities inherent in this drawing encouraged Guston's further figurative investigations, apparent in his works from 1958 on.

Forms in Change (p. 85), with its gestural line composition developing out of two focal points of heavy black marks, indicates a different direction of his investigations at this time and led in 1960–61 to a series of thin-line drawings devoid of locational marks—such as *Sortie* (p. 88) and *Pleasures* (p. 90)—often reminiscent of landscape configurations, as well as to drawings like *Celebration* (p. 89), wherein the reappearance of a figurative element is distinctly noticeable.

Eventually, in the late sixties, these two courses of investigation would merge into a new figurative idiom. And a series of gouaches, in 1963–64, such as *Departure* (p. 93) and an untitled work (p. 94), mediated the transition. The underlying principle of composition in these rather painterly gouaches is that of the earlier, "plus-and-minus" drawings: the mark is here enlarged, extended, almost impastoed, but even in paint it remains essentially drawn. In the gouaches, the marks from the drawings of the late fifties such as *Head—Double View* and *Forms in Change* consolidate into figurative shapes (mostly heads or still-life objects). This new development heralds the emphasis on objective form that will dominate his heavily textured work of the later sixties.

In an interview just a few months before his death, Guston discussed all the different phases of his creative life. About this period, which signaled the end of his Abstract Expressionist phase, he said, "Toward the end of the 1950s I was slowly evolving toward a different kind of figuration. Sort of black heads on fields of gray. Again I began to feel the necessity for a subject. It's a different contest when there's both subject and structure."[24] This was essentially what he pursued in the gouaches, and also in exercising his hand with numerous black-and-white drawings—attempting to find more satisfying solutions to the problematic contest between subject (whether figurative or not) and structure. He firmly believed that only by attempting multiple answers could one arrive at new forms of expression. His own search led toward greater corporeality and tangibility of pictorial form.

As his search went on, the early sixties continued Guston's period of discontent. This was true even though his work had been regularly shown for some time and was generally well received by the critics. Since 1955—along with Kline, de Kooning, Pollock, and Rothko—Guston had been represented by the Sidney Janis Gallery and had had a series of one-man shows there. In 1956, he had been included in the "Twelve Americans" exhibition at The Museum of Modern Art and, in 1958, in the Museum's circulating exhibition "The New American Painting," which introduced a number of European countries to the Abstract Expressionists. Then came showings of his work at the Bienal de São Paulo (1959) and the Venice Biennale (1960), followed by a full retrospective at the Guggenheim Museum (1962).

Despite such success, on the creative level Guston was restless. As at other times (such as in 1945) when his work was critically acclaimed, he became dissatisfied; he felt burned out and started to search for new means of expression. It seems that in such periods of searching and doubt he repeatedly returned to studying his pantheon

of Old Masters, as if hoping for fresh inspiration. (He again had an opportunity to study their work first-hand in the summer of 1960; during a three-month European trip at the time of the Venice Biennale, he once more toured Umbria, to revisit and restudy the work of Piero della Francesca.) Somehow, critical acclaim worked for Guston in ways just the contrary of what one might expect. It was, indeed, a stimulus to his creativity, but in a back-handed, almost perverse way. It never encouraged him to keep proceeding straight ahead, in a direct development, but instead provoked a rejection of everything that had dominated the preceding phase, everything that had won praise. Finally, a new style would emerge out of the vestiges of earlier preoccupations, now given a different focal point.

Toward the middle of the sixties, a different focal point does begin to emerge. An untitled drawing of 1962 (p. 92), which sums up the work of 1960–61, proposes a vocabulary of forms that would be explored in the mid-sixties in drawings suggesting still lifes of domestic objects. Further, in the 1962 drawing Guston introduced a different spatial structure: the objects appear to exist in different locations in depth, on different planes. The composition can be read both as a surface and in depth. This kind of composition—which followed some works of 1961, such as *Drawing* (p. 90), wherein forms that were still non-objective already began to acquire an associative quality—subsequently developed into recognizable figurative shapes. His desire to reintroduce figuration—expressed in the early sixties in the use of a thin, energetic, unshaded line that began to describe common forms—culminated in works such as *The Scale* and *The Stone* (p. 96) of 1965.

This entire series of drawings executed in 1965 (pp. 96–97) evolved out of compositions of the type represented by the untitled drawing of 1962 (p. 92). They were analytical exercises, probing the possibilities of quick, gestural definition of simple forms evocative of real, three-dimensional objects. In their very simplicity these drawings convey a great sense of fullness, as a resonant quality arises from the play of light on the white expanse of the support. With a sure touch, the descriptive contour line achieves a delicate equilibrium of form and space: figure is a translation of negative space, circumscribed by line.

It is interesting to compare the 1965 series with Guston's own account of the 1963–64 gouaches (pp. 93, 95), works in which large, mostly black forms dominate the composition against a gray or gray-mauve background. Guston had

> become involved in images and the location of those images, usually a single form, or a few forms. It becomes more important to me simply to locate the form. So I use the most elementary way of making a mark, which is black on white. . . .[25]

When explaining the process of creating these marks—applying white over black and vice versa, scraping and reworking the form—he emphasized that for him the crucial issue remained "locating the form you are making." He further stressed:

> I like a form against a background—I mean, simply empty space—but the paradox is that the form must emerge from this background. It's not just executed there. You are trying to bring your forces, so to speak, to converge all at once into some point.[26]

Now, the intention behind the semi-figurative drawings of the mid-sixties is, in my view, exactly the same: to locate the form, which must emerge from the background. But in this case Guston does not so much build out the form as enclose a part of space with a thin contour line, which results in a simple form evocative of an object and palpable space.

It cannot be overemphasized that this clearly expounded intention "to locate the form" persists throughout different stylistic phases in Guston's work; we also must remember that in its initial impulse it grew out of his studying works by Piero della Francesca. It is just this exactness of location of each form within the composition that gives to the work its perfect equilibrium, yet with a continuously hovering motion, poised between the single form and the whole. As Guston said, "The image must feel as if it's lived."[27] What fascinated him in the process of creation was the "unexpected-ness" of the resulting form.

Perhaps it is for this reason that in spite of his desire to introduce "objects" into his work, Guston at this point still did not want his "objects" in drawings and paintings to be too easily recognizable; he wanted them recognized by association. He invited the viewer to participate in a more active perceptual relationship, wherein the viewer's power of recognition would take on more of the task of relating the forms in the composition to actual objects in the surrounding world. He emphatically stated this intention in an interview with Harold Rosenberg: "The trouble with recognizable art is that it excludes too much. I want my work to include more. And 'more' also comprises one's doubts about the object, plus the problem, the dilemma of recogniz-ing it. I am therefore driven to scrape out the recognition, to efface it, to erase it. I am nowhere until I have reduced it to semi-recognition."[28] At the time—in contrast to a few years later—Guston was still opposed to realism of object, finding it too limiting, constricting the freedom of interpretation, foreclosing the possibility of a more unex-pected meaning.

"PURE" DRAWINGS AND IMAGES OF OBJECTS: 1966–68

In 1966 Guston had an exhibition of his recent paintings and drawings at The Jewish Museum in New York. At about that time he stopped painting, and for the next two years concentrated on drawing. He felt exhausted, drained of the creative energies that had sustained him through the early sixties paintings and the haunting, dark gouaches of 1963–64 (twenty-two of which were in the Jewish Museum show). Now he needed time for renewal. But it was to be a period of anxiety, both personal and artistic: two years of struggle.

Within that two-year span he executed hundreds of drawings—"pure" draw-ings as he called them, as well as images of objects—in brush and ink or in charcoal. Again feeling encumbered by the accumulated baggage of his experience, he turned once more to drawing, trying to reinvent the way to "locate the mark." But his struggle grew not only out of his dissatisfaction with where he had arrived in his own work. It was also related to the changed situation that was coming about in American art in the sixties. A broad reaction against the values of Abstract Expressionism was setting in, with the younger generation of artists attracted to Pop art, to hard-edge

painting, to a cool, Minimal art, or to Conceptual art. Some of Guston's friends and contemporaries within the first generation of Abstract Expressionists, such as Pollock and Kline, were no longer alive, while those that remained saw their work undergoing change. In this new climate, Guston felt a need to reevaluate the shifting situation and his own objectives in art.

In a commentary on the manuscript of Dore Ashton's monograph *Yes, But...: A Critical Study of Philip Guston* (published in 1976), he elaborated on this two-year period. It is such a compelling account of an artist at the crossroads that it should be read in full:

> It was for me a very significant interlude of about two years, before going into the objective work of '68–'70.
>
> I did literally hundreds and hundreds of drawings, mostly brush and ink, and charcoal on paper. They were all over the wall and floors.... My strongest sensation at that time was a feeling of needing to start again with the simplest means to clear the decks. The drawings that didn't work, and were thrown away, were just lines. In the ones that were good the whole space was activated.
>
> I remember days of doing the "pure" drawings immediately followed by days of doing the other—drawings of objects. It wasn't a transition in the way it was in 1948, when one feeling was fading away and a new one had not been born; or as now, where without any conflict necessarily one kind of statement moves into the next. *It was two equally powerful impulses at loggerheads.* I would one day tack up in the house a bunch of pure drawings I had just done, feel good about them, think that I could live with this. And that night go out to the studio to the drawings of objects—books, shoes, buildings, hands, feeling *relief,* and a strong need to cope with tangible things; and I would denounce the pure drawings as too thin and exposed, too much "art," not enough nourishment, and as an impossible direction with no future. The next day, or the day after, back to doing the pure constructions, and to attacking the other. And so it went, this tug-of-war, for about two years.
>
> Looking back, it was as if all the conflicts ... had come together and been compressed in time, and the force equally distributed between the two alternatives. Only when certain doubts cleared in '68, and I began feeling more positive about the drawings of the tangible world, did I begin to paint again....
>
> In the drawing combat I speak of it was as if the debate took place on the level of drawing rather than painting, not only because one's impulses surface more rapidly in drawing, but because the drawings seemed to symbolize the issue.
>
> I was completely detached from the art world during this period, even from looking at *any* painting, past or present. In fact, until the fall of 1970, as you mention later about being isolated at that time, I couldn't bring myself to go to N.Y. to see the shows of friends, to whom I would send telegrams making limp excuses. Occasionally, there would be a visitor up here: you, Bill Berkson, and David McKee, who was planning a show at Marlborough in the fall of 1970.
>
> I go into all this because I have never experienced such a fierce confrontation. Perhaps when you see the drawings of '66, '67, '68, '69—or the photos, you will see what I mean. For this reason I think of this period as of paramount importance.[29]

This is one of Guston's few extended statements specifically addressing the issues of drawing. He instinctively connects drawing with his internal struggle, with the shifting dynamics of his changing frame of mind at the moment of creation, "not only because one's impulses surface more rapidly in drawing, but because the drawings seemed to symbolize the issue." His comments lay bare the issue he was faced with: whether to pursue abstraction, in all its purity and economy of formal expression, or to abandon it, and embark on work tied firmly to the untidy, but tangible, reality of life. From 1966 to 1968, Guston vacillated between the two attitudes: the coolly intellectual versus the emotionally compelling. Always conscious of contemporaneous developments in art, even though sometimes staying removed from them, he might have been in some way responding, in his "pure" drawings, to the works and ideas of the Minimalists.[30] On the other hand, his strong sense of felt life and keen interest in the surrounding world, possibly reinforced by the imagery of Pop art, created a desire to express himself in a more direct and forceful manner.

Analyzing the reductive drawings that the artist saw as a crucial step in his work—such as *Full Brush, Edge, Form, Haven,* and *Mark* (pp. 98–100)—one can appreciate his force of conviction in placing the mark. There is a certain quality of finality in these simple, straightforward exercises of the hand. At moments, superficially, they invite comparison with Robert Motherwell's contemporaneous Open series works (fig. 12), shown at the Marlborough Gallery (which also then represented Guston) in 1969. Yet although there is between them a certain visual affinity of forms, the conceptual underpinnings of the compositions and the intensity of the executed marks are entirely different. In Motherwell's Open series, line is a vestigial outline of a color plane, and defines planar structure; his sources go back to Matisse's work, such as the *View of Notre Dame* of 1914 (The Museum of Modern Art, New York). But in Guston, the heavy black mark (whether charcoal or ink) is instead "locational," not unlike the marks in his drawings from the mid-fifties; it is itself the beginning and the end, establishing its position in space.

Guston's "pure" drawings, while each self-contained, viewed in groups create a sequence that reveals a painstaking search for a new pictorial solution. It was in a way his return to the essential, the basic, yet at the same time he felt an urge for a

palpable object. Thus *Full Brush* is on the one hand a reevaluation of the accumulated mark of the mid-fifties, and on the other a more concrete, object-like sign, while *Form* mediates between the reductive "pure" drawings and concurrently done drawings of tangible things. To satisfy his need to draw things "of the tangible world," Guston found subjects among the everyday objects surrounding him in the studio, or among personal effects, or the parts of the human body. Books, shoes, clocks, hands, brushes, and flatirons entered his iconographic vocabulary around 1968 and remained for the rest of his life.

These simple objects, as in *Book* (p. 102) and *Car* (p. 103), made use of the line familiar from "pure" drawings, which slowly began to describe an object and evolved into enclosure drawing. This progression is explicitly evident in the sequence of works from *Statement* through *City* to *Head (Stranger)* (pp. 104, 105). The crudeness of line and presentation share a stylistic lineage with the cartoon aesthetic. Yet the line has a peculiar quality of sureness, energy, and authority about it. Indeed, with their straight-forward presentation, devoid of extraneous detail, and their boldness of scale, these newly figurative drawings achieve monumentality and an almost human presence; yet they have the stillness and melancholy of the desolate spaces encountered in de Chirico. Done in an almost caricature-like style, they confer a certain strangeness of rediscovery on the familiar and commonplace. But they remain simple statements of fact, presented without commentary from the artist; it is the viewer who provides their individual significance.

While Guston was conducting his interior debate about drawing in the late sixties—vacillating between non-objective and objective, trying to resolve the conceptual, psychological, and formal issues pressing upon him—his moral support came again from intellectual exchanges with his close friends. As with Morton Feldman in the early fifties, now it was the writer Philip Roth and a young poet, Clark Coolidge, both his Woodstock neighbors, who were the sounding board for Guston's ideas. Coolidge was himself deeply affected in his literary work by what Guston was doing in drawing. (As Dore Ashton has pointed out, the two shared an interest in discerning the fundamental structural principles of a work of art, whether its compositional parts were words or pictorial objects.)[31] Coolidge's poetry began to move away from the reductive and abstract toward the more descriptive, tinted now with humor and attentive to objects, and as Coolidge himself pointed out, in this respect it owed a debt to Guston's drawings.

T he final victory in the "drawing combat" between the reductivist "pure" drawings and the bold drawings of objects was won by the figurative style. It would dominate the last twelve years of the artist's life.

His new figuration introduced a very private, introspective imagery which was nonetheless profoundly moralistic and expressive of more universal themes. Guston was always deeply affected in his creative work not only by his own personal preoccupations, but by current events in art, society, and politics. He was always, from his early days as a mural painter, a socially conscious artist. The turmoil of the late sixties

NEW FIGURATION: 1968–70

sharpened his social awareness and made him feel the need to openly raise his voice. At the same time, the alarming political events seemed to verify his own personal distress. Hence, his works of this period are permeated by a sense of disaster and desperation operating on both the private and public levels.

In his artistic pursuits, these concerns precipitated a desire for "tangibility." As Guston years later explained, when he first started doing works which people were calling "figurative" he "wanted to get into more of what I call 'tangibility.' I wanted 'touchable' things. I felt all along, with the nonfigurative things that they were simply nonrecognizable, figurative things."[32] Self-referential, non-objective art at this point seemed "too simple" and "too easily consumed...too thin";[33] it did not seem to have enough substance. Yet the surrounding reality had almost too much substance. In 1945 Guston had found himself dissatisfied with figuration and, after a period of struggle, evolved an abstract idiom. Now, the process seemed to be reversing itself. But his need for deeper content would not permit a mere retreat to a traditional figurative idiom; instead, he was prompted to search again for a truly new style. The process of stylistic development was not so much reversing itself as repeating itself, extending itself. As he explained:

> Working with figuration the way I am doing now [in the seventies] is a purely imaginative projection, of course, because I don't paint from things, you know, as you do when you look at an object. It is all imagined with me. I think ... you enter into a really complex, almost insoluble "contest" be-tween meaning and structure—plastic structure—and that is what I miss in totally non-objective painting: the lack of that contest, when it becomes too possible....[34]

Figuration permitted him to create a more "inclusive" art. Non-objective works offered only the challenge of elaborating the picture plane (the all-over field of Abstract Expressionism). But working in a figurative idiom revealed many more options for pictorial investigation; it presented greater possibilities for exploring ways to activate and penetrate space. By allowing image-making to be integrated into the all-over field, it resolved the contest between meaning and structure through their perfect fusion.

The interest in figuration brought back into the artist's language not only a representation of the human form but also narrative content. Among the repeatedly used iconographic motifs—such as books, clocks, and severed legs and fists—the hooded Ku Klux Klansman appears as a main protagonist in many works of 1968–70. The hooded figure, which made its first appearance in the 1930 drawing for *Conspirators* (p. 50), now becomes a vehicle for transmitting both a personal and a public message. On the one hand, the figure is the painter himself, hooded, hiding behind a disguise (p. 118); it has become a meditation on the nature of identity, and on the

FIG. 13. George Herriman. Detail from a *Krazy Kat* comic strip. 1927

artist's fears—of artistic expression itself and its attendant self-revelation—during a period of crisis. On the other hand, it is an image of evil and culpability that comments, however coarsely, on a contemporaneous social reality. The drawings have a surprisingly moralizing quality—the artist's reflections on society during a period of racial unrest and political upheaval.

FIG. 14. Robert Crumb. *Zap Comix* cover illustration. 1968

In its concealment of identity it is, in fact, a descendant not only of the earlier Klansman motif, but of his Punchinello of 1933 and various masked figures of children in the paintings of the early and mid-forties. There are also conceptual affinities to the masks of Ensor, the melancholy Punchinello figures of Tiepolo, Gilles of Watteau, and the characters in Goya's *Caprichos*. From a number of different psychological angles, these many different figures (which often imply metamorphoses into other beings) would appeal to his rather Kafkaesque sense of the ominous within the absurd, the real within the fantastic. They gave form to the artist's inner sense of ambivalent identity, bodying forth the mystery of how the tangible is shrouded in the imaginary.

The crude line characteristic of these drawings reflected not only Guston's interest in cartoons during his youth, notably the drawings by George Herriman for the *Krazy Kat* comic strip (fig. 13),[35] but also showed affinities with the underground *Zap* comics of the late sixties by Robert Crumb (fig. 14). Yet it was related as well to the coarse drawing of Max Beckmann, whose work Guston first encountered in 1939 and admired particularly in the early forties, returning to it periodically later. Beckmann's heavily and crudely outlined forms, combined into powerful, psychologically disturbing compositions, such as *Apache Dance* (fig. 15)—included in the exhibition at which Guston "discovered" him—as well as his obscure personal symbolism, corresponded to Guston's own sensibilities and captured his imagination.[36]

The simplicity and crudeness of drawing of his new works was related to the expressive intention behind the motifs. The mood of Guston's drawings of 1968–70 is both anxious and melancholy. In them he became again, in the literal sense of the term, an "image" maker, and he always considered this to be his primary function. He wanted to create compositions that would "tell stories," convey his state of mind as well as his attitude toward the social and political atmosphere of the time. To communicate such messages it was necessary to reintroduce figuration, but not as it existed in the traditional sense. Realistic drawing would not have had the imaginative potency to create the spectral mood of his evocations of racial repression, the Holocaust, or nuclear war. In finding his new figurative idiom, Guston may have been helped by the emergence of Pop art, with its cartoonish figures and objects of consumers' desire. But his drawings do not share that feeling of being mass-produced, devoid of emotional content. Instead, his drawings can be, in their way, troubling, even tragic—full of unaccountable events and misunderstood emotions that give them a quality something like the George Herriman cartoons. That mood is conveyed not only through the feeling of interrupted narrative but also through the generalized enclosure drawing, which eliminates humanizing detail, and through the spatial configurations. For instance, an extreme horizon line, occasionally with architectural elements growing out of it, can create a stark landscape, disheartening to behold.

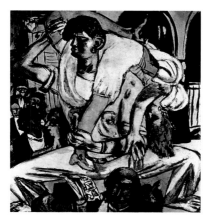

FIG. 15. Max Beckmann. *Apache Dance.* 1938

Guston's hooded figures are depicted either as solitary—engaged in everyday activities, as with *The Law* (p. 114) and *Window* (p. 120), and sometimes painting (p. 118)—or enacting various scenes in groups, as with *At the Table* (p. 112) and

Discussion (p. 115). However, even in groups the figures are always emotionally self-contained; they participate in events but do not interact. Each is psychologically encapsulated within his own shrouded self.

There is an uncomfortably obsessive quality about these drawings that comes, in part, from the repeated use of the same props: books (often open or presented as tablets of the law—Moses with the Ten Commandments), bare light bulbs, clocks. Some of the more complex drawings, in which the hooded figures are depicted against a background of architecture (pp. 107, 113) are more blatantly menacing and oppressive; even the figures, themselves an ominous presence, seem to be threatened by the overpowering architecture. Such compositions, as they reintroduce urban imagery into Guston's drawing, echo his social concerns of the late thirties and especially the early forties; but they do so in a novel way, in a new figurative idiom that flaunts its crudeness.

Guston was very conscious of the adverse reaction to his new figuration among the critics and the audience, but as he commented on the new works to Harold Rosenberg, one of those few who appreciated the courage and radicalness of the new idiom:

> Naturally, I'm very involved with the culture of painting: nevertheless, getting involved in the painting means to divest myself continuously of what I already know and this gets you into an area of, well, you call it crudeness, but you see at that point it's not crude to me. I just want to realize a certain subject.[37]

The process of divesting himself of what he already knew required innumerable drawings. Many of them were closely related to paintings, but most were explorations, in long sequences, of compositional possibilities. For Guston, each picture evolved out of the one preceding it, an aspect of his creative process particularly apparent when looking through a large series of his drawings. The importance of this process Guston himself emphasized in his conversation with Harold Rosenberg, indicating that making numerous drawings before setting up to paint enabled him to work out "the idea": "It wasn't so much the composition, but the forms, the subject-content of it, the images."[38]

It was a satisfying conceptual process that helped him work his way to certain pictorially expressive possibilities. A case in point is the drawing *Wrapped* (p. 121), which succeeds in expressing the ambiguous relationship between abstraction and figuration. It represents a final step in Guston's exploration of the single-hood motif, where all the extraneous details of the torso and head have been eliminated, and what remains is almost abstract: a massive mound of figure, or a form suggestive of ancient architecture.[39] The sources for Guston's imagery in the drawings were his own everyday activities and the objects around him (the book was a natural subject, since he read so much; the bare light bulb was a reminiscence of his youth, when he would draw in a closet in the family's apartment). The hood motif mediated the transition between animate and inanimate object.

But even though the hooded figures sometimes acted as objects in a still life, mostly they were humans in human postures, often betraying Guston's misgivings about political events or human relations. Frequently they were depicted in attitudes

of violence (pp. 106, 111). Eventually they became calmer, more reflective, almost meditative, less intent on "doing"—driving, beating, pushing. Nonetheless, Guston always insisted that they were not illustrating any particular events; they were simply conveying his personal feelings, and through them some more general sense of the world: "I wanted to go deeper into meaning and overtones. Now they're thinking about it all. It's more inside; I have to dig for the images that come out."[40]

The unexpected results of this two-year period of feverish creativity were first publicly shown in an exhibition at the Marlborough Gallery in New York in October 1970, and the critical reaction to them was almost uniformly negative. The abrupt shift in style by an artist earlier admired for lyrical abstractions was greeted with scorn and almost complete incomprehension. The works shown (thirty-three paintings and eight drawings, all of 1968–70) were considered crude, vulgar, cartoonish, grotesque, mere caricatures. Few found anything to admire in the radical new style, or saw courage in his refusal to make things "pretty." Among the reviewers, John Perreault was in the minority:

> Guston's new paintings are cartoony, looney, moving and social. Hooded (KKK?), slot-eyed figures rumble around in cars, paint paintings, beat each other, smoke cigars. Clocks, light bulbs, pointing hands, and out-sized shoes spoof and accuse. It's as if de Chirico went to bed with a hangover and had a *Krazy Kat* dream about America falling apart. Too much.... It really took guts to make this shift this late in the game, because a lot of people are going to hate these things.... Not me.[41]

Harold Rosenberg was more specific: in the works presented at Marlborough, Guston "has revolutionized both his style and his conception of painting to a spectacular degree." But he noted that the "scandal" of the exhibition was not in the fact that Guston introduced narrative and social comment into his work, but that these two aspects seemed to overshadow the concerns of painting; that "line, color, form, even the tensions of creation, are handled, as it were, casually."[42]

Although these reviews refer primarily to the paintings that constituted four-fifths of the exhibition, the issues they address were essentially issues of drawing, which in Guston's new style had become the fundamental structural agent of the composition. Considerations of space became secondary; they were reduced to shape and placement of figures in shallow space, pushing them toward the foreground. Outline drawing played a paramount role and when Guston had begun to paint again, in 1969—after two entire years of drawing only—he had returned to it by way of small-scale, sketch-like paintings of single objects (related to his 1968 drawings of books, ink pots, and the like), which were direct transpositions of drawing into the painterly medium. The paintings shown in 1970 were in fact drawings executed in paint, which would remain the principal characteristic of Guston's work for the rest of his life.

But Guston's work of 1968–70 was not such a complete break with his earlier styles as it seemed at first glance. The gestural, nervous line, although now playing the descriptive role of defining a figure, has the authority and conviction of the fragmented, bold lines used in his fifties drawings. Furthermore, some of the compositional configurations bring to mind the works of the fifties with a crowding of elements toward the

center and reduced density toward the perimeter of the support. Even the repertoire of repeated symbols is already familiar from his early figurative phase of the late thirties and forties: not only the hoods and masks, but the legs sticking out from a pile, showing nail-studded soles, had first appeared at that time in works such as *Porch II* (fig. 7), which had made plain the initial impact on Guston of Picasso's *Guernica* (fig. 6). And all of these motifs would reappear with obsessive intensity in the last series of pen-and-ink drawings and acrylics, which were executed in 1980, shortly before the artist's death.

THE ROMA SERIES: 1971

When his new figurative works encountered a hostile public reaction and adverse criticism, Guston, depressed, removed himself from the New York art scene. He had been invited again to spend a year as artist-in-residence at the American Academy in Rome and, shortly after the Marlborough opening, left for Italy. It was his third Italian stay and this time, as twice before, he traveled extensively throughout Italy (as well as Sicily and Greece), revisiting familiar places—Orvieto, Florence, Venice—and reacquainting himself once more with the works by the Old Masters from his "pantheon": Piero, Titian, Tintoretto, and others. At first, he was unable to work, paralyzed by the negative response to his latest pictures. But in February 1971 he was able to write to David McKee, who had organized the Marlborough exhibition, that he had begun working again: "Small things…but new images and feelings—I've done a large number of things, and they feel new and strange to me."[43]

The works in question were oils and acrylics on paper, a series of over a hundred pictures of Roman gardens and Etruscan and Roman excavations (pp. 128–136). Although done in painterly mediums, these works, the Roma series, are essentially drawings: line describing form becomes a dominant aspect. When studied together, the individual works look like sheets from the artist's sketchbook, fragmented notations of the scenery that caught his eye. In his letter to McKee, Guston points out what his interest had focused on:

> Modern art—Roman style—is remote for me, like some kind of sentimental Victorian oddity. Etruscan and early Roman painting, Piero, Giotto, Lippi, Baroque architecture, facades, formal gardens, all so exciting and complex, so plastic, so alive and complex, so much to think about, so truly contemporary that I am really unable to see the modern display of a few flat, simple planes of color spaces. Besides, it is clear to me that only the great film men here are the true inheritors of the rich and complex art of the past. Fellini is a great fresco painter in every sense…and so is Pasolini.

Indeed, Guston's long-standing interest in film, which in the fifties was expressed in works like *To Fellini,* seems to exist here, too, in pictures that could constitute episodes in a cinematic sequence on the subject of Rome.

Although Guston saw them as completely new, unrelated to the work left behind in New York, these seductive drawings in fact continue the simplified, linear

style of the 1968–70 works as well as their spatial configurations, often organized into horizontal registers. The simple geometry of forms (such as the crowns of numerous trees) narrows them to shapes suspiciously like hoods; the background wall—reminiscent of both Piero and de Chirico—is a descendant of the similar device used long ago in a study for a mural (p. 53) and, even further back, in the drawing for *Conspirators* (p. 50). The main difference between the Roma works and the 1968–70 drawings is the quality of the space in which the objects were now situated. It is not a mental, schematic, internal space, but has become an outdoor space, as if for the first time Guston were trying to work from the object and reconcile the world around him with pictorial space. A striking element of these works is the luminosity of color, redolent in their shimmering pinks of the abstract paintings of the early fifties. They are pure and simple statements of fact, tangible and monumental in their presence and presentation. On the other hand, they have a poetic quality conveyed through the luminous surfaces and pervasive pink-red coloring. They look back to the past in the use of the lexicon of motifs—hoods, books, feet, brick wall—and at the same time look ahead to the spatial organization that will begin to emerge in the subsequent works of 1974–80, where the forms, in great profusion, float in space or are massed along a high horizon line. In the Roma series Guston has achieved a delicate balance between the images, the surfaces, and the color, using them to their full expressive power.

These works proved the astonishing resilience of Guston's creative powers. Rebounding from "black despair" after a deeply disappointing exhibition, he was capable of producing these vibrant works within the span of a few months—reinventing, making things that seem to announce a new beginning.

He returned to America after the summer of 1971, decided to resettle definitely in Woodstock, and ended his contract with the Marlborough Gallery. Another period of personal turmoil followed, and around 1973 a new pictorial idiom emerged.

A s Guston once explained to his students, he realized after Italy that he was "finished with the hoods; they were done." Now, resettled in Woodstock and at a safe distance from the inhospitable art scene, he was anxious again to embark upon something new. He began looking for a change of subjects and turned once more to elements of the everyday environment: "the road outside, a couple of telephone poles, paint cans, a pile of junk."[44] But as usual, the anxieties of life affected his creative energies. Although the trip to Italy and the renewed contact with Quattrocento art had helped him to recover from the deep depression that followed the exhibition of hooded-figure works, a serious illness of his wife in 1971 brought about another period of distress.

Like many artists of a saturnine temperament, pensive and brooding, he looked for a way to portray his state of mind in his work. (It is not surprising that he always had a reproduction of Dürer's engraving *Melancholia* pinned up in his kitchen.) From 1972 on, as the mood of his work became darker and more anguished, he started focusing again on the painter as the main protagonist of his pictures. But now he invented a new self-image. He lifted the hood and revealed what had been hidden

THE HEADS: 1974–76

37

underneath. What emerged was a large, bloated head, seen in profile, devoid of features; it was unconnected to a body and dominated by a single bulging eye, which stared fixedly at objects or figures directly ahead. Severed from the rest of the body, the head became another object amid the detritus that littered Guston's eerie landscape. It always retained, however, the identity of a human being, which powerfully organized the entire composition. This alter ego is represented in a variety of situations, reflecting the artist's ponderings about his environment, his conflicts, and himself. Perhaps its disturbing sense of self-discovery is related to one of Guston's favorite literary works, Kafka's *Metamorphosis,* whose protagonist awakens one morning to find himself unaccountably transformed in his bed into a gigantic insect.[45]

The drawings of the two years 1974–76 constitute an autobiography. Their intensity and the private conflicts they unveil—conflicts not uncommon to creative artists—make them as unsettling for the viewer as the oppressive, aggressive, hooded figures of a few years earlier. Indeed, by comparison, the hoods seem like the costumes of some grotesquely playful participants in an elaborate masquerade, while the blimp-like head has a more tragic, tormented, physical presence. Yet, there is at times an almost Surrealistic association with the macabre, obvious in *Smoking in Bed II* (p. 139). Here, the bean-shaped head lies in bed, eye almost closed, yet it is still puffing on a cigarette, which was ever-present in Guston's real life. The shrouded body lies as if on a catafalque, the corpse of a martyr laid out for public viewing before burial—the artist as martyr to critical or social opinion, reflecting an attitude that goes back to the French Realist and Symbolist traditions, as with Courbet and, later, Gauguin. It is also a portrait of Guston's own recurrent psychological state, confronting what he called the "impossibility of painting"—the artist lying awake in despair, contemplating his own creative paralysis. *Smoking in Bed II* is part of an entire series of drawings in which the head, sentient yet powerless, assumes such importance that it begins to fill the sheet.

This intense, disquieting alter ego allowed Guston to bring the world of his everyday reality into the pictorial realm. It enabled him to comment openly—even with a certain mordant humor—on his real-life problems. *Head and Bottle* (p. 144) is a direct allusion to the pitfalls of alcohol. *Fist* (p. 144)—in which an immense, looming head, its brow furrowed in concentration, closely scrutinizes a tiny canvas, while a clenched fist rises from sea level—reflects Guston's tenacity and determination about art: painting is shown as the single-minded focus of his life, even while frustration, perhaps rage, is acknowledged. This leading thought returns with strength in a group of drawings that usually include the alter ego, the head of Musa (the artist's wife, often seen in partial front view, but sometimes from the back), an easel, a book, and a ball or wheel (which may allude to the myth of Sisyphus) (p. 145). Further reflections on the artist's world and his creative abilities are expressed through a more straightforward use of the hand motif than in *Fist.* Cut off at the wrist, or reduced to looming fingers, it is presented as the conveyor of the artist's creative thought to the paper or canvas, and thus assumes a role comparable to that of the Cyclopean head. While introducing these figures in a mental landscape into his compositions, Guston at the same time introduces elements of illusionistic depiction, representing the objects in new configurations of single-layer space, as in *Message* (p. 140) and *Elements* (p. 146).

Drawings such as these, executed in quick, nervous strokes, have the quality of jotted notations, sketches of fragments of thoughts. That quality makes the line

now describing figures different from the thick, crude outline endemic to the hood pictures. As used in drawings such as *Four Heads* (p. 138) or *Web* (p. 142) it shows affinities to both the nervous, broken-up stroke of the early fifties drawings, such as *Loft II* and *Autumn,* and the thin, descriptive line of 1960–62; it is really a combination of the two.

The drawings also begin to include a profusion of objects—intertwined, strewn about, piled up in a heap—which will return in Guston's last series of drawings, executed shortly before his death in 1980. Drawings such as the two related to the painting *Web* (pp. 142, 143) represent variations on that profusion as they explore the relationship between animate and inanimate objects. In a lecture, while discussing the origin of certain motifs in his work as the result of sheer accident, Guston remarked on the origin of *Web:*

> One morning my wife, after the rain, pointed out a spider that was making a marvelous web, so I started doing a number of web pictures with my wife and myself, and a lot of paraphernalia caught in the web. That's her on the right, with the hair coming down her forehead, and then I thought I'd put a shoe on her head. It's a terribly corny idea, but what can you do? It led to a whole series of paintings with both of us caught in a web.[46]

These *Web* drawings were among the few directly related to specific paintings. Although Guston drew incessantly, when he painted it was "a form of germination"; only rarely did he make actual working drawings. The studies for *Green Sea* (p. 147) and *The Wall* (p. 157) are among those which closely resemble final pictorial compositions.

Despite Guston's insistence that the choice of subjects for his compositions simply resulted from images that happened to catch his eye, his choices nonetheless communicate on a deeper emotional level. His personal feelings are reflected in the selection of imagery that defines the mood of the works. The floating heads seen in the mid-seventies—some just above the level of water, others half-submerged and sinking, as in *Aftermath* (p. 143) and *Lower Level* (p. 152)—express the despair that haunted him anew when he came to the end of what had been a euphoric painting streak during the early part of 1975.

The drawings of the mid-seventies embody quite explicitly Guston's idea of how images metamorphose during the working process he described in the *Web* drawings. The forms never have only one meaning; they are multivalent symbols that, from their placement within the composition, can evolve into an entirely different form and symbol, a device which will assert itself increasingly in the 1980 drawings. The book, flatiron, brushes, and other objects within his reach at the studio are not only elements of a still life; they could also become fragments of a landscape, translated into new forms by the process of looking at them. They thus represent different meanings even to the artist, who in the course of his working assigns to them a provisional identity expressly related to a specific context, while they might be understood in quite other ways by the viewer, who brings to them his own associations. It was the interpretative freedom which pictures allow that always interested Guston, as he often said.

The psychological undercurrents that manifested themselves with such force in Guston's drawings of 1975–76 betrayed an additional source of apprehension:

entering old age. His health was deteriorating and he knew it. (In 1977 his wife, Musa, suffered a serious stroke, and in the works done after that the themes of illness and death recur with greater force, becoming a main preoccupation.) The mood of the compositions after 1975 grows much more somber and more personal, the drawing tighter. Heads, mostly his and Musa's, barely afloat, appear as images of fragile mortality (pp. 151, 155). We are allowed to overhear the private thoughts of an artist as he is physically overwhelmed, carried helplessly away by the "deluge" (a metaphor made explicit in his titles).

It was to his drawings that he confided his fears about old age. To convey these feelings he changed his drawing technique: the heavily outlined forms like the heads in *Lower Level* (p. 152) are composed of a multiplicity of short, rapid strokes which create a network or grid-like structure. The piling up of objects, predominantly the floating heads, overlaid with a grid of rain-like strokes, here creates the illusion of composition in depth, as if Guston would revive illusionistic space. Drawings such as this one or *Current* (p. 153) elaborate on subjects seen the year before in *Rain* (p. 142) and *Aftermath* (p. 143), but with a slightly different stylistic treatment characterized by this even more compulsively gestural quality.

During the five years from 1974 until his first heart attack, in March 1979, Guston was exceptionally prolific, painting and drawing without end. The works that resulted are disconcerting—distressing yet at the same time strangely powerful. On the one hand, they brood obsessively on the fate of one individual, carried off by the tide. Yet on the other, they also reveal a new depth of human compassion, as the artist poignantly shows the shared destiny of all.

LAST DRAWINGS: 1980

As Guston recovered from his first heart attack during 1979, he resumed working, but only in small format, since his health did not permit strenuous effort. He made a series of small paintings of single objects much like those in his drawings of 1968. In 1980 he executed what would be his last two series of drawings: black-and-white pen-and-ink drawings and a series in acrylic and ink. The images are bleak, powerful, and unsettling.

The pen-and-ink drawings, showing mounds of miscellaneous junk, have an air of finality about them. They convey a sense of coming to the bitter end, as amid the debris are discovered more disturbing forms, including severed limbs and entrails. All of the works in the group employ the same vocabulary of motifs—feet, flatirons, shoes, books, brushes, nails, and random detritus—either piled up or rolled into a ball, as if all the fragments had congealed into one spiky mass. The line defining the forms is heavier now than the one seen in the mid-seventies; used emphatically, it imbues these symbolic objects with an aggressive presence.

There is a curious analogy, in the use of symbols and scale, between these drawings and the works of the Mexican muralist Orozco, which Guston knew from his own years as a muralist in the thirties, when the Mexican mural tradition was a great stylistic influence on him. In Orozco's political work (fig. 16),[47] such motifs as oversize feet and chains were used repeatedly as symbols of his outrage against oppression;

compilations of objects and an expressionistic use of inanimate objects, also very often large in scale, were other devices to convey powerful, violent emotions. There is a further affinity between them on the expressive level: both push the use of personal symbolism to such an extreme that it begins to reveal their implicit psychology rather than just their explicit ideology or even their aesthetics. Indeed the very scale of their symbols seems to demand a psychological interpretation, an explanation of what provoked such exaggerated attention to the physicality of the objects: there is something brutal, yet also fragile and vulnerable, in the way such personal symbols are so conspicuously displayed.

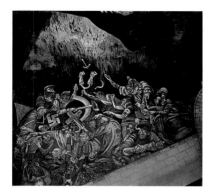

FIG. 16. José Clemente Orozco. *Political Circus* (detail). 1937

Guston's deployment of symbols is particularly telling in drawings like *Fault* and *Layers*. In *Fault* (p. 160), the artist's stock of symbols is piled up into a mound that is being climbed by a single, severed foot, behind which is placed a large, round stone. Once more, things take the shape of the myth of Sisyphus. The image suggests the artist himself striving to pull his materials together, but it is an uphill struggle. The implication is that, as with Sisyphus, the stone always rolls back down; the symbols always collapse back into chaos.

The treatment of objects in the drawing *Layers* (p. 158) is revealing in a different way. A large expanse of heavy black space dominates the center of the composition, encompassing such familiar objects as oversize cigarette butts, the staring eye, a flatiron, and a scroll. These objects have fallen to the bottom of a pit. But a few others are arrayed, in the distance, along a high horizon. In other words, the objects are in a space that seems expandable. And the line, at times shaded, seems to define three-dimensional objects, while the black, velvety texture is achieved with thin, overlapping strokes that endow the objects with relief.

Compositions such as these begin to create a cycle of explorations of pictorial space. An explanation that Guston gave in 1978 regarding how he composed his paintings seems to describe this series of drawings as well:

> The forms, which touch and bump and overlap each other, strain to separate themselves, yet cannot exist without one another. While they strive to become independent, a condition of delirium persists, as if these forms desire to configure other combinations of themselves. What a restless and startling state for forms to be in![48]

Indeed, in these last drawings the relationship between the tangled forms is constantly in flux, creating the sensation of an ambiguous space. This bizarre domain is Guston's mindscape. Even though the space is structurally different, it somehow recaptures the sense of a forsaken, otherworldly landscape in the works of European Surrealists over forty years earlier. The desolation of de Chirico's empty expanses, an important influence in Guston's early work, also permeates these compositions. But the mental landscapes in Guston's last drawings, their extraordinary combination of torment, imagination, and wisdom, show the creative freedom possible only for a mature artist.

Another drawing (p. 163) effectively conveys his hard-won understanding of himself and his art. An enormous ball made up of familiar objects rolls menacingly toward the artist's sanctuary, where, in isolation, oblivious to the danger, the blimp-head alter ego sits in front of his easel, at work in a studio lit by a bare, hanging light bulb. The round mass looks as if one of his late landscapes has been rolled into a lump,

with heavy objects sticking to the surface and jutting out in all directions. Yet it also has a certain touchingly anthropomorphic quality: it is a kind of conglomerate head made up of the artist's familiar subjects, peering in the window, looking over his shoulder as he paints.

These objects, used repeatedly through the last decade, are the accoutrements of his studio: the flatiron (often held up by the handle to be used as a shield, but also as a weapon), canvas stretcher, oversize nails, heavy rope, and cigarette butts. They have become living symbols of the artist's struggles. But even though they are so personal, these drawings also reflect the artist's command of the history of art. For in their formal structure, as "layered" configurations of objects, they are new interpretations of Piero della Francesca's structuring and layering of space, encountered, for instance, in *The Defeat of Chosroes.*

His very last group of works was a series in acrylic and ink. Although quite painterly in medium and execution, these compositions rely on drawing as an essential element of pictorial structure. They explore the same iconographic motifs that appeared time and again in the last pen-and-ink drawings (p. 160). But in their straightforward presentation of bold shapes in frieze-like arrangements, these works emanate a less intense mood of valediction and melancholy. For instance, an untitled still life (p. 168) composed of a coffee mug, ball, shoe, flatiron, and a canvas stretcher presents these objects with crude directness as seen through an open studio door. Dispersed in a whitish blue background, these trivial items are each set off, given a separate, personal identity, until they become people-like presences; they stand about, available for selection, ready to enter into more complex configurations. They comprise Guston's ABC of symbols, his "attributes of the arts," that classic still-life subject since the seventeenth century.

Even though the medium is different, the manner of drawing and the line that describes the objects have the same oddly exact crudeness as his pen-and-ink drawings. His objects are not beautiful. They are almost grotesque. Yet it is their homely quality, even their ugliness, that engages his feelings. As Ross Feld has noted:

> He both loves the objects of the world and is cast down by them. Depression and delight are impartially described with a foolish amount of courage; foolish courage—art making—in turn becoming one additional and transcendent object for the artist's consideration.[49]

Freedom and foolishness: these were the two words Guston often used when discussing his art. His personal way of approaching the subject and its manner of presentation always expressed his desire to be free in choosing the right form in spite of what the reaction might be.

The works in this last series of acrylics recapitulate Guston's earlier subjects but restate them with a new boldness. There is a certain tragic air—whether of mere loneliness or of unfulfilled aspiration—in them. Truncated ladders are draped with flaccid, nailed legs that could not hope to climb, even without the dead weight of enormous, flatiron-like shoes (p. 164). Or, ladders just stand desolately by themselves (p. 167), leaning against the blue sky, solid but vulnerable. A kettle with bandage-like shapes across its body (p. 165) becomes a figure in back view whose coat is torn with

age, while the cloud of steam extending from its spout turns into smoke from the painter's cigarette. The bandaged body of the kettle then metamorphoses into a bandaged head gazing up as it climbs (or slides down) a hill littered with familiar props of wheels and stones (p. 171). The head is a descendant of the potato-head self-image of the mid-seventies, with a black iris fixedly looking forward. One can see this head as a symbol of victimization, even as an allegory of the artist martyred in the service of art, stoned like a saint by the critics and public. It is, perhaps, a despairing statement of his later vision of his place in the world: a figure crude, bereft of poetry, bereft of everything except what it sees ahead. But it also achieves an undeniable iconic presence: the solidity and weight of forms Guston so admired in Piero.

Perhaps his most direct statement about the finality of things is another untitled work from the series of late acrylics (p. 170). Here, the Sisyphean stone occupies almost the entire field of the picture. A forlorn foot sticks out, as if some figure were trapped, rolled up inside. But in the wedge between the horizon and the stone we glimpse a radiant sun. It is an image poised between life and death. Figuration again approaches abstraction, as Guston finds himself unwillingly impelled toward his own vision of a more abstract realm. It is a very moving, almost tender, drawing, containing in itself the wisdom of a life-worn man, a consummate creator conscious of the waning cycle of life and work, or as he would say, of "a life lived."

A few years before his death, Guston's work had finally started to receive more favorable critical attention. In the (fairly infrequent) reviews of Guston's exhibitions in the late seventies, compared with those of the preceding ten years, the changed appreciation of the work is unmistakable. It reflected the changed conditions of the artistic scene.

GUSTON AND HIS LEGACY

Guston's turn toward figuration presaged new tendencies that began to dominate European and American art in the seventies. The emergence of German Neo-Expressionism and its Italian counterpart changed the context in which Guston's art was now being viewed. (It is interesting to note that as early as 1958–59, when Guston's art was still abstract, it was already appreciated by a younger generation of German painters. When Guston's work was shown in Europe in the "New American Painting" exhibition in 1958, artists such as Georg Baselitz were particularly attracted to it.)[50] To the younger generation of Americans, born after World War II, Guston became an influence and an inspiration. His daring move toward figuration and the reintroduction of narrative provided a way out of reductivist abstraction and satisfied a need for a more inclusive art. What Guston had achieved after years of internal struggle and an arduous process of artistic evolution, a younger generation was now free simply to appropriate—without his intense psychological engagement. In this more pluralistic era, figurative work assumed an importance as great as, if not greater than that of abstraction as a viable idiom of expression.

As the younger artists came to maturity, Guston's new figuration opened up alternate possibilities that they had not seen in the art of the sixties—such as Pop art, hard-edge painting, Minimalism, and Conceptual art—or, looking farther back, in the

generally accepted line of art-historical development from Cézanne through Cubism, Mondrian to Minimalism. Pop art, with its ready-made imagery from commerce and popular culture, parodied not only its own demotic sources but high art itself, and hence seemed twice removed; it seemed too impersonal and mechanical, lacking emotional content and narrowing the viewer's range of interpretative possibilities. On the whole, the cool, objective, detached art of the sixties virtually eliminated subjective experience, and the younger generation now found such an approach too limiting, bereft of creative impetus. They began to look to sources outside the Cubist-derived tradition to readdress the significance of personal experience; the later works of de Chirico, Guston, Picabia, and Hélion, those masters outside the mainstream of modernist tradition, contained a subjectivity of vision the young found inspiring.

The young American artists saw in Guston's work what they were looking for in their own. To instill new meaning that was not self-referential and to return to the image, but in a non-traditional way, were the central focuses of their search. They were attracted to Guston's work by precisely the features that his critics had ridiculed: assertive, direct drawing manner; the desire to monumentalize trivial subjects of everyday life; and, particularly, the concern with a subjective experience of the world. All these elements came to characterize the new figurative-image painting that began to dominate the art of the seventies and eighties. Guston's schematic, diagrammatic style—based on images that were removed from the usual associative backgrounds, generalized in form and stripped of detail, made "episodic" in nature, and rendered with deliberate clumsiness—was prophetic for a younger generation of artists looking to establish a new artistic identity. Their use of recognizable images, frequently not susceptible to definitive interpretation, or combined into a non-linear narrative that offered freedom of explanation and association, was a direct legacy of Guston's new figurative work of his last decade. Furthermore, the fusion of diverse sources so evident throughout different phases of Guston's evolution, and particularly prominent in his late phase, anticipated the tendency toward historicism and appropriation in the works of younger artists.

The influence of Guston's work and ideas was exercised on two levels: visual and intellectual. Although, or perhaps because, Guston was primarily an active creative artist, he was also a charismatic teacher. He taught off and on throughout his life, perhaps more actively after 1967: he gave regular seminars at the New York Studio School from 1967 until 1973; in 1969–70 and again in 1972–73, he was a guest critic at the Graduate School of Fine Arts at Columbia University; and from 1973 until 1978 he taught at Boston University. As a teacher Guston believed in a very disciplined education and in working out one's own philosophy; a thorough knowledge of art history and of drawing were in his view the two most essential prerequisites for a painter. In fact he generally taught life drawing, considering it the basis for the development of a personal style. Studying drawing and learning from observation were the fundamental principles of Guston's teaching.

This emphasis undoubtedly ensued from his understanding of the multiple roles of drawing in his own work: as an expressive medium in its own right, allowing for great immediacy of communication; as a means of working out themes before facing the canvas; and also (embodied in brushwork) as a structural element in painting. But most of all, Guston was deeply conscious of the inherently expressive, almost

symbolic, character of the basic physical aspects of drawing, such as line and color or the absence of color. During the most intense periods of drawing, he worked in a most classical way, exploring to the full the essential nature of black-and-white drawing. For example, he used monochrome marks in differentiated ways to convey different meanings, pictorial and emotional, varying the emphatic qualities of line (aggressive, agitated, fragmented, or tentative) to evince the appropriate responses. He also investigated the special symbolism of black. Like Matisse, who was a master of exquisite nuance in black, Guston probed the possibilities of black line as a division that can be coloristically and emotionally active. For line enhanced the action of black—black being not only a means to indicate the absence of light (i.e., shadow) but also to suggest the darker psychological states.

Line always remained the most recognizable feature of Guston's artistic handwriting. He was able to use line to maximum expressive effect. It was fluid but never superficial; it was used economically, yet with great concentration of energy. It allowed the artist to evoke, with the most condensed vocabulary of formal means, a broad range of emotional and aesthetic reactions. Indeed, what has never been stated clearly as a general principle about Guston's change to his later figurative style—which came to influence and be appreciated by a whole generation of younger artists—is the fact that the style was predicated upon a new emphasis on drawing.

Guston reinvented drawing in its role as creator of appearances. Drawing is of course viewed fundamentally as a means of externalizing the inward, the artist's state of mind or perceptions. But as Kenneth Baker noted in a review of Guston's drawings,

> Part of the ability to draw is knowing what others will see when they look at the marks made. What Guston's drawings make us see that other drawings don't is this: that to draw is to form appearances only because to look at a drawing is to form appearances.[51]

Guston's is never a realist drawing imposing on the viewer a singular interpretation of a represented form. It requires the active participation of the observer; it offers a suggestion of what can be seen, and it is the viewer's responsibility to find, through emotional and mental involvement, the meaning of the depicted forms. To be sure, Guston's iconography in the late works is deeply personal, unveiling very disturbing aspects of the artist's psyche, but the option given viewers of creating their own responses made the imagery expressive of the human psyche in the more general sense. This might have been among the reasons for the initial rejection of Guston's new figurative work. It was rejected on a superficial level for failing to be what it was not—beautiful drawing. It was harsh, almost repulsive in its crudeness and child-like execution. But a more considered examination revealed much more, a deeply human drama whose uncomfortable truth—disclosed by a mode of drawing bordering on the grotesque—could induce a shock of recognition. As Baker further wrote:

> Guston's drawings reveal to us the reflexive movement of our attention towards recognition, towards that feeling of transparency for which no one seems responsible, that happens when we look at what might be an image.[52]

This "reflexive movement...towards recognition" is what Guston explores in a most formidable manner, allowing the depicted, tangible objects to metamorphose continuously into something else. His images embody not only freedom of creation (which de Kooning was the one to appreciate at the disastrous Marlborough show in 1970)[53] but also freedom of discovering one's own meaning. Drawing becomes a cognitive act. It offers to the viewer, too, different imaginative possibilities, conveyed through the suggestive marks drawn by the artist. A new understanding of what happens in the spontaneous moment of recognition, in the moment when we see, would become an important legacy of Guston to the younger generation of artists.

In 1978, while discussing his recent work, Guston stressed that when he painted he tried to work in a quick way so as not to lose his "thought or urgency, and without stepping back to look at it." He further elaborated:

> The worst thing in the world is to make judgements. What I always try to do is to eliminate, as much as possible, the time span between thinking and doing. The ideal is to think and to do at the same second, the same split second.[54]

Drawing, by the very nature of the medium and format, allows for quick gesture and quick statement of fact with the most elementary means. It therefore provided Guston with such a split-second process of creation, as quick and unpremeditated as the process of seeing. This was in the tradition of what he considered an ideal among arts of the past, Chinese Sung painting, in which the creative moment was felt through the rhythm of activity rather than through the time-taking process of first looking and then judging, erasing, and improving. The inner life of the artist speaks more easily through the unpremeditated act of drawing. A new recognition of how drawing reveals a personal way of seeing the world was a vital part of Guston's legacy.

Philip Guston sketching in Rome, 1971

NOTES TO THE TEXT

1. Interview with Joan Pring, June 25, 1957; transcript in the Archives of The Museum of Modern Art, New York, p. 1.

2. Quoted in David Aronson, "Philip Guston: Ten Drawings," *Boston University Journal,* Fall 1973, p. 21.

3. Philip Guston, "Piero della Francesca: The Impossibility of Painting," *Art News,* May 1965, p. 38.

4. Guston himself emphasized his strong response to the de Chirico works, in the film *Philip Guston: A Life Lived, 1913–1980,* prepared by Blackwood Productions, New York, in 1980, at the time of his retrospective at the San Francisco Museum of Modern Art.

5. Guston, interview with Pring, p. 3.

6. See Dore Ashton, *Yes, But...: A Critical Study of Philip Guston* (New York: Viking, 1976), p. 7.

7. David McKee, conversation with the author, fall 1987.

8. Guston, interview with Pring, p. 37.

9. Harold Rosenberg, "The American Action Painters," *Art News,* December 1952, p. 22.

10. Irving Sandler, *The New York School: The Painters and Sculptors of the Fifties* (New York: Harper & Row, 1978), p. 48.

11. Ibid., p. 51.

12. Ashton, *Yes, But...,* p. 97.

13. Guston, "Piero della Francesca," pp. 38, 39.

14. "Philip Guston—Random Notes, June 29, 1972" (Dore Ashton Papers, Archives of American Art, Washington, D.C.), p. 5.

15. Ibid.

16. Ibid., p. 39.

17. Ibid., p. 5.

18. Bill Berkson, "Dialogue with Philip Guston, November 1, 1964," *Art and Literature: An International Review,* Winter 1965, p. 69.

19. Ibid.

20. See Sam Hunter, "Painting by Another Name," *Art in America,* December 1954, pp. 291–95; and Robert Rosenblum, "Varieties of Impressionism," *Art Digest,* October 1, 1954, p. 7.

21. Mercedes Matter, interview with the author, November 1987.

22. Ashton, *Yes, But...,* pp. 106–11.

23. David McKee, artist's questionnaire prepared for the Department of Drawings, The Museum of Modern Art, July 24, 1984: "He [Guston] considered it *[Head—Double View]* to be the first manifestation of the head and the beginning of his disaffection with abstraction. The possibilities implied in the drawing encouraged further figurative investigations apparent in paintings of 1958 on."

24. Mark Stevens, "A Talk with Philip Guston," *The New Republic,* March 15, 1980, p. 26.

25. "Philip Guston's Object: A Dialogue with Harold Rosenberg," in Sam Hunter, *Philip Guston: Recent Paintings and Drawings,* exhibition catalogue (New York: The Jewish Museum, 1966), n.p.

26. Ibid.

27. Ibid.

28. Ibid.

29. Philip Guston, comments about the manuscript of *Yes, But...* (Dore Ashton Papers, Archives of American Art, Washington, D.C.), p. 110.

30. The first important exhibitions of Minimal art in New York took place in 1966: "Systemic Painting" at the Guggenheim Museum (where four years earlier Guston had had a retrospective), and "Primary Structures" at The Jewish Museum (where he had a show that same year).

31. See Ashton, *Yes, But...,* pp. 160–61.

32. Jan Butterfield, "A Very Anxious Fix: Philip Guston," *Images and Issues,* Summer 1980, p. 34.

33. Ibid.

34. Ibid.

35. For a discussion of Guston, Herriman, and *Krazy Kat,* see Adam Gopnik, "The Genius of George Herriman," *The New York Review of Books,* December 18, 1986, pp. 19–28.

36. It is curious to note that Beckmann succeeded Guston as art instructor at Washington University in St. Louis in 1947, but the two men never met.

37. Harold Rosenberg, "Conversations: Philip Guston and Harold Rosenberg—Guston's Recent Paintings," *Boston University Journal,* Fall 1974, p. 48.

38. Ibid., p. 54.

39. John Elderfield's *The Modern Drawing* (New York: The Museum of Modern Art, 1983) contains an illuminating discussion of this drawing.

40. Rosenberg, "Conversations," p. 58.

41. John Perreault, "Art," *The Village Voice,* November 5, 1970, p. 26.

42. Harold Rosenberg, "Liberation from Detachment," *The New Yorker,* November 7, 1970, p. 136.

43. Philip Guston, undated letter to David McKee, received February 18, 1971.

44. "Philip Guston Talking," in Nicholas Serota, ed., *Philip Guston: Paintings, 1969–1980,* exhibition catalogue (London: Whitechapel Art Gallery, 1982), p. 53.

45. Guston discussed an analogy with Kafka in "Philip Guston's Object," n.p.

46. "Philip Guston Talking," p. 56.

47. For this information on Orozco's imagery and symbolism, I am grateful to the artist David Saunders, who brought it to my attention and documented it with supporting materials.

48. "Philip Guston Talking," p. 51.

49. Ross Feld, "Philip Guston," in Henry T. Hopkins and Feld, *Philip Guston,* exhibition catalogue (New York: Braziller; San Francisco: San Francisco Museum of Modern Art, 1980), p. 34.

50. I thank Kynaston McShine for sharing with me this information, which came to light in the course of his preparing the exhibition "BERLINART 1961–1987," held at The Museum of Modern Art in 1987.

51. Kenneth Baker, "Philip Guston's Drawing: Delirious Figuration," *Arts Magazine,* June 1977, p. 89.

52. Ibid.

53. See Butterfield, "A Very Anxious Fix," pp. 30–31.

54. "Philip Guston Talking," p. 55.

PLATES

Drawing for *Conspirators.* 1930
(CAT. 1)

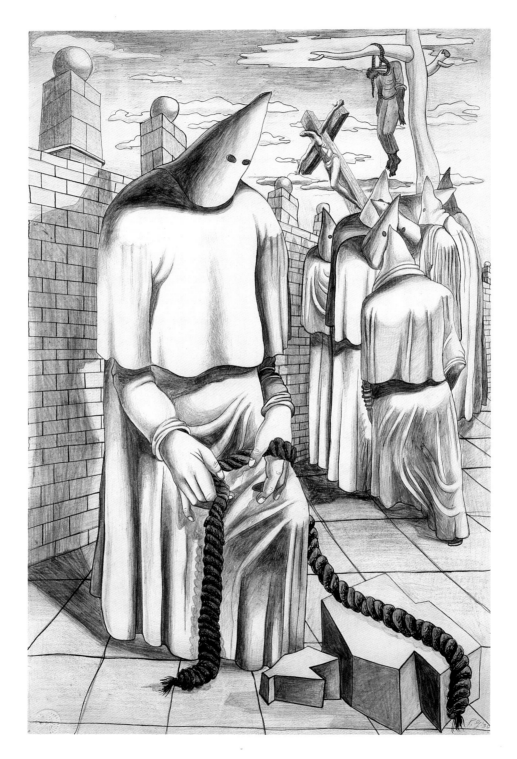

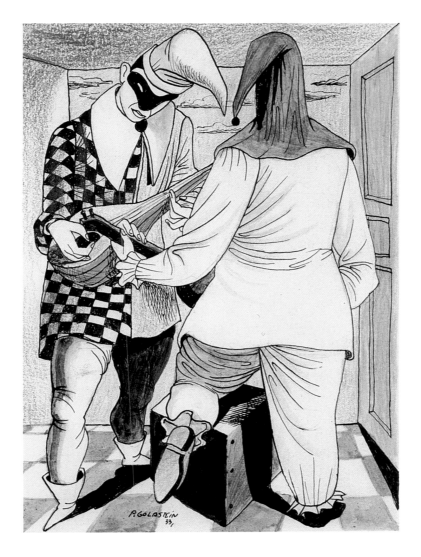

Boys Fighting. 1938
(CAT. 3)

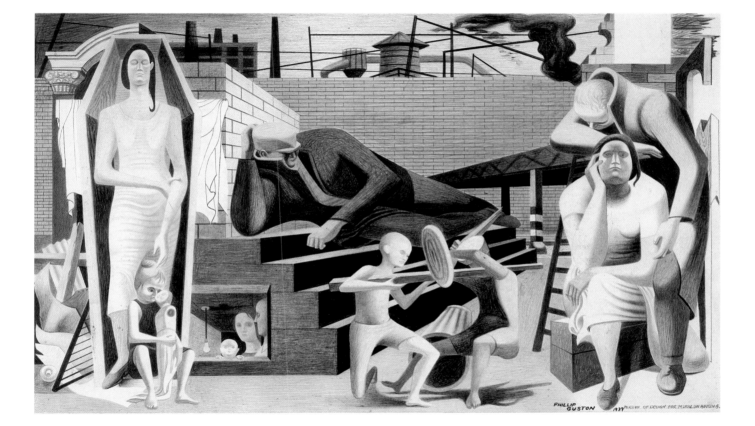

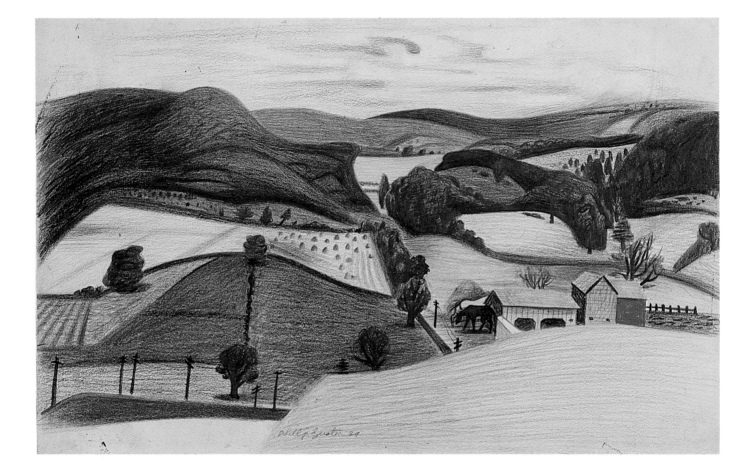

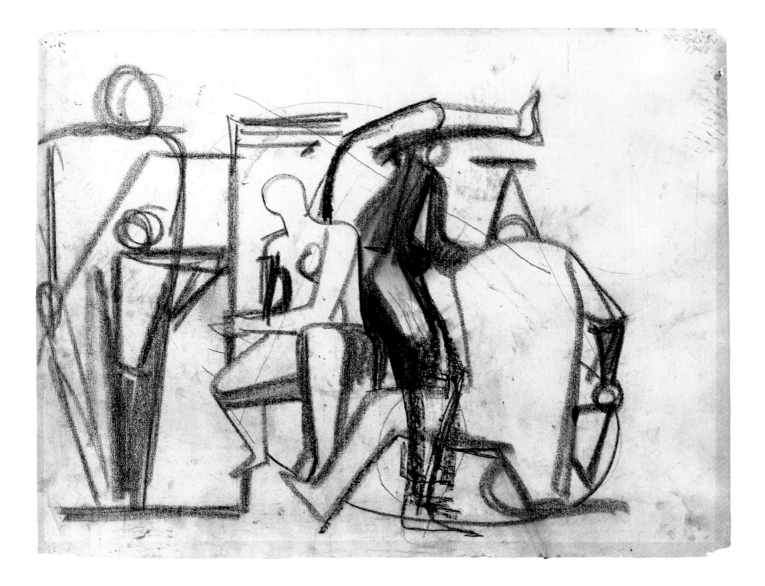

Clothes Inflation Drill
(for Navy Pre-Flight Training). 1943
(CAT. 7)

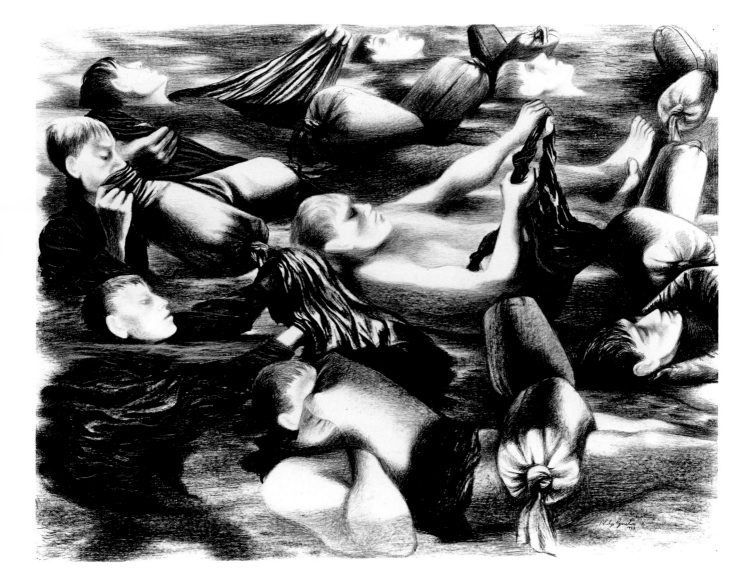

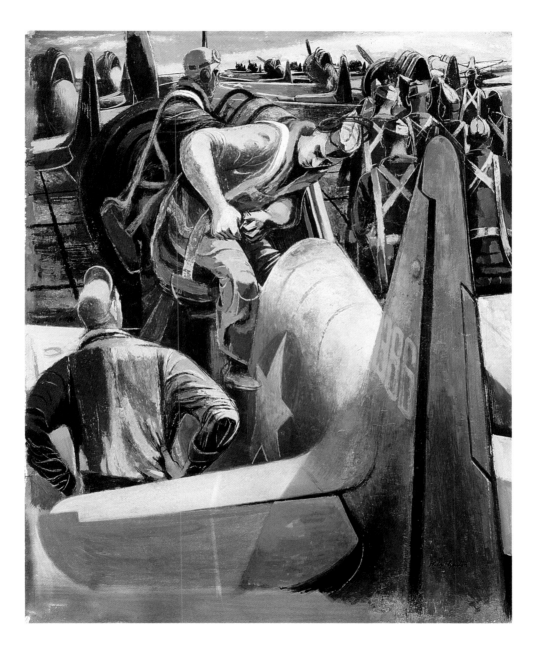

Untitled. 1946
(CAT. 9)

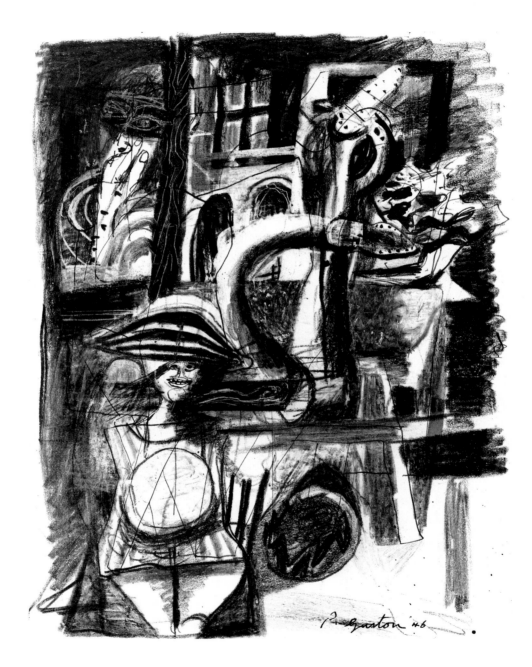

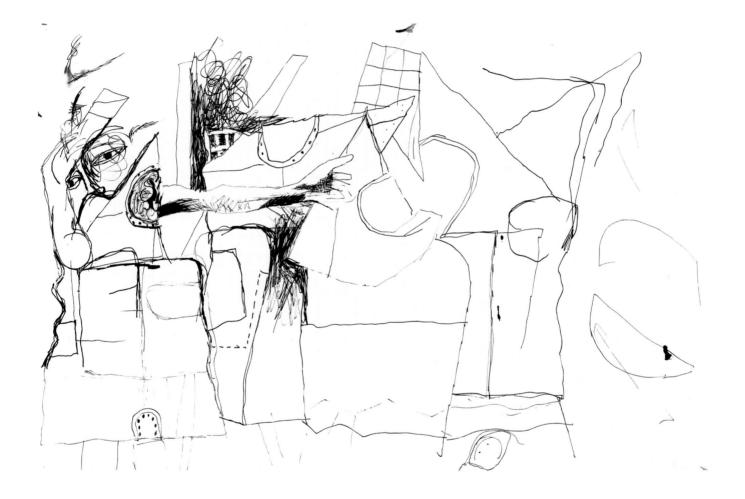

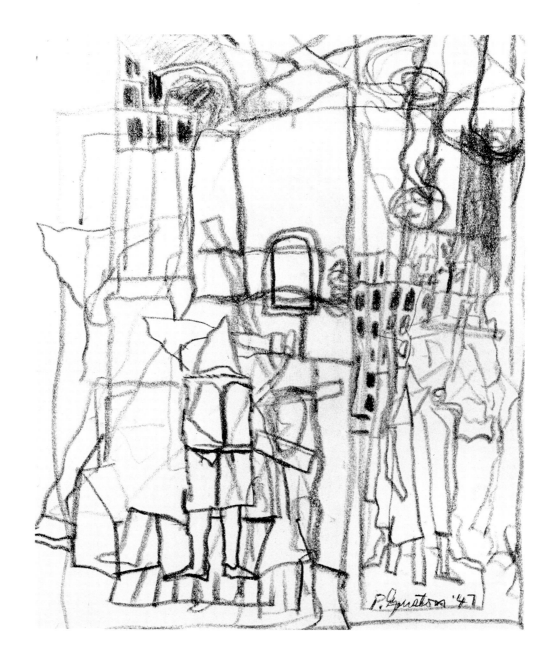

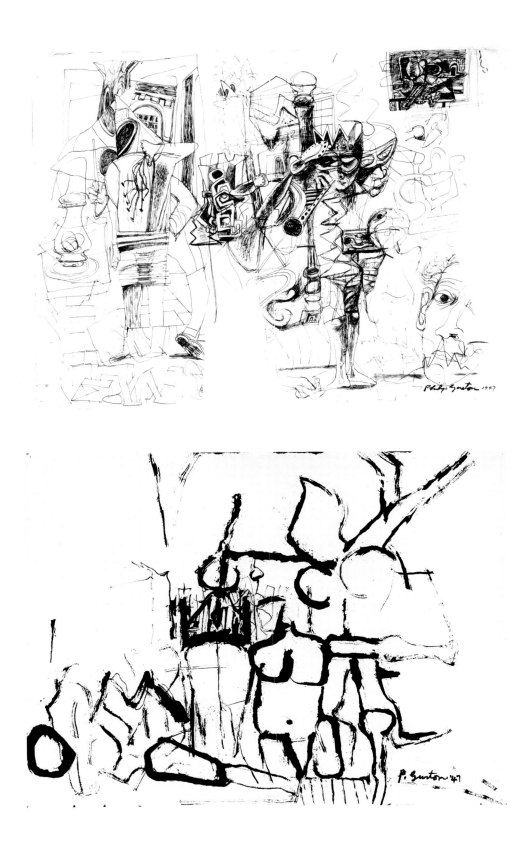

Sketchbook Drawing. 1947
(CAT. 12)

Angel. 1947
(CAT. 13)

Untitled. 1947–48
(CAT. 14)

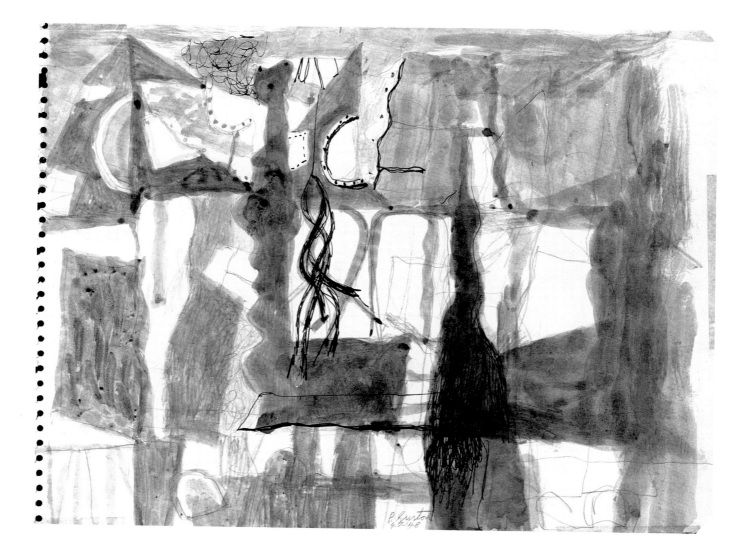

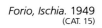

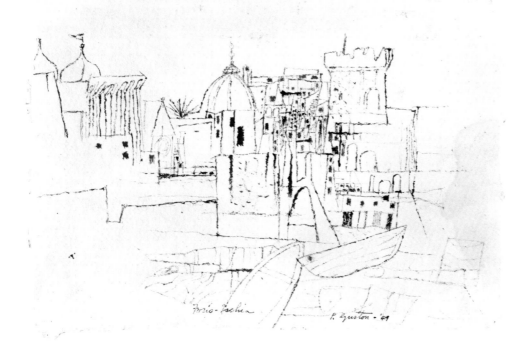

Ischia. 1949
(CAT. 16)

Small Quill Drawing. 1950
(CAT. 17)

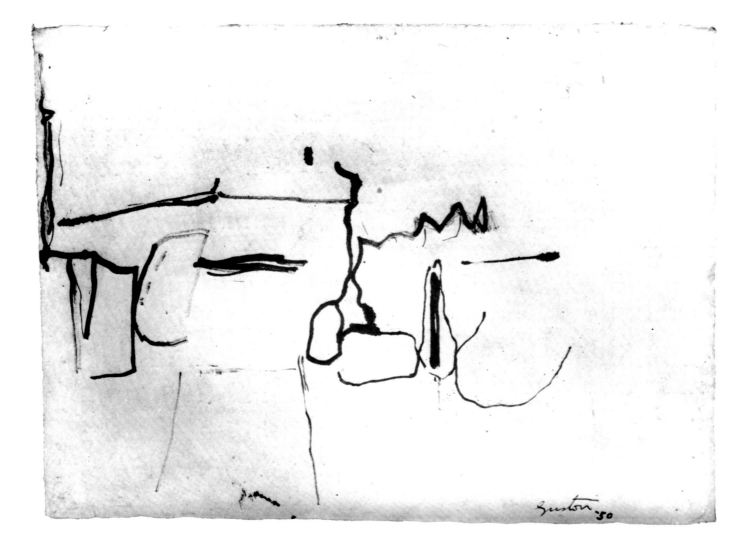

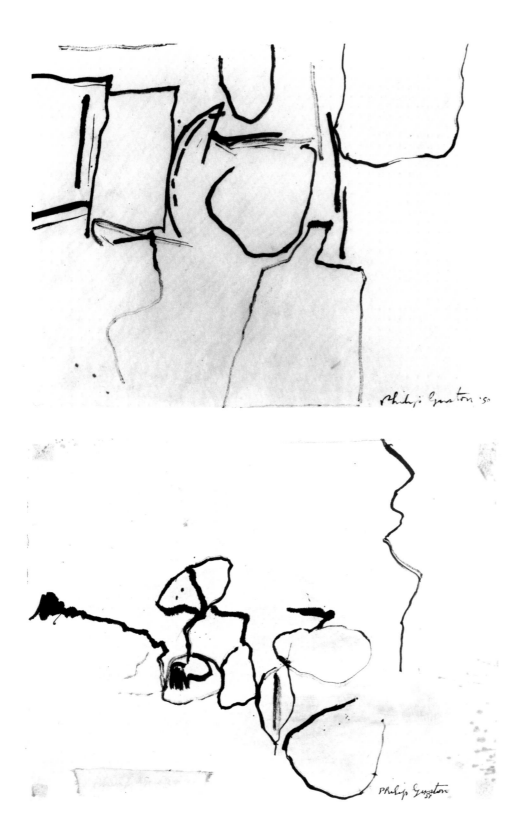

Early Drawing I. 1950
(CAT. 18)

Drawing. 1951
(CAT. 23)

Autumn. 1950
(CAT. 19)

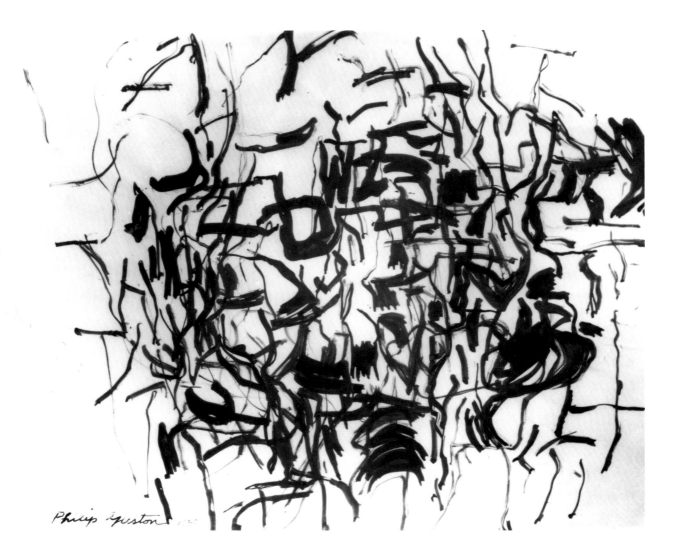

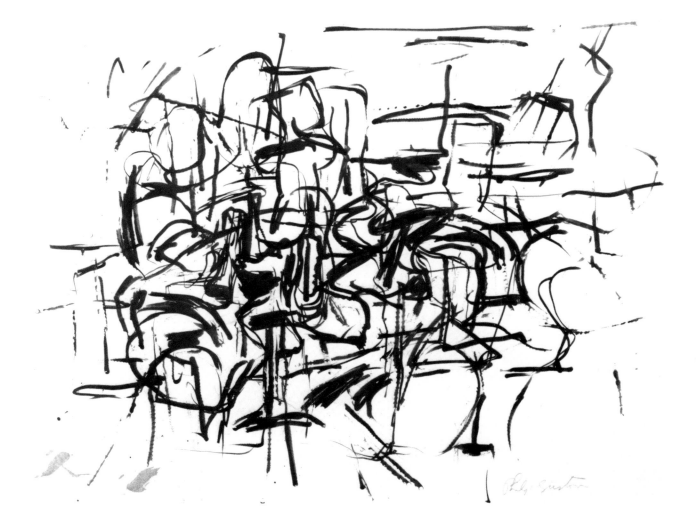

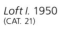

Loft I. 1950
(CAT. 21)

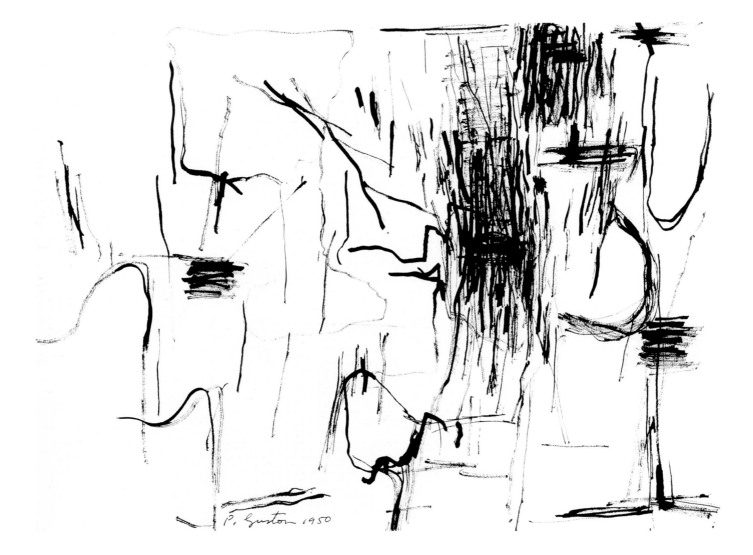

68

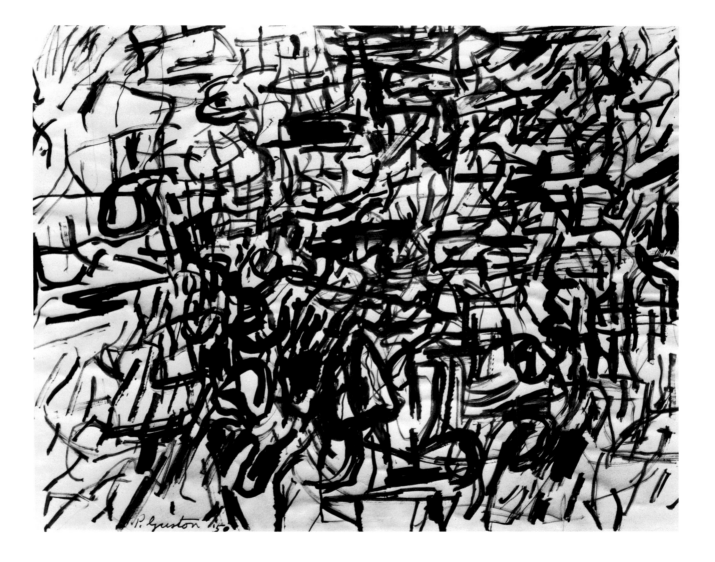

Downward. 1951
(CAT. 24)

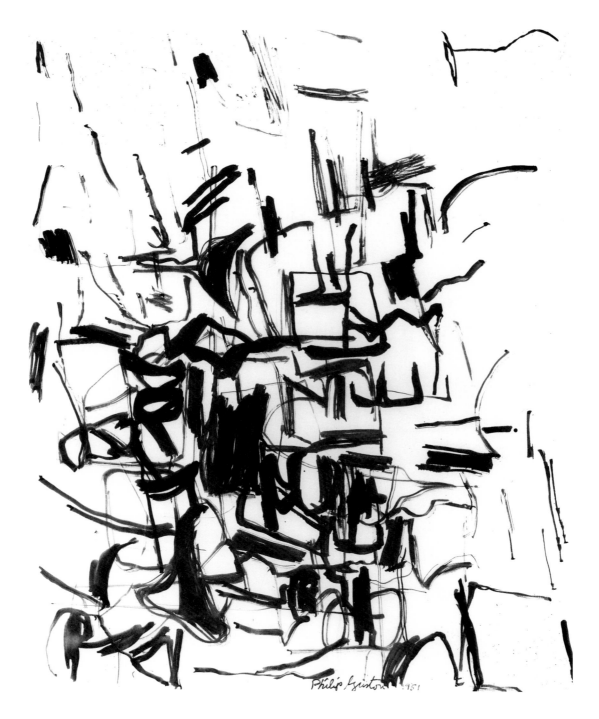

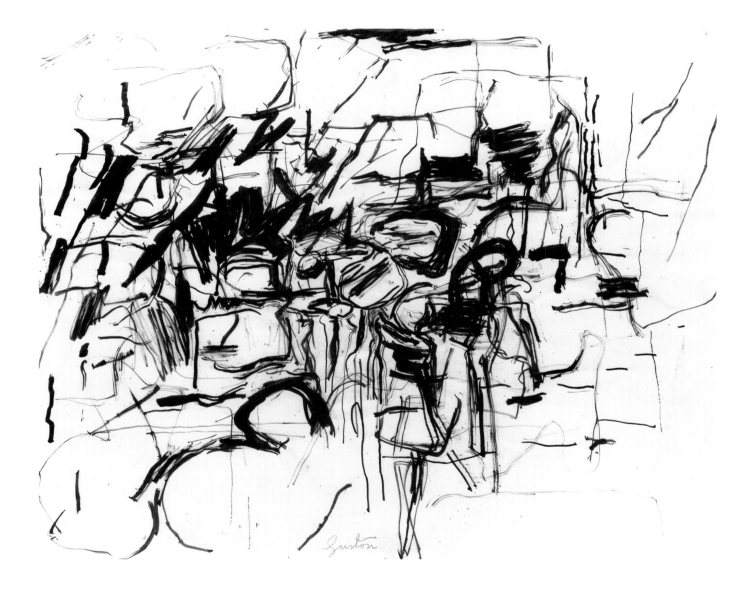

Ascent. 1952
(CAT. 26)

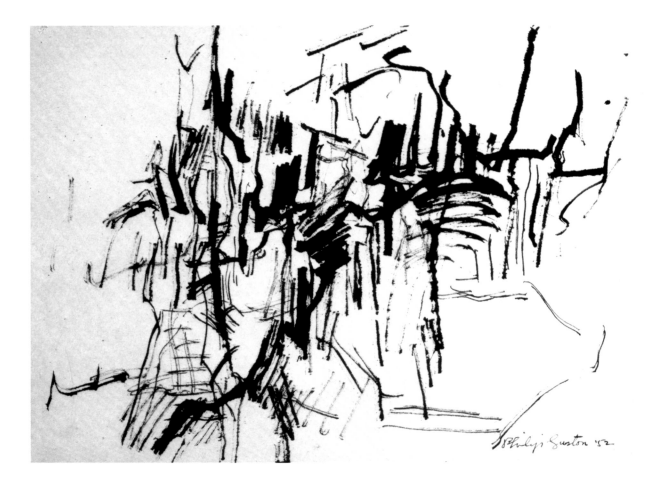

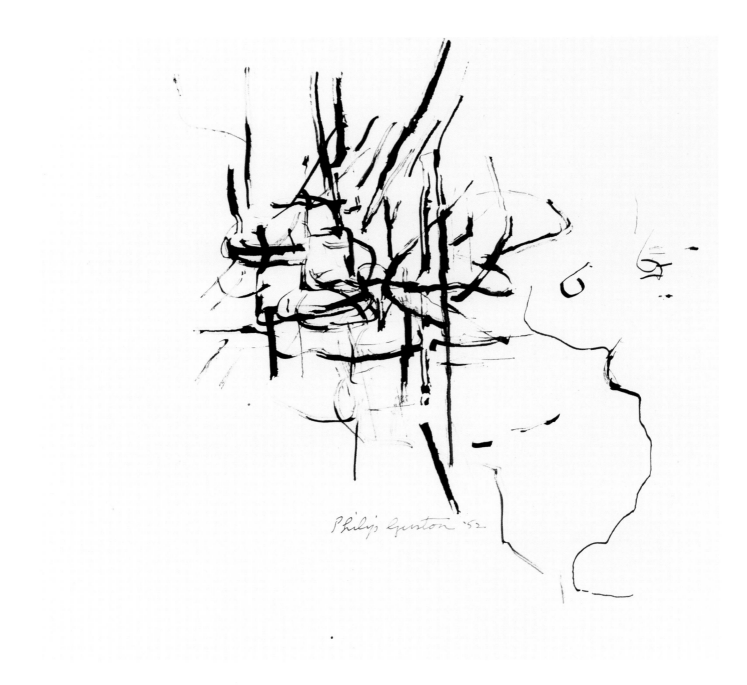

Philip Guston '52

Untitled. 1952
(CAT. 28)

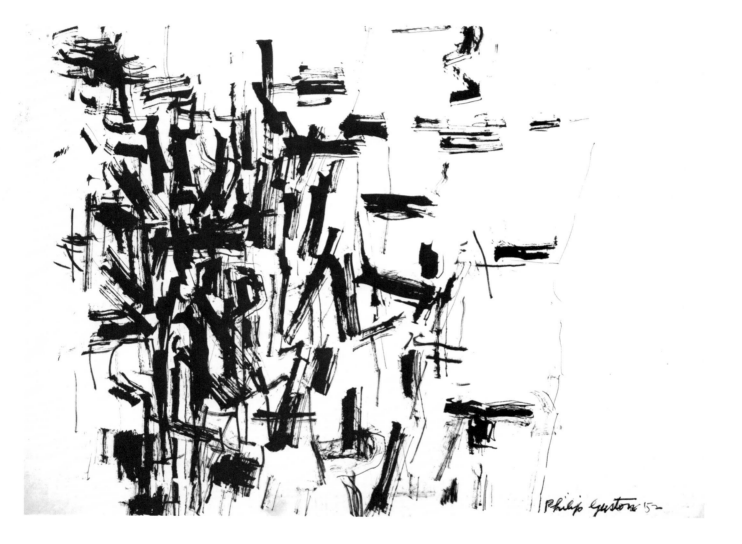

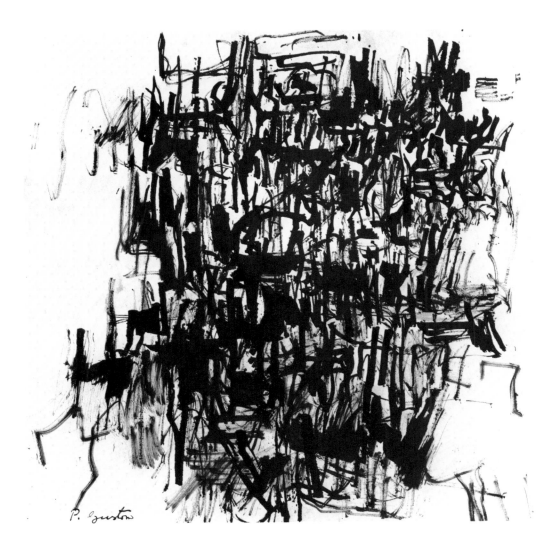

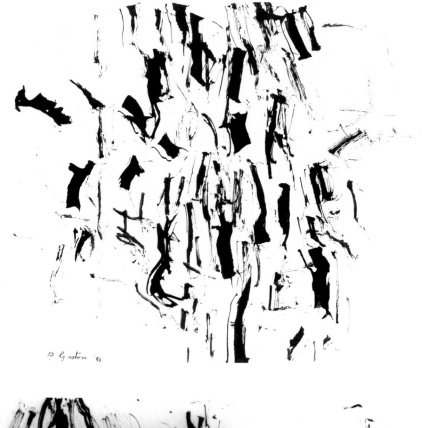

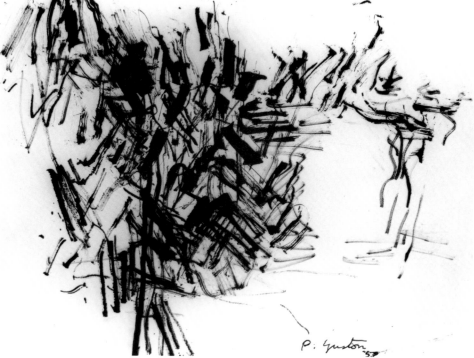

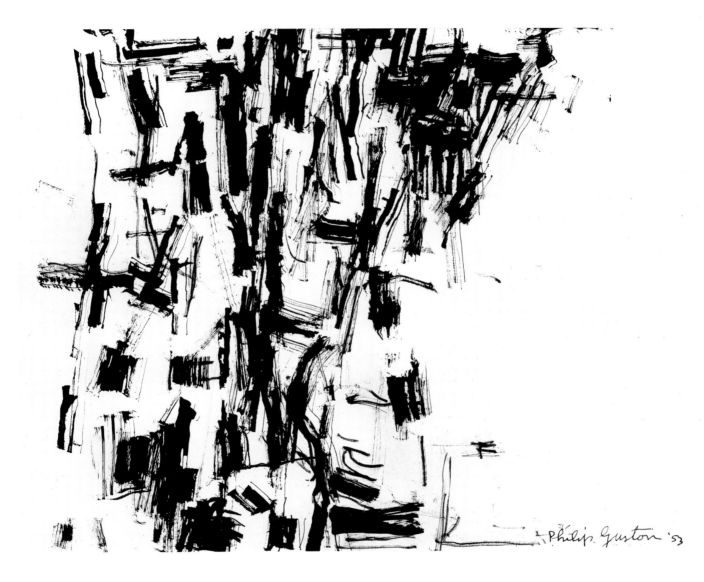

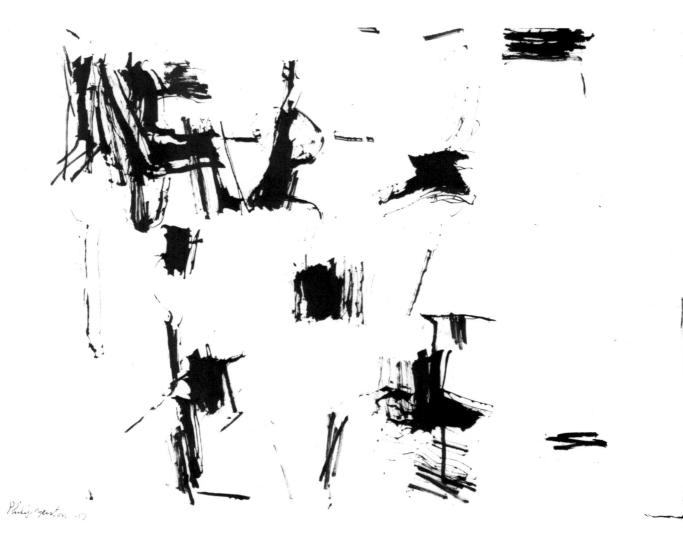

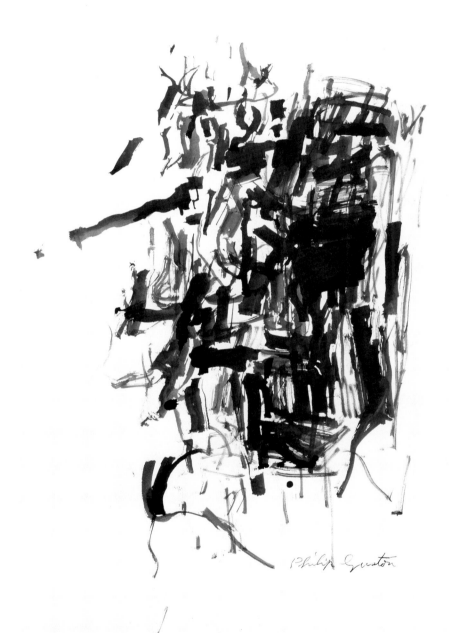

Philip Guston

Untitled. 1953
(CAT. 35)

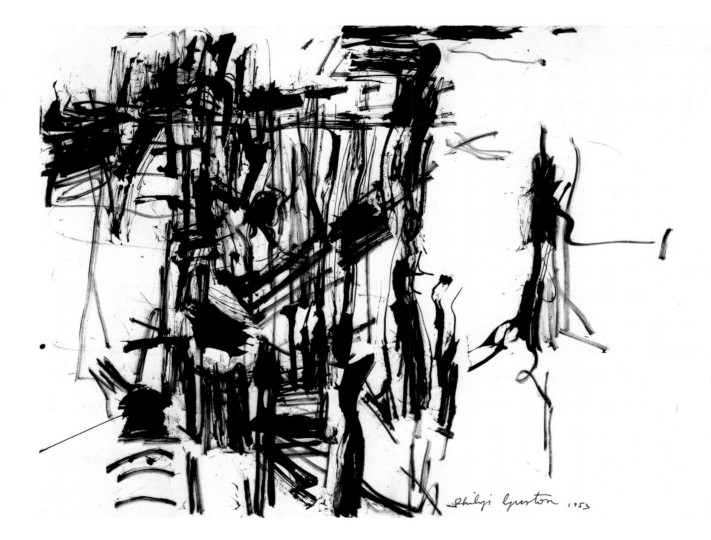

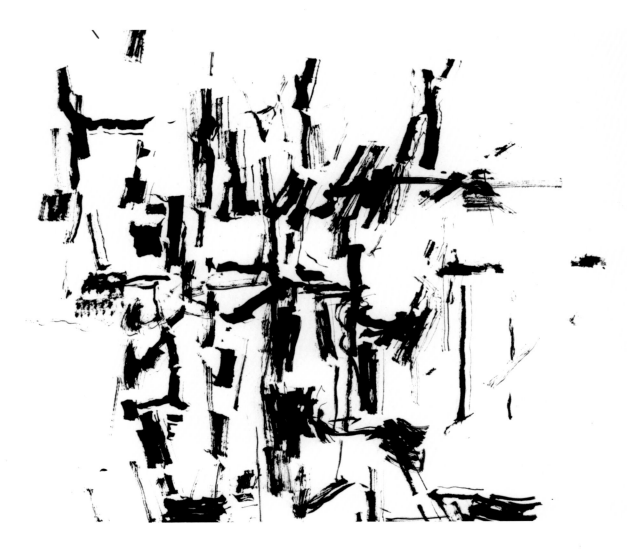

Drawing. 1954
(CAT. 38)

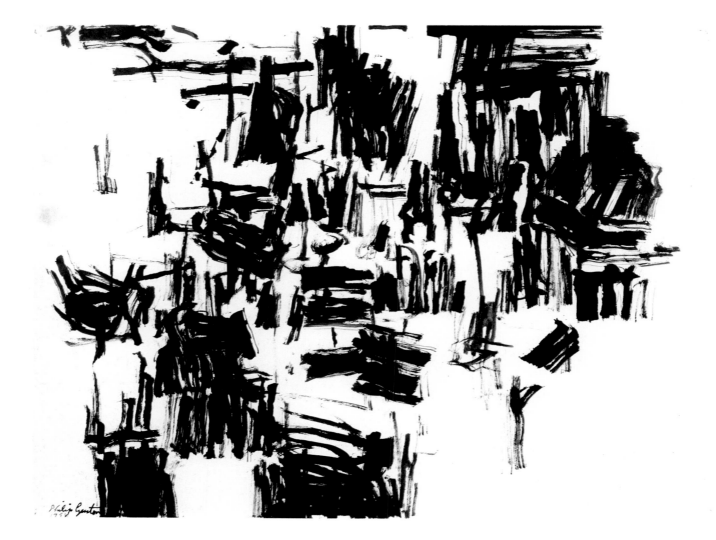

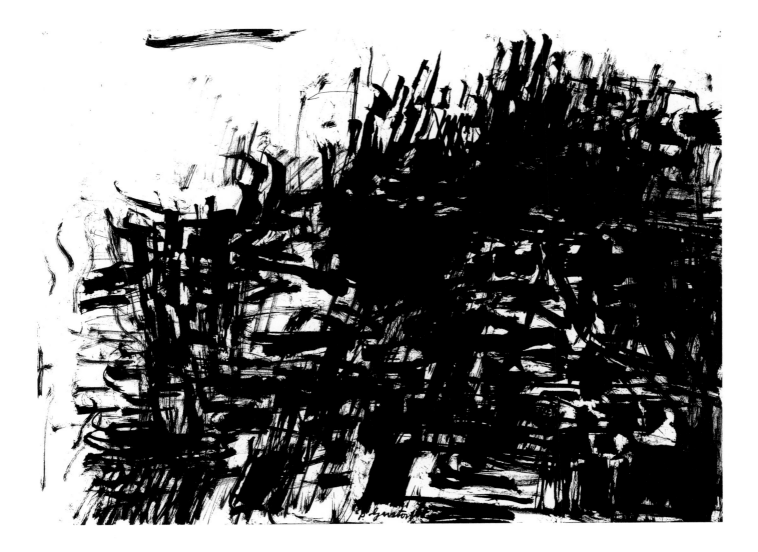

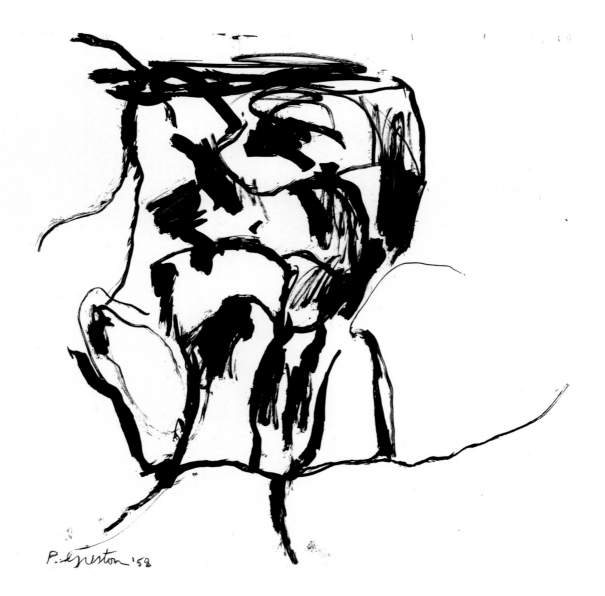

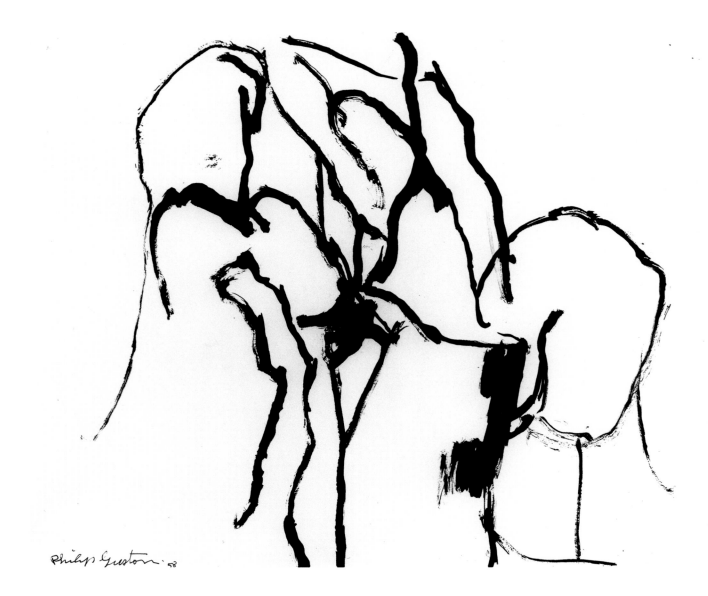

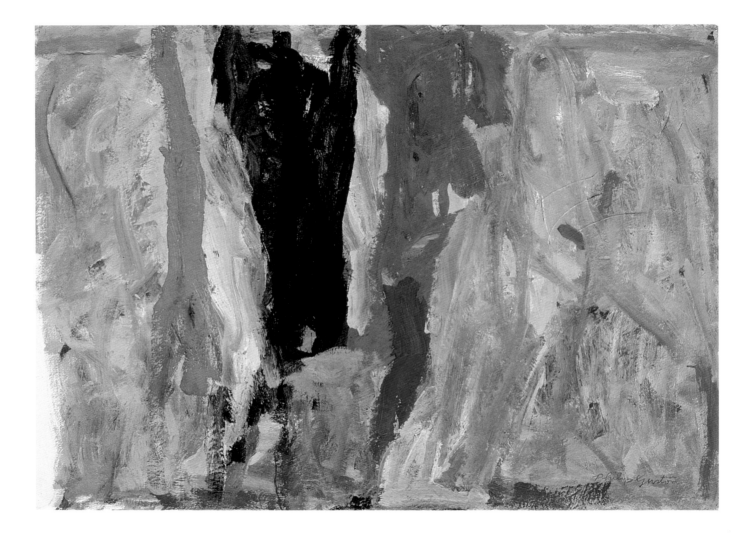

Last Piece. 1958
(CAT. 41)

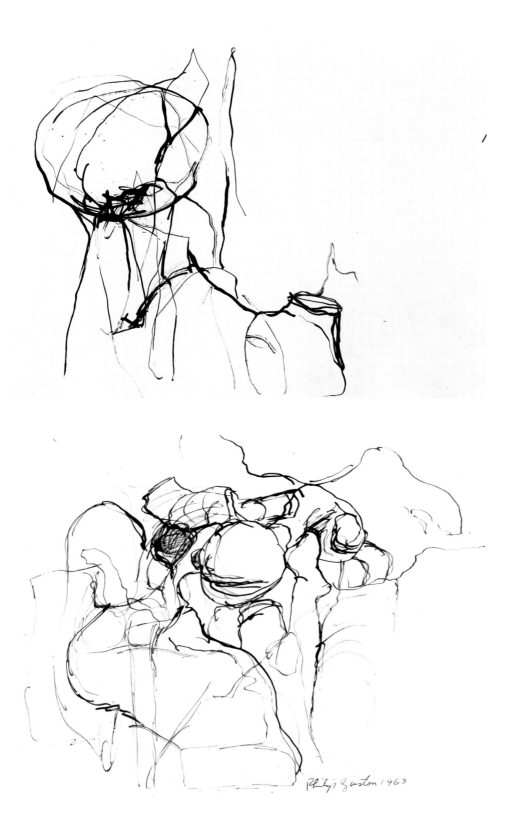

For M. 1960
(CAT. 42)

Untitled. 1963
(CAT. 52)

Sortie. 1960
(CAT. 43)

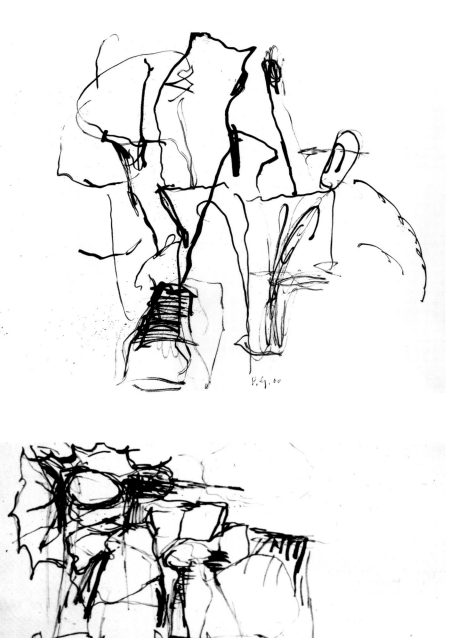

Untitled. 1960
(CAT. 44)

88

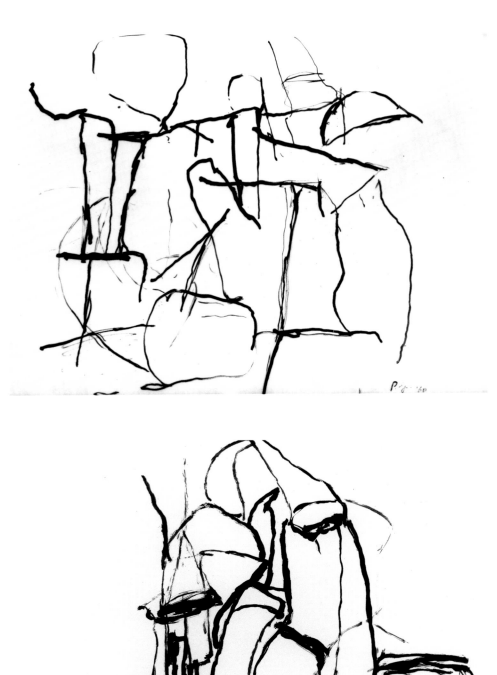

Drawing. 1961
(CAT. 47)

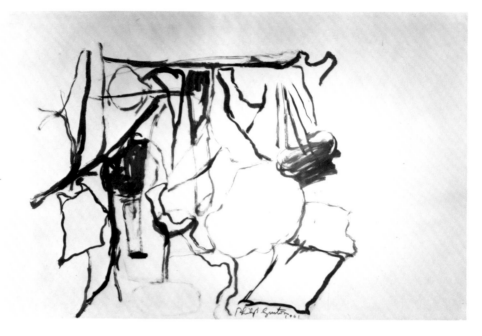

Pleasures. 1961
(CAT. 48)

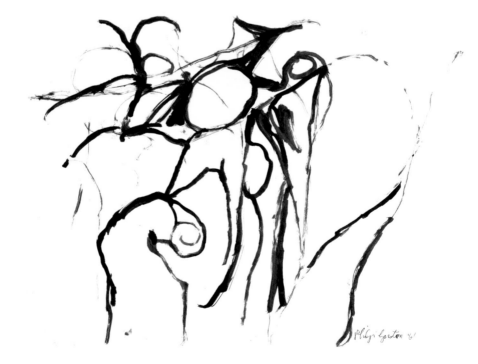

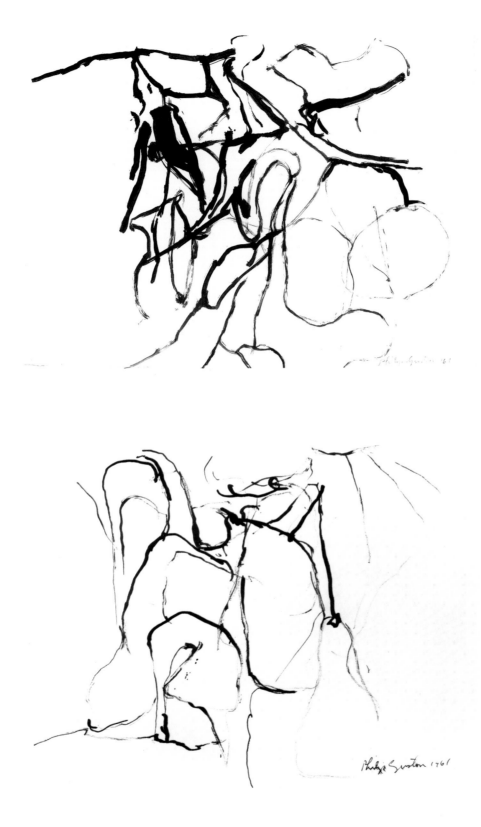

Pleasures I. 1961
(CAT. 49)

Woodstock Drawing. 1961
(CAT. 50)

Untitled. 1962
(CAT. 51)

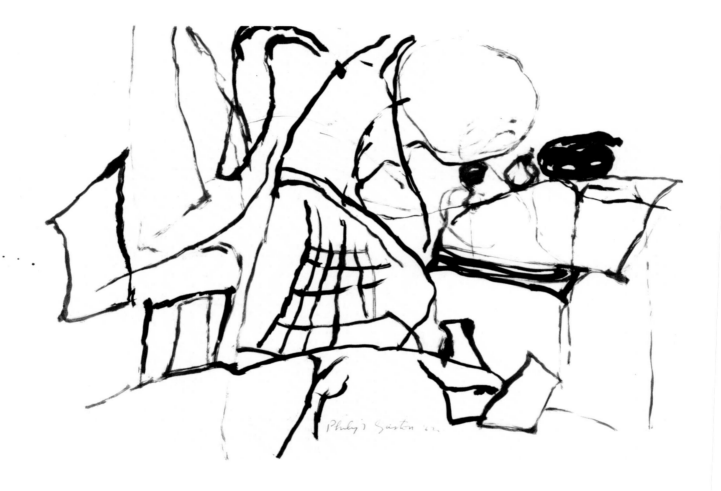

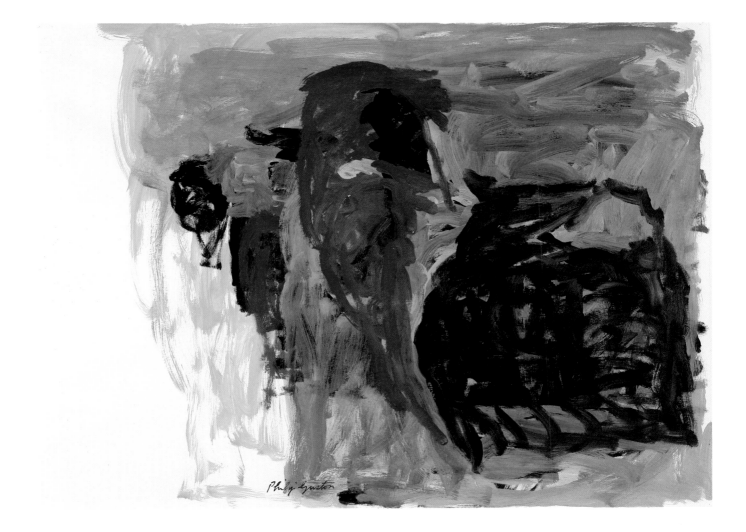

Untitled. 1963
(CAT. 54)

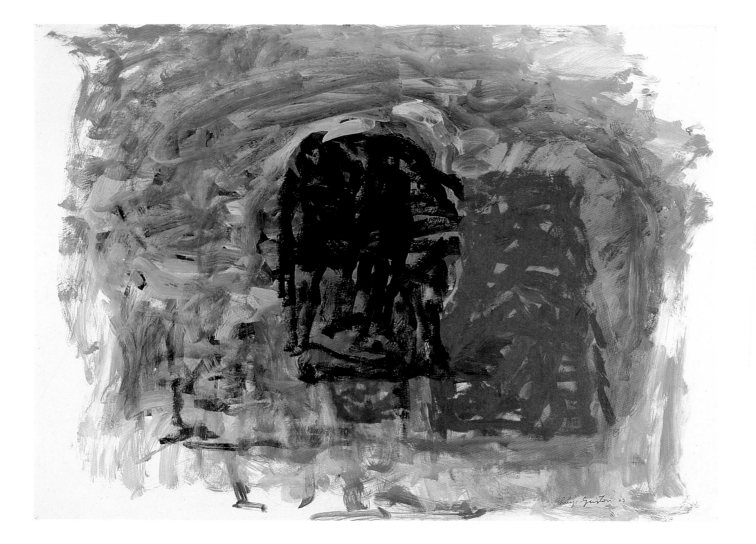

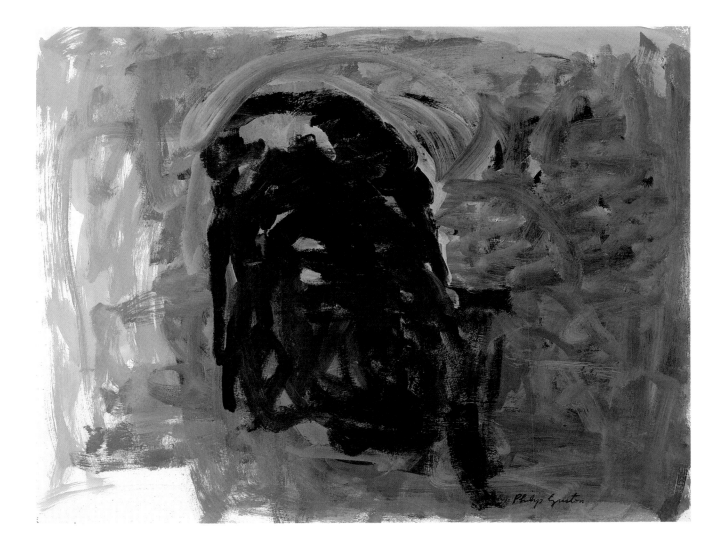

The Stone. 1965
(CAT. 56)

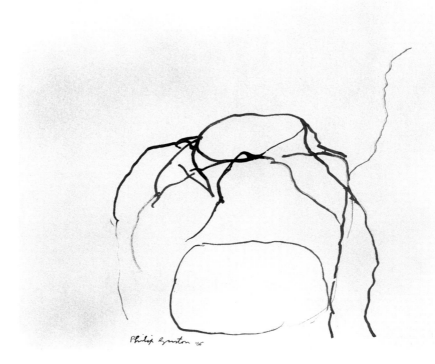

The Scale. 1965
(CAT. 57)

Untitled. 1965
(CAT. 59)

Full Brush. 1966
(CAT. 60)

Chair. 1967
(CAT. 61)

Mark. 1967
(CAT. 62)

P. G . 67

P. Guston 67

Edge. 1967
(CAT. 63)

Haven. 1967
(CAT. 64)

Form. 1967
(CAT. 65)

Philip Guston 67

Philip Guston '67

Book. 1968
(CAT. 68)

Book. 1968
(CAT. 69)

Philip Guston '68

Ink Bottle and Quill. 1968
(CAT. 71)

Statement. 1968
(CAT. 72)

City. 1968
(CAT. 73)

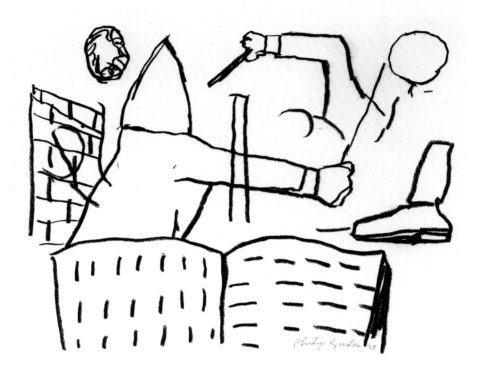

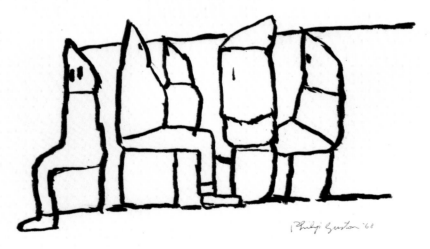

Group I. 1968
(CAT. 76)

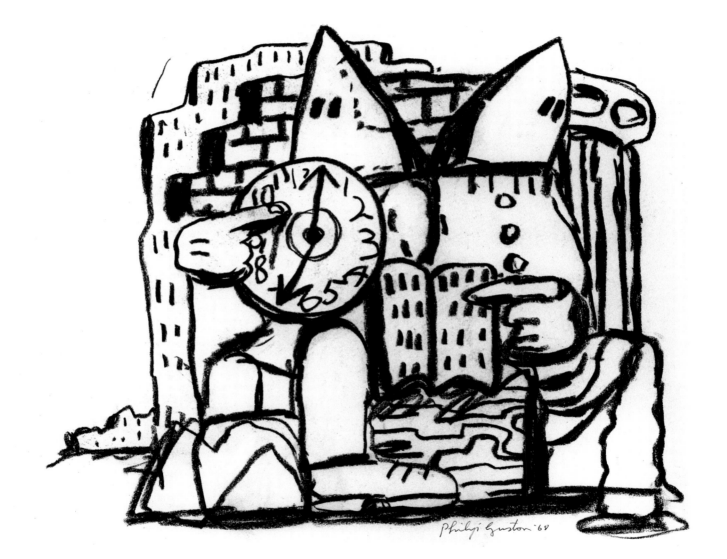

Brushes in Can. 1969
(CAT. 80)

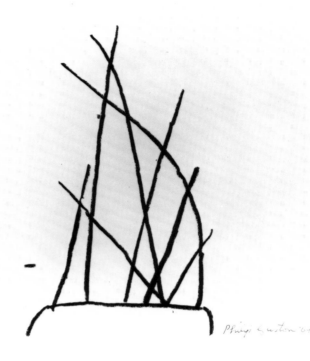

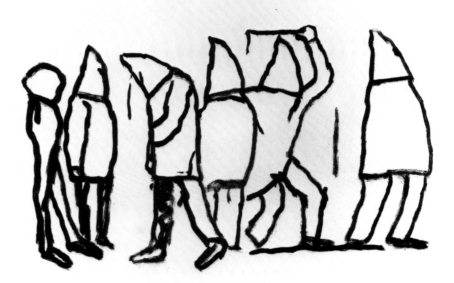

Group. 1969
(CAT. 81)

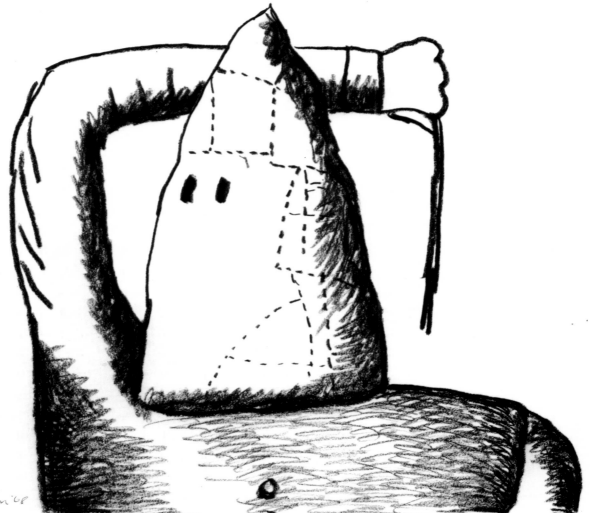

Clock. 1969
(CAT. 82)

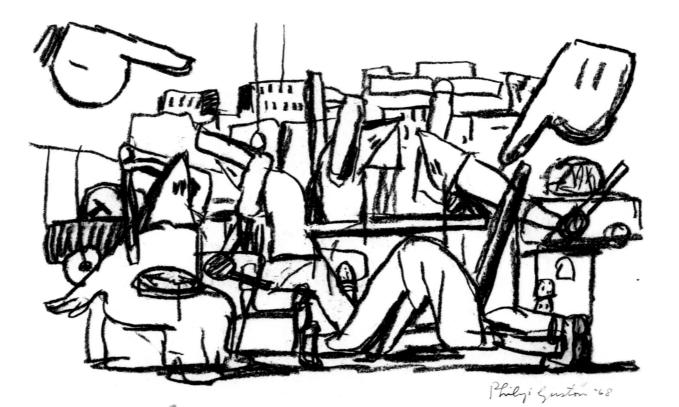

At the Table. 1969
(CAT. 83)

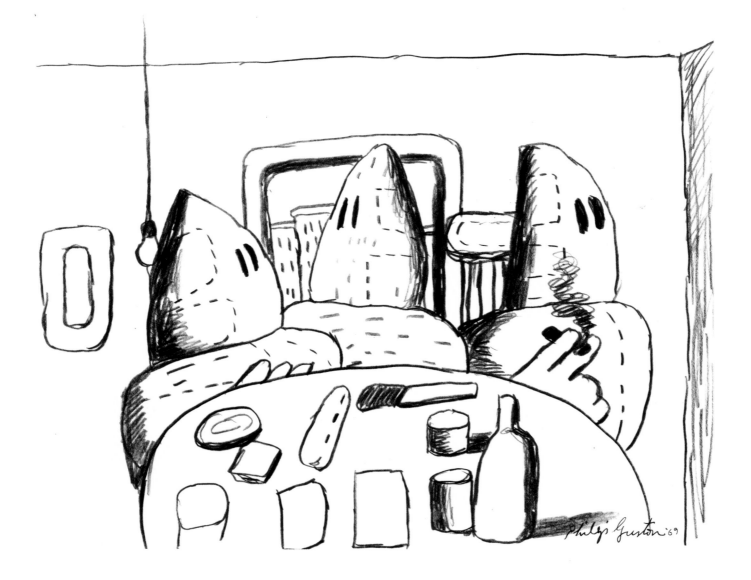

112

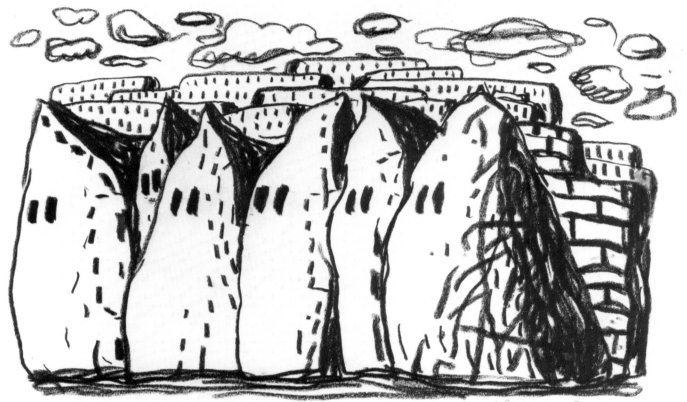

The Law. 1969
(CAT. 85)

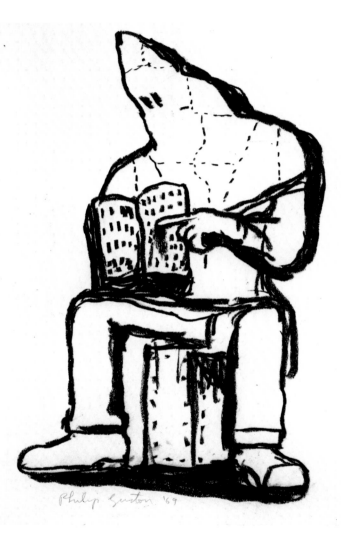

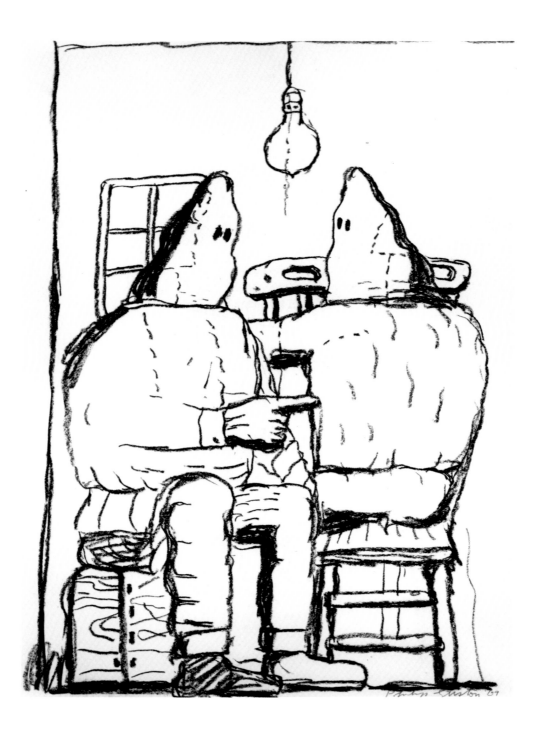

Study for *Edge of Town*. 1969
(CAT. 87)

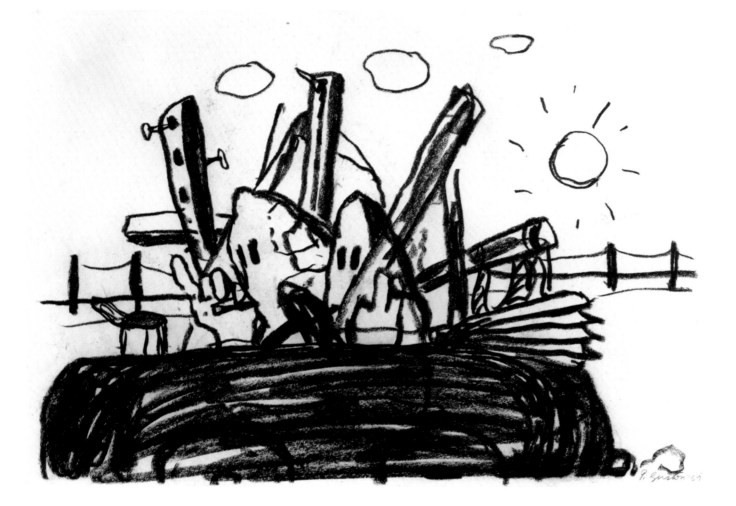

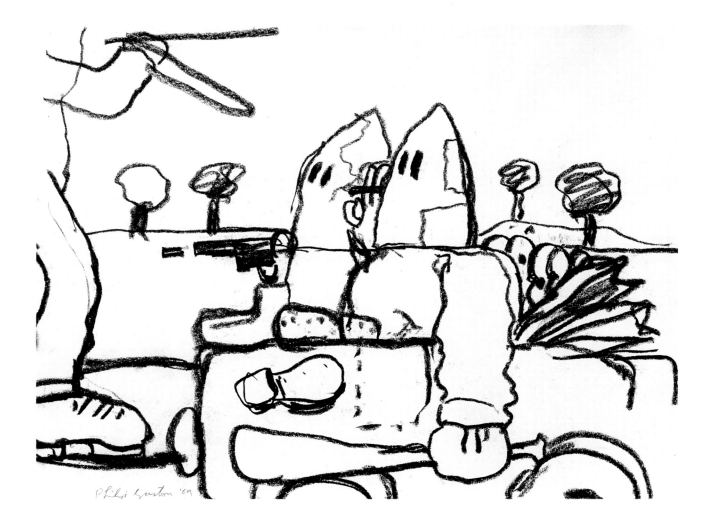

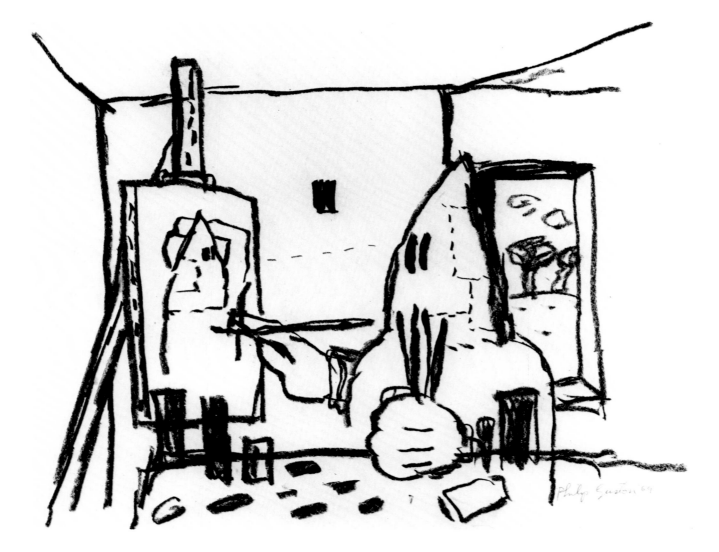

Untitled. 1969
(CAT. 89)

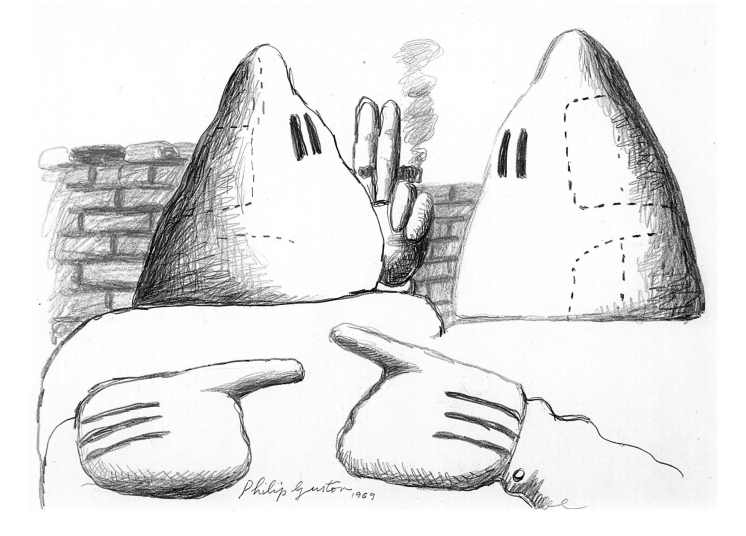

Philip Guston 1969

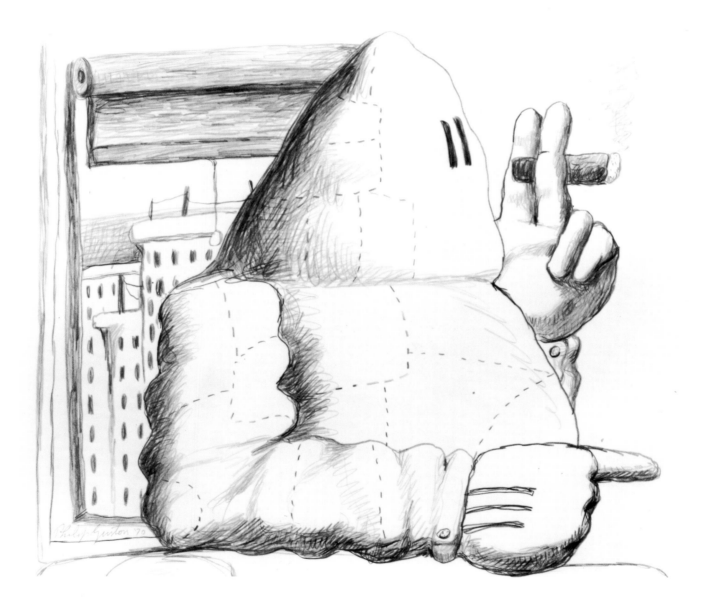

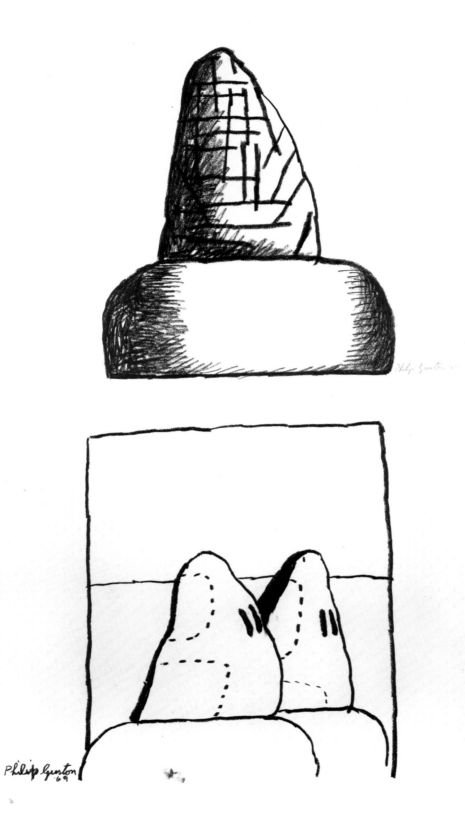

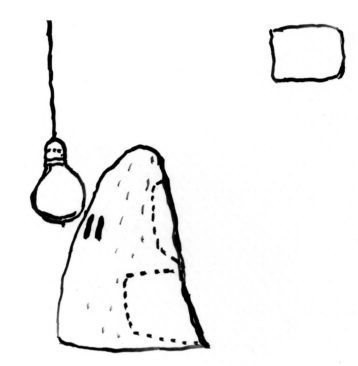

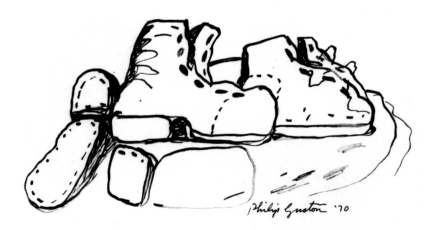

Boots. 1970
(CAT. 95)

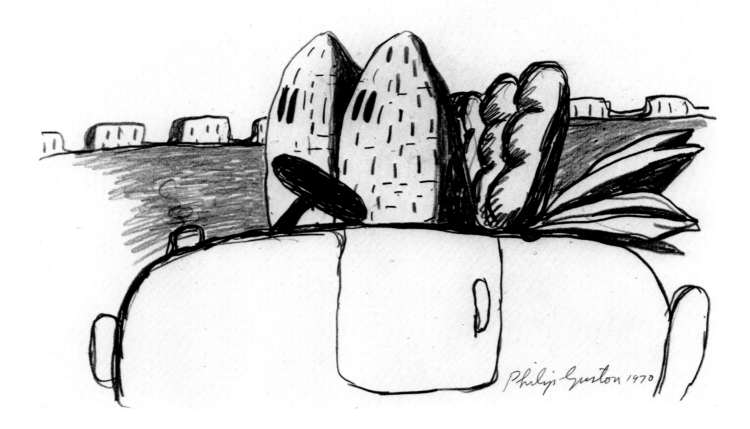

Stranger. 1970
(CAT. 97)

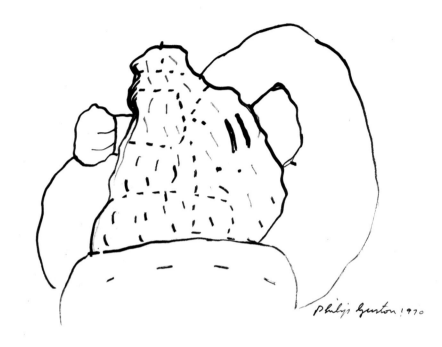

Study for *Sheriff.* 1970
(CAT. 98)

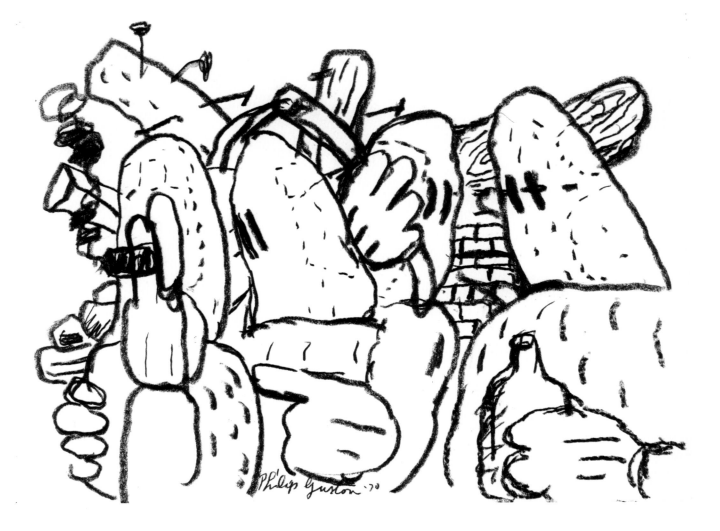

Street. 1970
(CAT. 100)

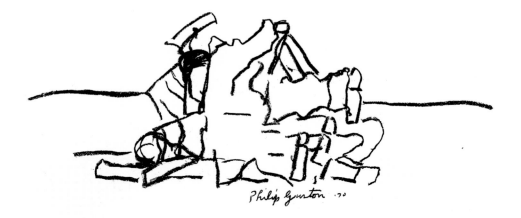

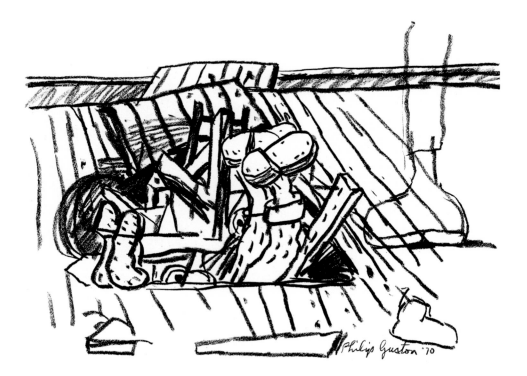

Study for *Cellar.* 1970
(CAT. 101)

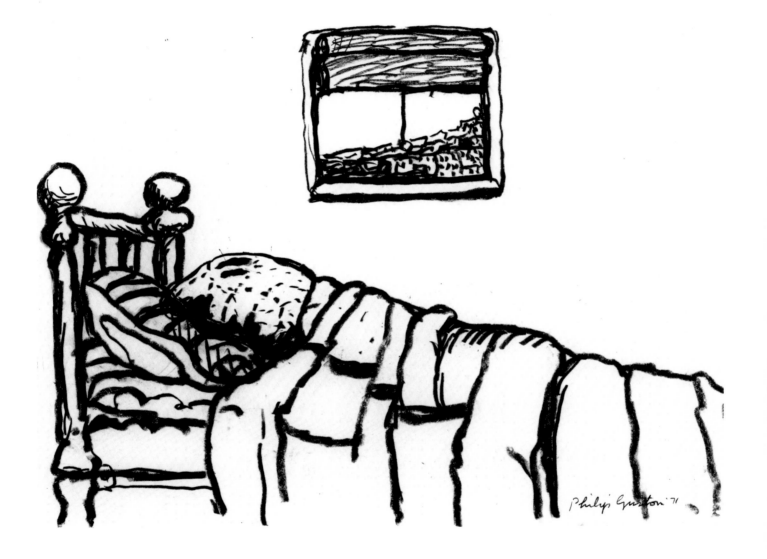

127

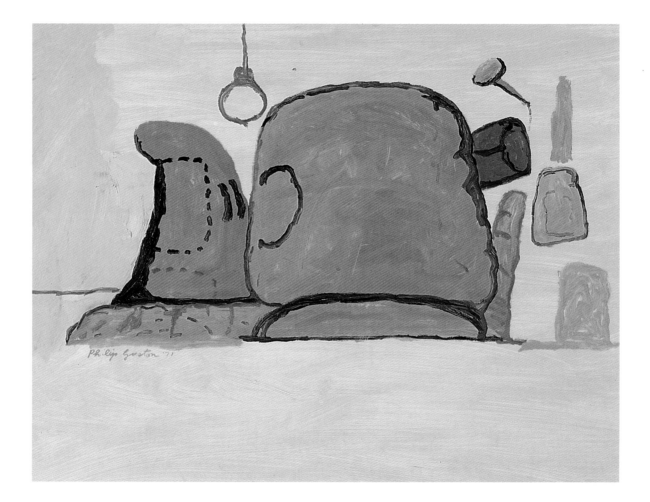

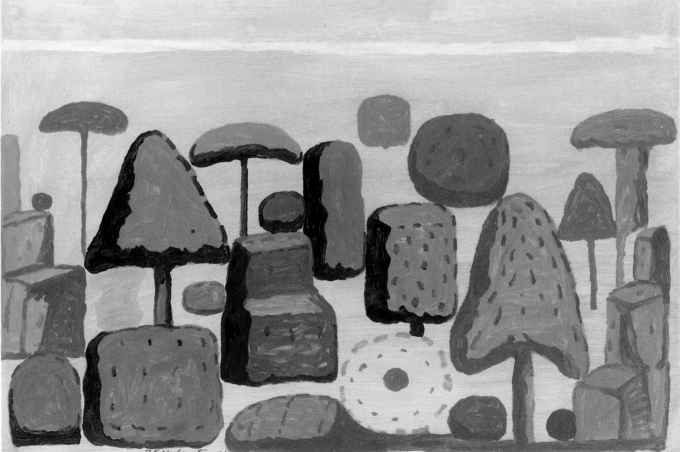

Roma. 1971
(CAT. 105)

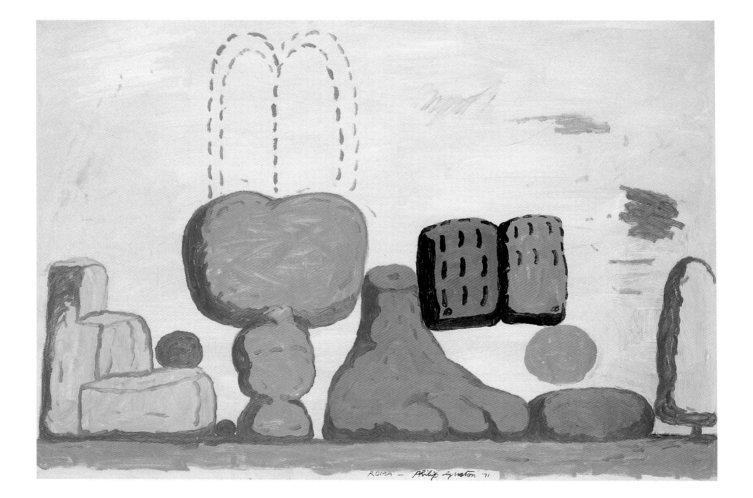

130

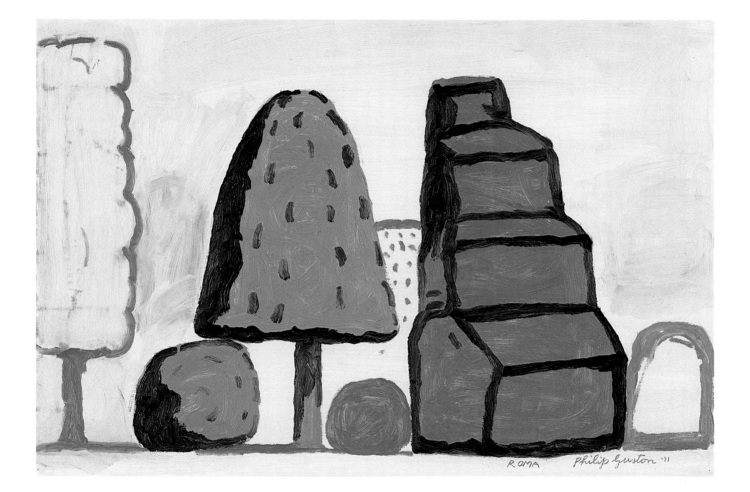

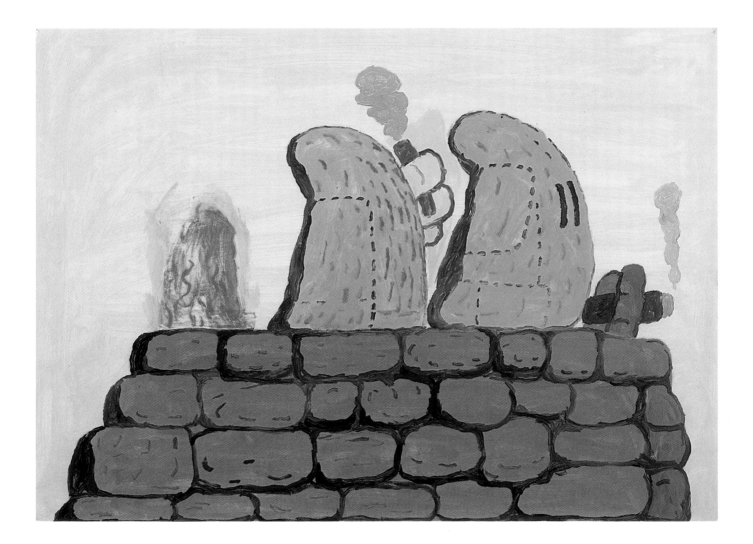

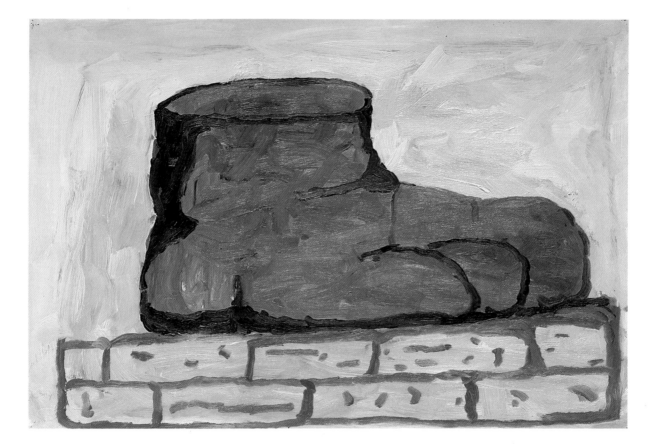

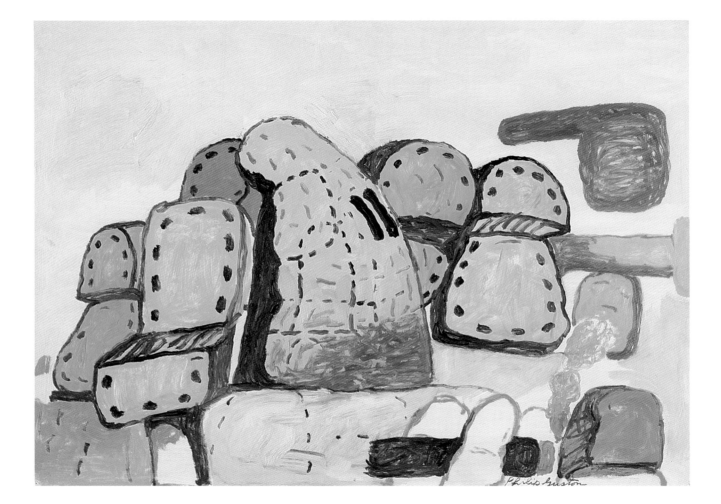

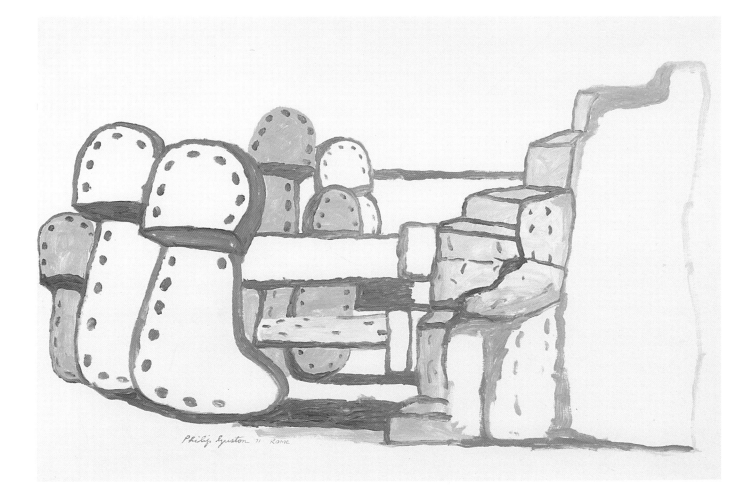

Untitled. 1971
(CAT. 111)

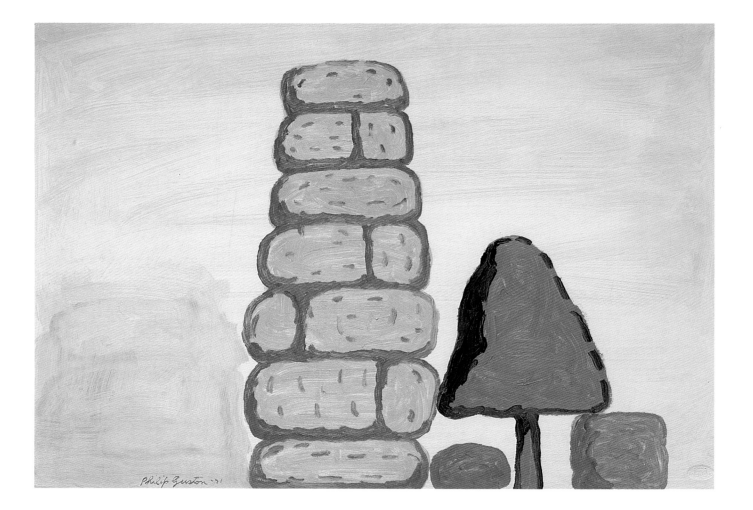

136

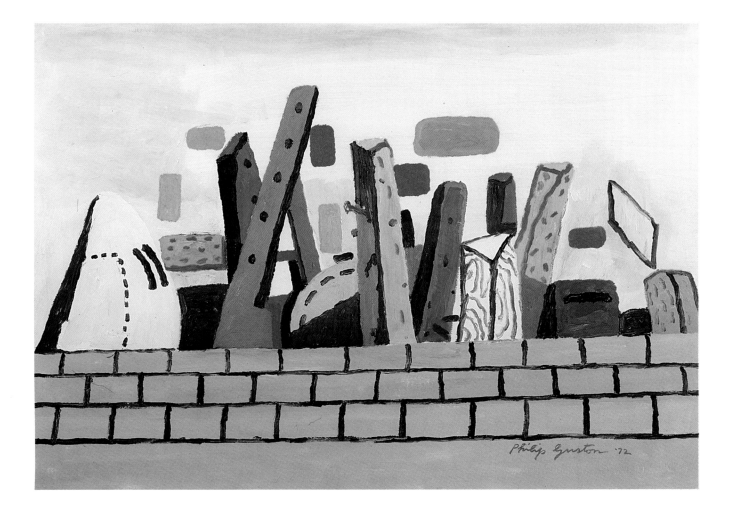

Four Heads. 1974
(CAT. 113)

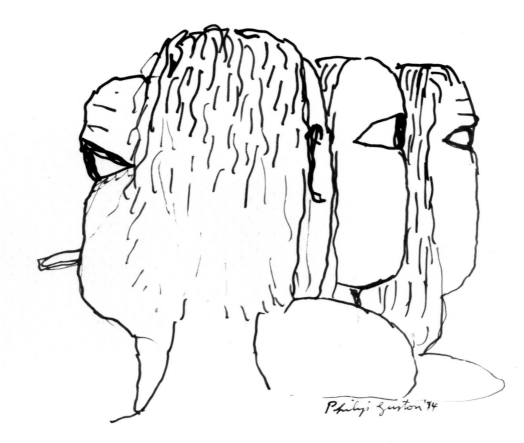

138

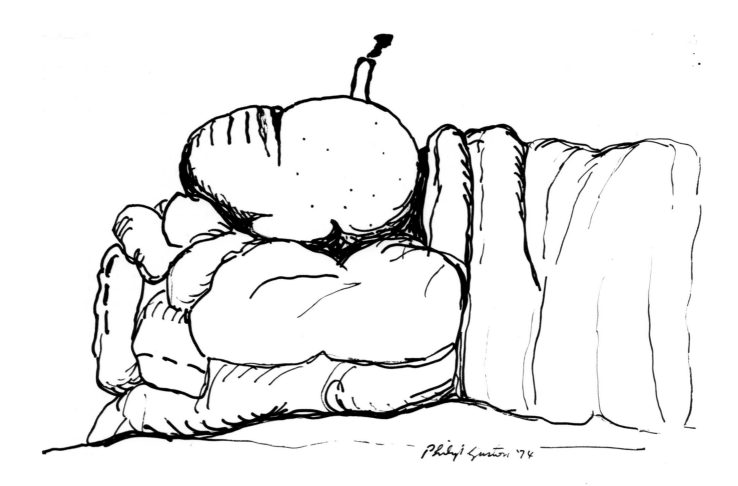

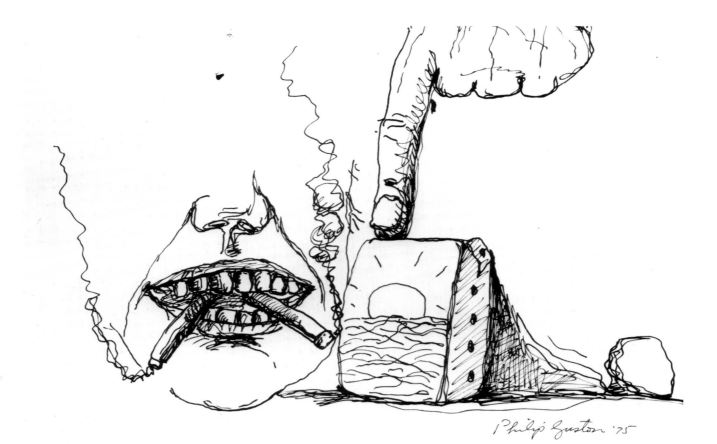

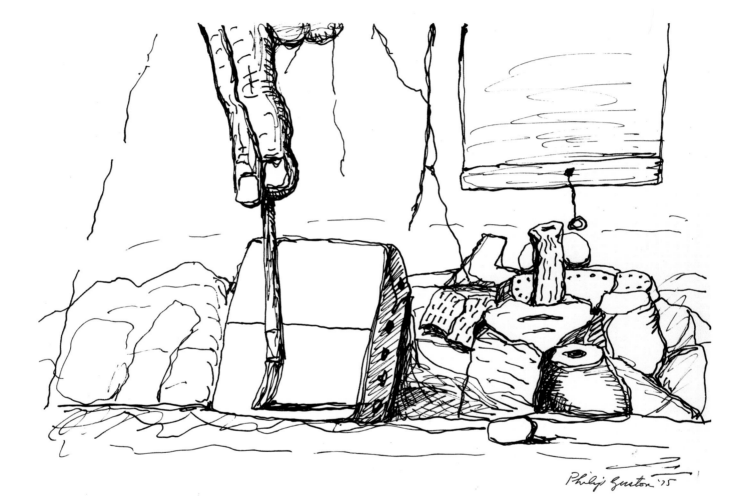

Rain. 1975
(CAT. 117)

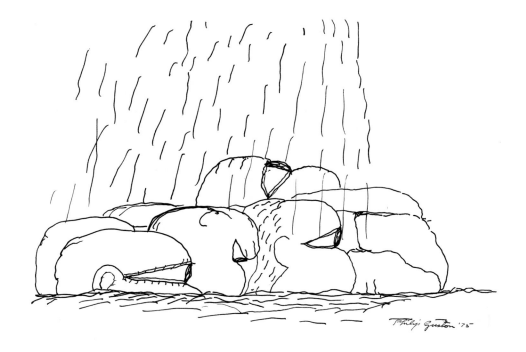

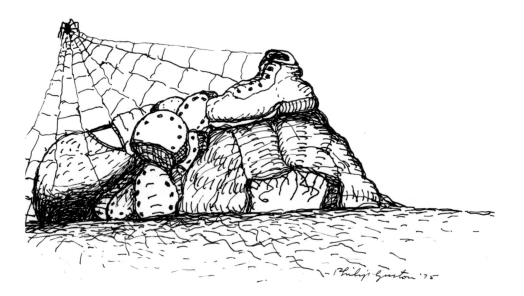

Web. 1975
(CAT. 118)

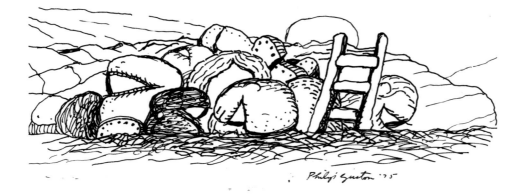

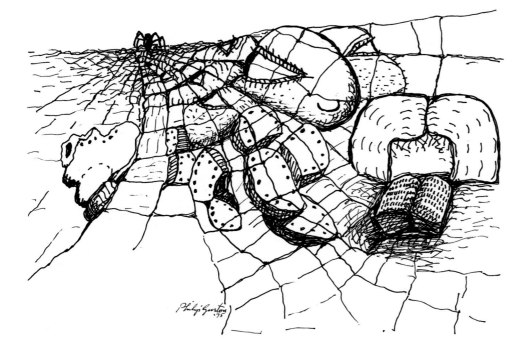

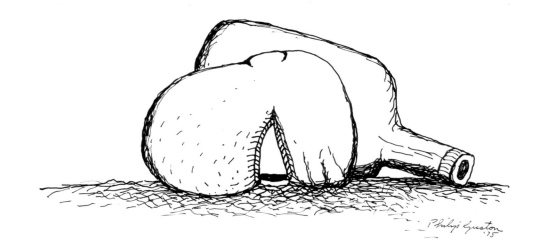

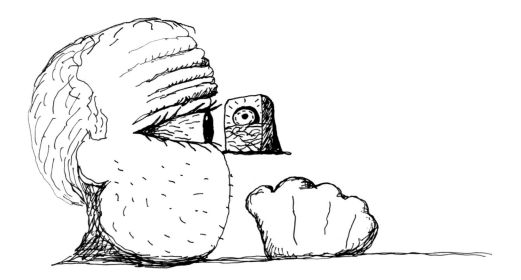

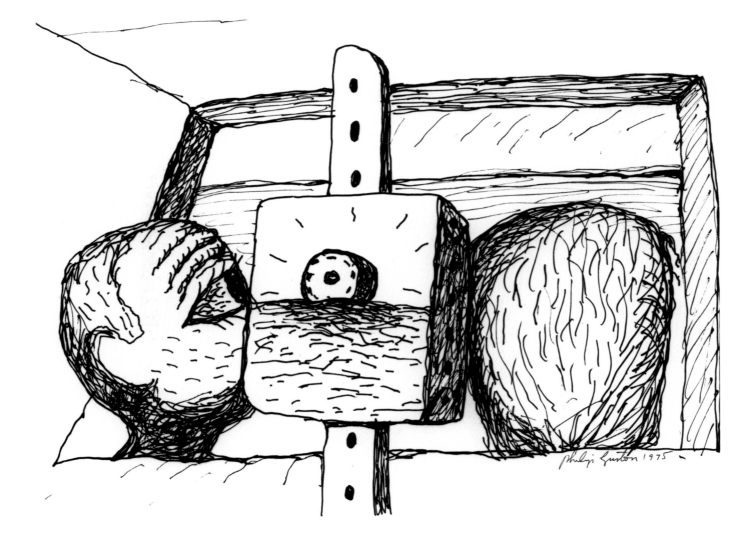

Elements. 1975
(CAT. 124)

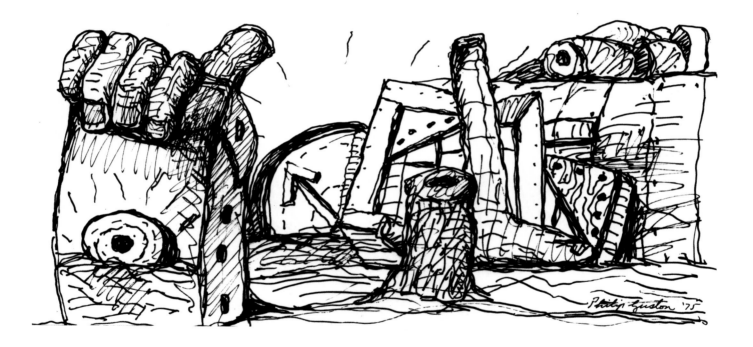

146

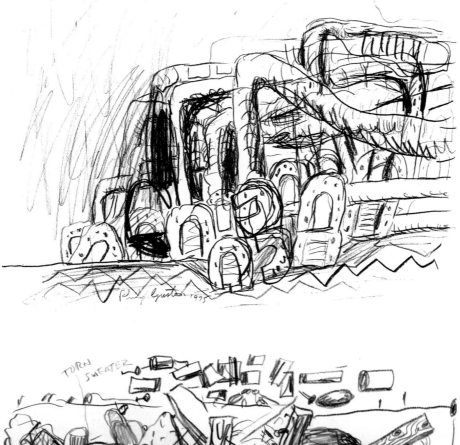

Study for *Green Sea.* 1975
(CAT. 125)

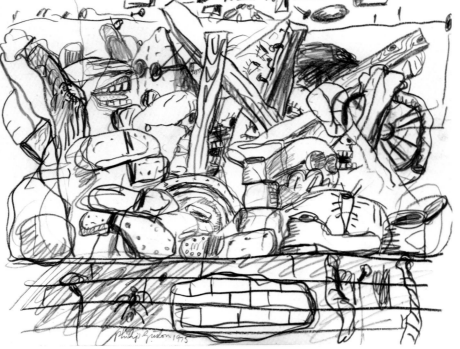

Untitled. 1975
(CAT. 126)

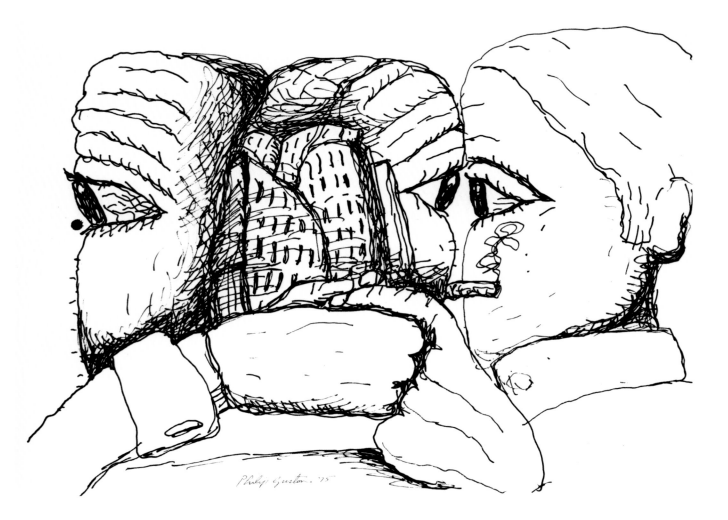

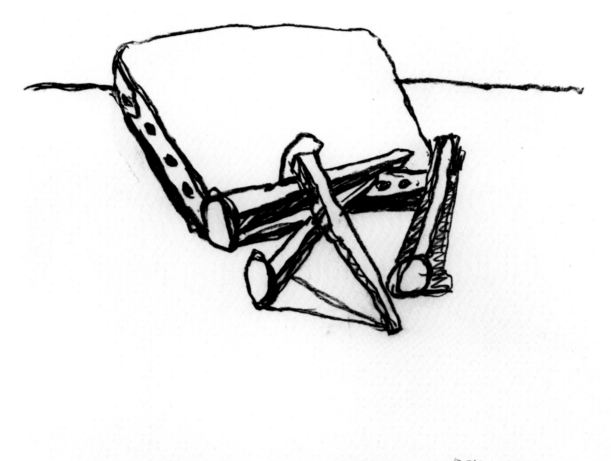

Philip Guston 1976

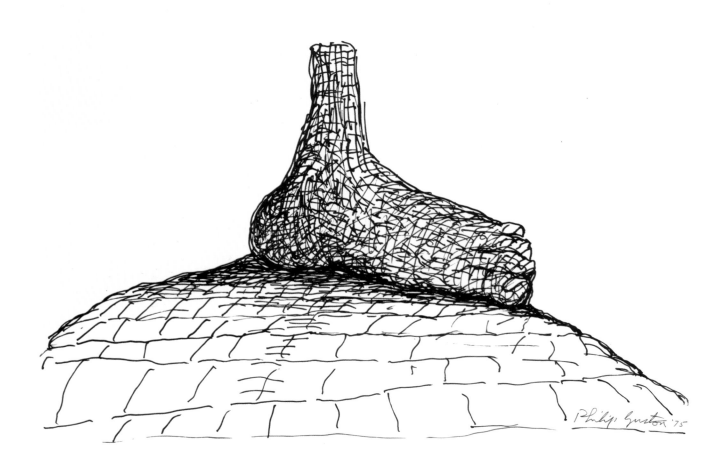

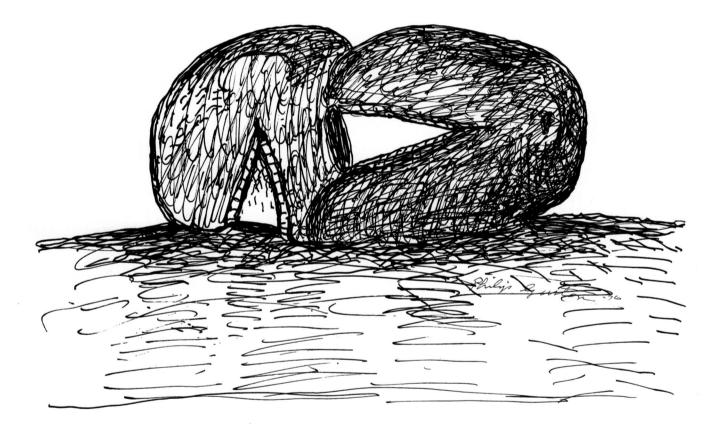

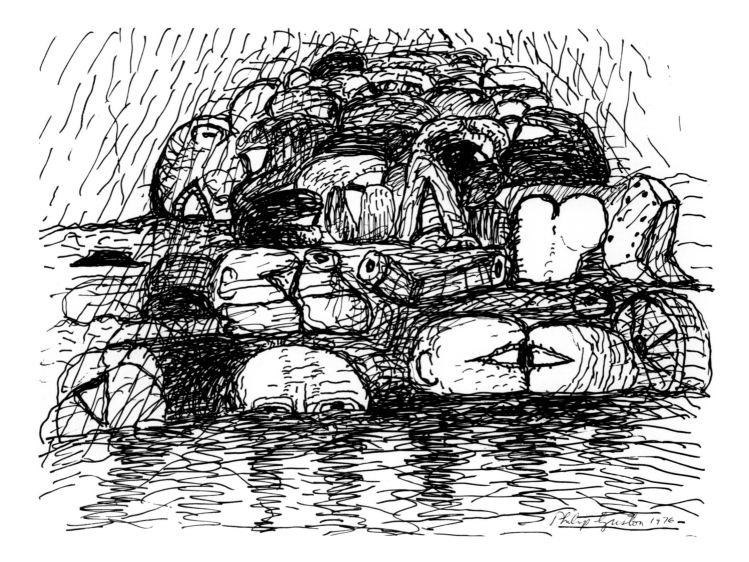

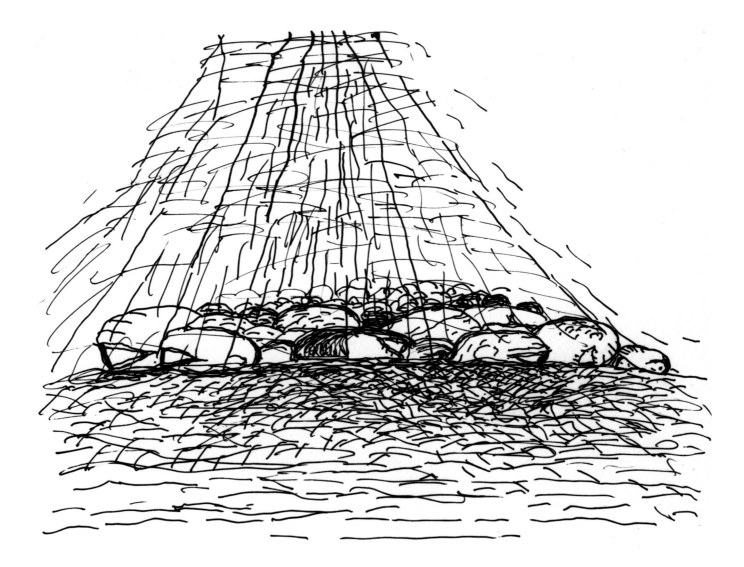

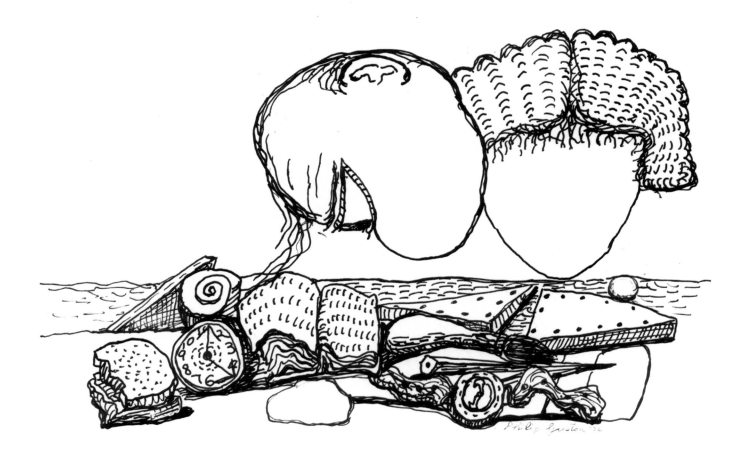

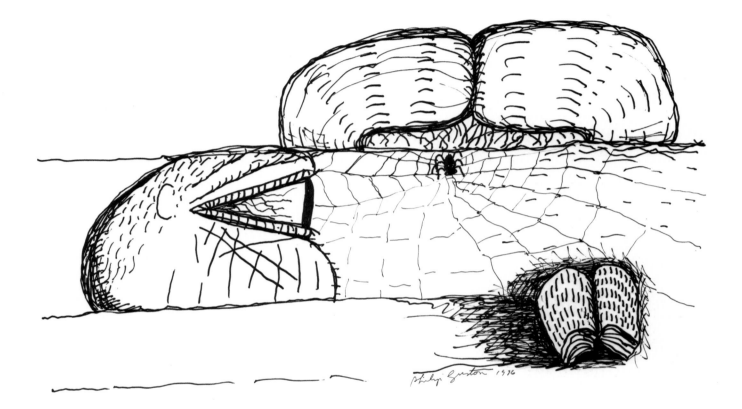

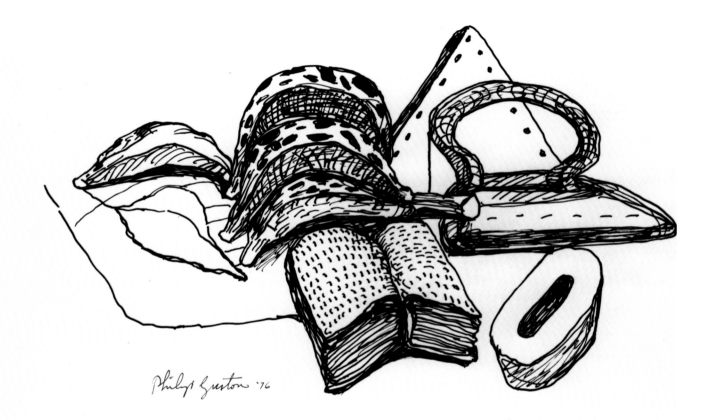

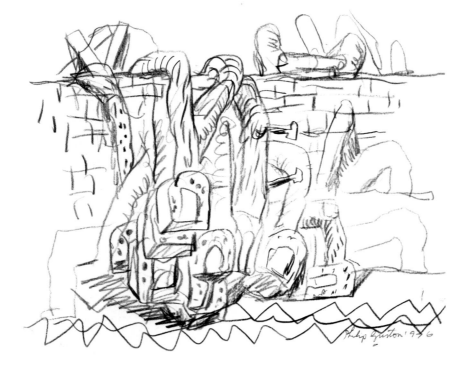

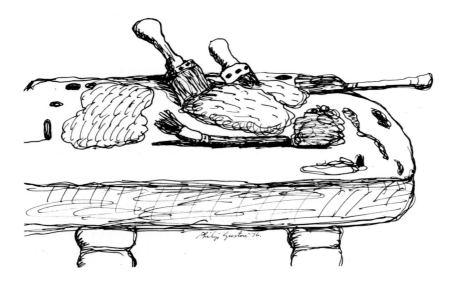

Palette. 1976
(CAT. 137)

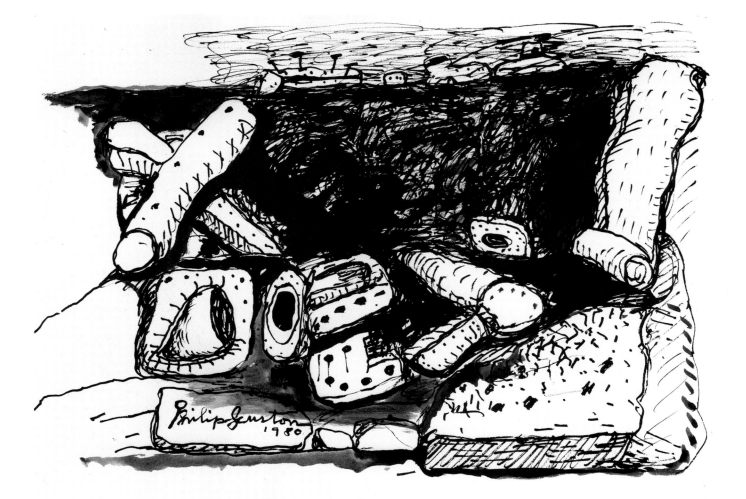

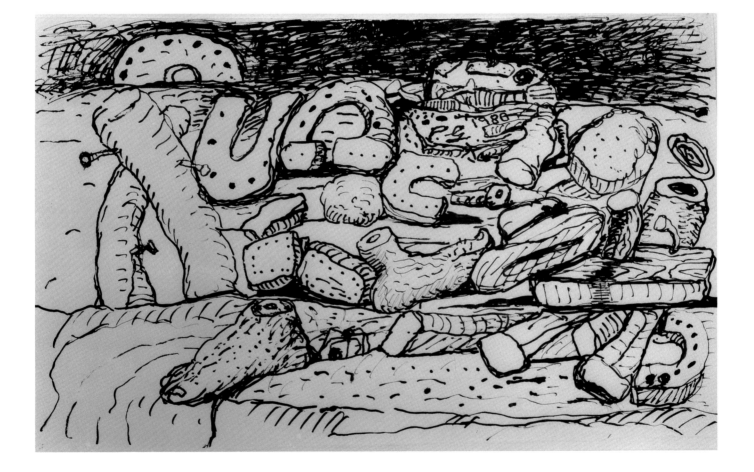

Fault. 1980
(CAT. 140)

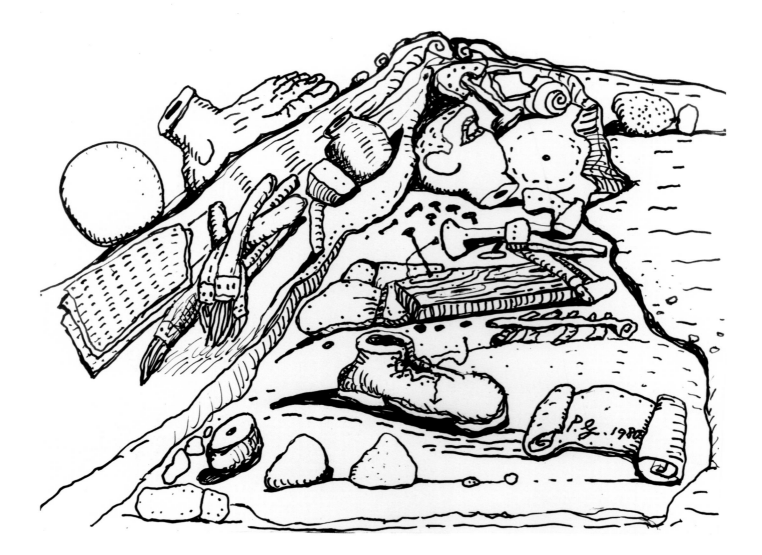

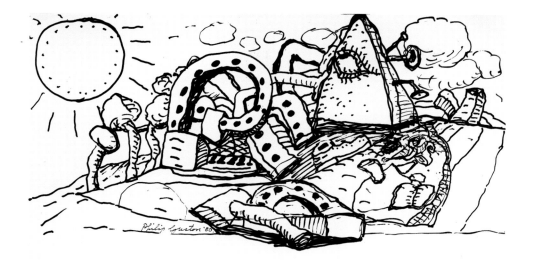

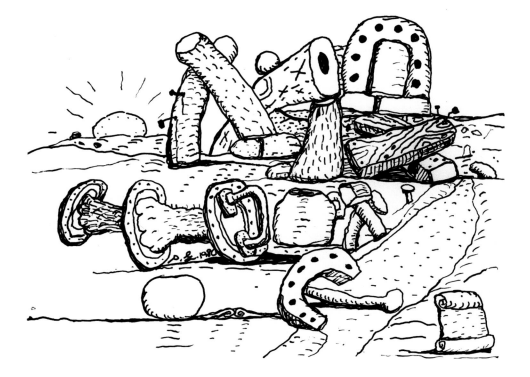

Untitled. 1980
(CAT. 143)

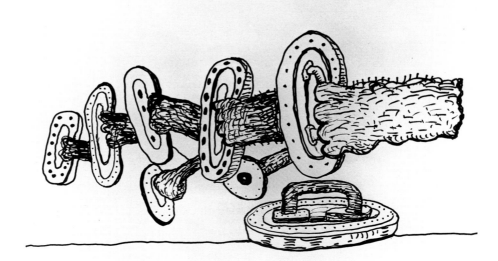

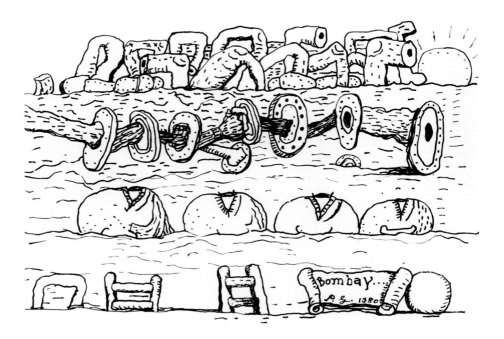

Bombay. 1980
(CAT. 144)

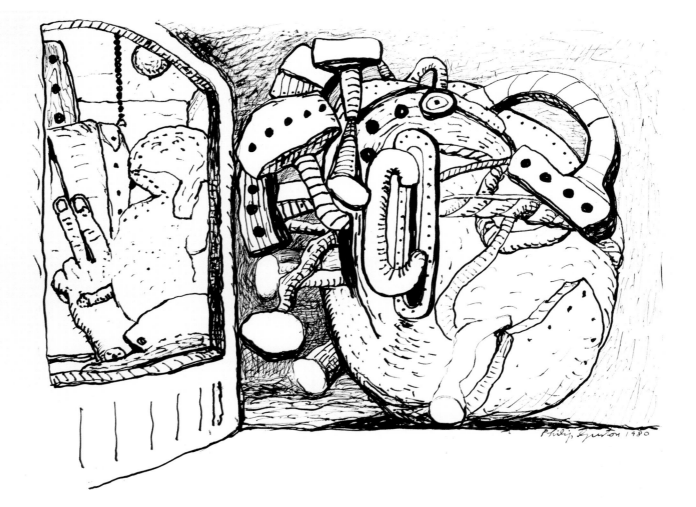

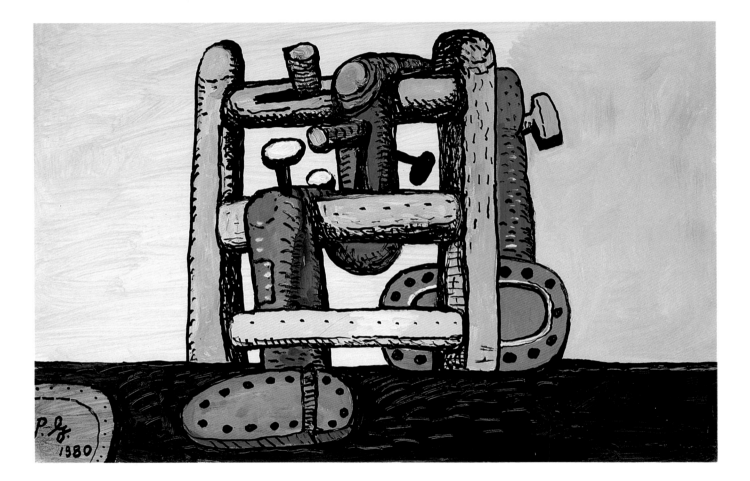

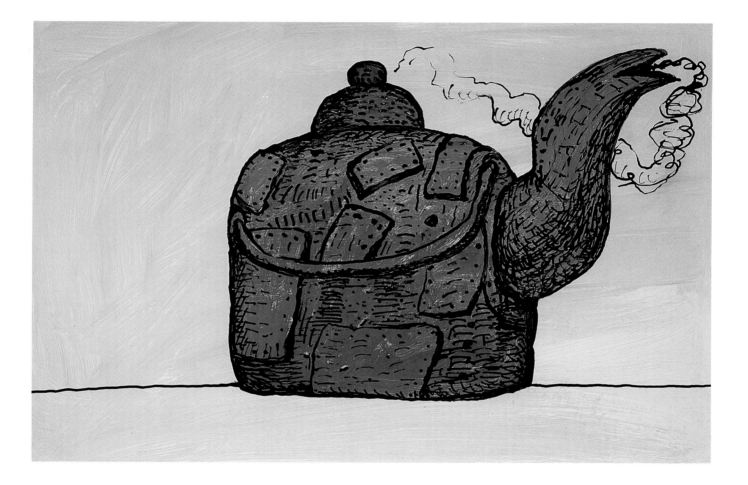

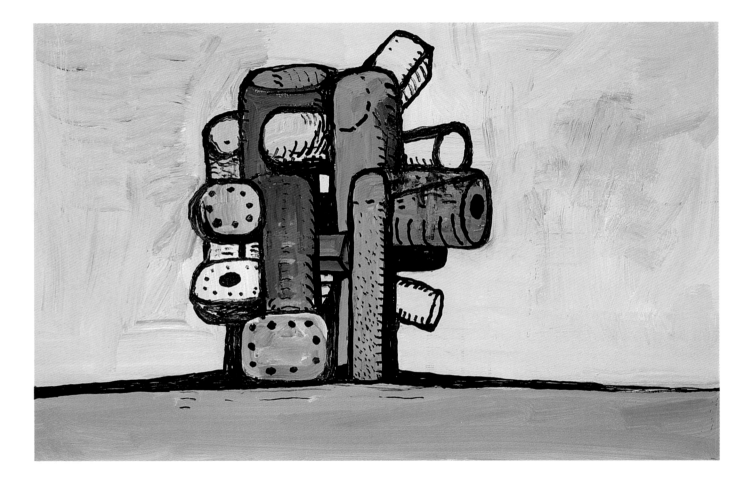

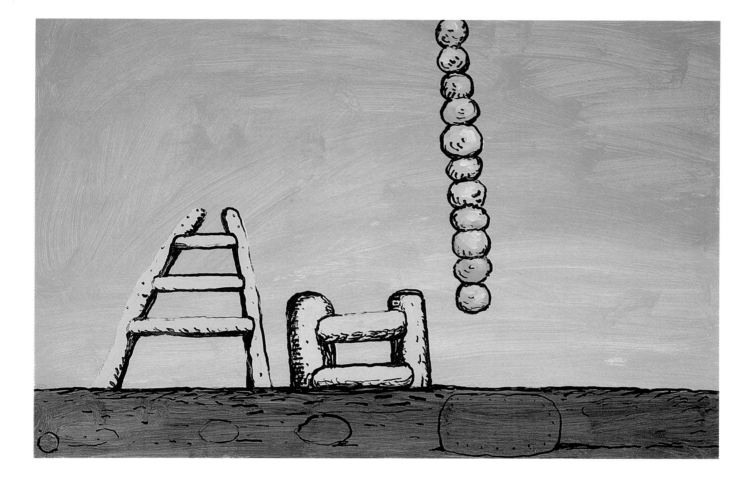

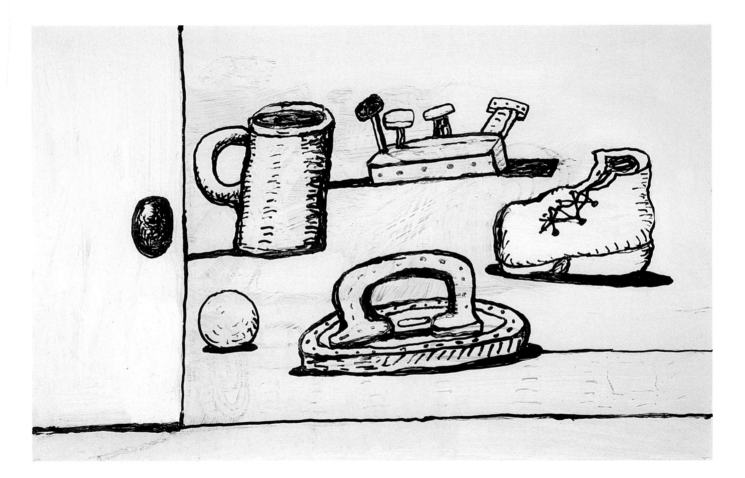

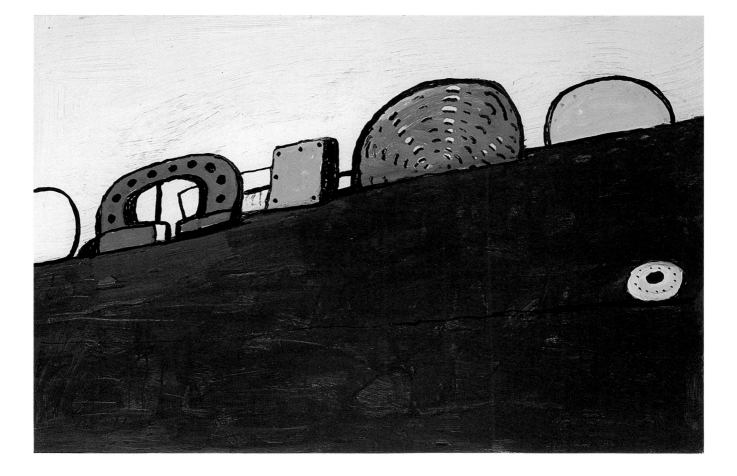

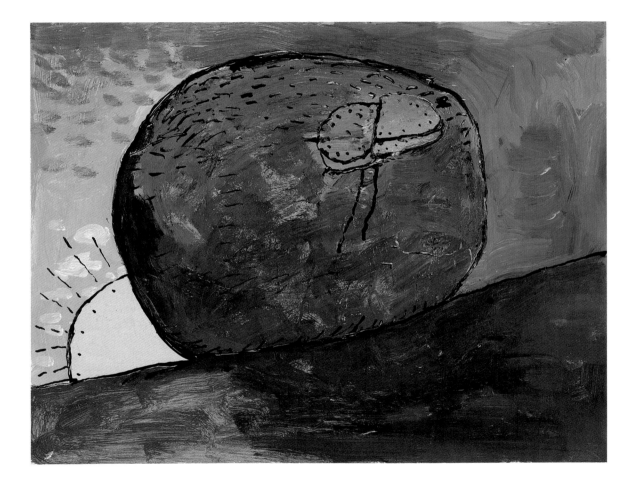

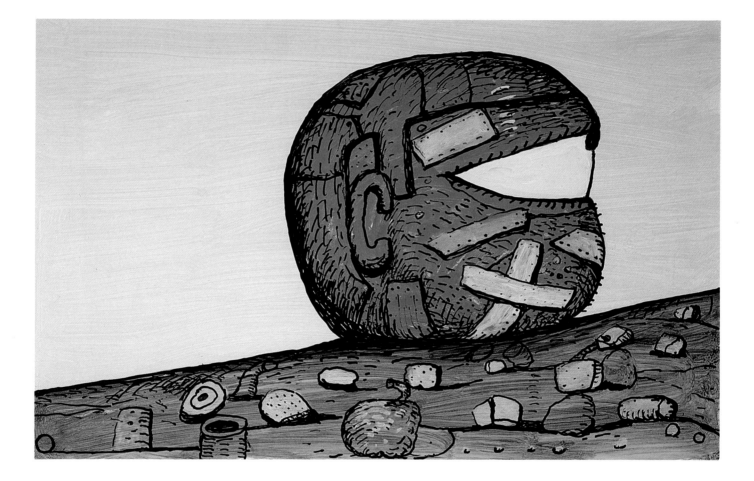

CATALOGUE OF THE EXHIBITION

In the catalogue, works are listed by year. Dates enclosed in parentheses do not appear on the works themselves. All works are on paper, unless otherwise noted. Dimensions are given first in inches, then in centimeters, height preceding width, and refer to the full sheet. With two exceptions (cats. 9 and 73), all works executed in colored mediums are reproduced in color in the plates. The titles used in the catalogue are generally those that were assigned by the artist.

In 1962, the artist assigned numbers to drawings included in the exhibition "Philip Guston" at The Solomon R. Guggenheim Museum, New York. Because many of the works reproduced in the publication that accompanied that exhibition (H. H. Arnason, *Philip Guston*) have come to be known by those designations, the numbers have been indicated parenthetically in the present catalogue.

1. Drawing for *Conspirators*. 1930
 (p. 50)
 Graphite, ink, colored pencil,
 and crayon, 22½ × 14½"
 (57.2 × 36.8 cm)
 Whitney Museum of American Art,
 New York. Purchase, with funds from
 the Hearst Corporation and the Norman and Rosita Winston Foundation,
 Inc.

2. *Punchinello Drawing*. 1933 (p. 51)
 Ink, watercolor, and crayon, 7 × 5"
 (17.8 × 12.7 cm)
 Collection Charles Craig

3. *Boys Fighting*. 1938 (p. 52)
 Colored pencil and pencil, 16⁵/₁₆ × 13"
 (41.4 × 33 cm)
 Private collection, Woodstock,
 New York

4. *Study for Queensbridge Housing
 Project Mural*. 1939 (p. 53)
 Colored pencil and ink, 15 × 24¾"
 (38.1 × 62.9 cm)
 Private collection, Woodstock,
 New York

5. *Bucks County Landscape*. 1939 (p. 54)
 Colored pencil, 10 × 15"
 (25.4 × 38.1 cm)
 Private collection, New York

6. Study for *Maintaining America's Skills*.
 (1939; dated on drawing 1940) (p. 55)
 Charcoal, chalk, and pencil,
 18¾ × 24" (47.6 × 61 cm)
 Collection Juliet and Michael A.
 Rubenstein

7. *Clothes Inflation Drill (for Navy
 Pre-Flight Training)*. 1943 (p. 56)
 Pencil and crayon, 22½ × 29"
 (57.2 × 73.7 cm)
 Private collection, New York

8. *The Air Training Program* (illustration
 for *Fortune* magazine). (1943) (p. 57)
 Gouache, 30 × 23¾"
 (76.2 × 60.3 cm)
 Private collection, New York

9. *Untitled*. 1946 (p. 58)
 Ink, pencil, and crayon, 11¾ × 9"
 (29.8 × 22.9 cm)
 Estate of the artist, courtesy David
 McKee Gallery, New York

10. Drawing for *Tormentors (Drawing No. 1)*.
 (1947; dated on drawing 1947–48)
 (p. 59)
 Ink, 14⅞ × 20⅞" (37.8 × 53.1 cm)
 Estate of the artist, courtesy David
 McKee Gallery, New York

11. *Untitled*. 1947 (p. 60)
 Lithographic crayon, 14 × 11"
 (35.6 × 27.9 cm)
 Private collection, New York

12. *Sketchbook Drawing*. 1947 (p. 61)
 Ink, 22½ × 29" (57.2 × 73.7 cm)
 irreg.
 Estate of the artist, courtesy David
 McKee Gallery, New York

13. *Angel*. 1947 (p. 61)
 Ink, 18 × 24" (45.7 × 61 cm)
 Estate of the artist, courtesy David
 McKee Gallery, New York

14. *Untitled*. 1947–48 (p. 62)
 Ink wash, ink, and pencil,
 10¾ × 13⅞" (27.3 × 35.2 cm)
 Estate of the artist, courtesy David
 McKee Gallery, New York

15. *Forio, Ischia*. 1949 (p. 63)
 Ink, 11½ × 15½" (29.2 × 39.4 cm)
 Collection H. H. Arnason

16. *Ischia*. 1949 (p. 63)
 Ink, 10¾ × 13¾" (27.3 × 34.9 cm)
 The Edward R. Broida Trust, Los
 Angeles

17. *Small Quill Drawing*. 1950 (p. 64)
 Ink, 12⅛ × 16⅛" (30.8 × 41 cm)
 Private collection, New York

18. *Early Drawing I*. 1950 (p. 65)
 Ink, 12¼ × 16⅛" (31.1 × 41 cm)
 Estate of the artist, courtesy David
 McKee Gallery, New York

19. *Autumn*. 1950 (p. 66)
 Ink, 16½ × 22" (41.9 × 55.9 cm)
 Collection Leonard and Stephanie
 Bernheim

20. *Untitled*. (1950) (p. 67)
 Ink, 18¾ × 23¾" (47.6 × 60.3 cm)
 Private collection, New York

21. *Loft I*. 1950 (p. 68)
 Ink, 17 × 22" (43.2 × 55.9 cm)
 The Edward R. Broida Trust,
 Los Angeles

22. *Loft II*. 1950 (p. 69)
 Ink, 18¾ × 23⅜" (47.6 × 59.4 cm)
 Collection Mr. and Mrs. Harry W.
 Anderson

23. *Drawing*. 1951 (p. 65)
 Ink, 9⅛ × 11⅜" (23.2 × 28.9 cm)
 Collection Dore Ashton

24. *Downward*. 1951 (p. 70)
 Ink, 23½ × 18½" (59.7 × 47 cm)
 Collection Roselyne and Richard Swig

25. *Untitled*. (1951) (p. 71)
 Ink, 19½ × 24" (49.5 × 61 cm)
 Arthur Ross Foundation

26. *Ascent*. 1952 (p. 72)
 Ink, 12 × 17¹⁵/₁₆" (30.5 × 45.6 cm)
 The Edward R. Broida Trust,
 Los Angeles

27. *Center*. 1952 (p. 73)
 Ink, 18 × 19" (45.7 × 48.3 cm)
 Collection Mr. and Mrs. Craig P. Wood,
 Tampa, Florida

28. *Untitled*. 1952 (p. 74)
 Ink, 17⅞ × 24" (45.4 × 61 cm)
 Collection Mr. and Mrs. Lee V. Eastman

29. *Untitled*. (1952–53) (p. 75)
 Ink, 16⅞ × 16⅞" (42.9 × 42.9 cm)
 Collection Philip Anglim

30. *Drawing (Drawing No. 15)*. 1953
 (p. 76)
 Ink, 17 × 22" (43.2 × 55.9 cm)
 Collection Dore Ashton

31. *Passage (Drawing No. 18)*. 1953
 (p. 76)
 Ink, 16½ × 21¼" (41.9 × 54 cm)
 Private collection, New York

32. *Drawing No. 14*. 1953 (p. 77)
 Ink, 17½ × 22⅜" (44.5 × 56.8 cm)
 The Solomon R. Guggenheim
 Museum, New York

33. *Fall*. 1953 (p. 78)
Ink, 18 × 23⅞″ (45.7 × 60.7 cm)
Private collection, New York

34. *Untitled*. (c. 1953) (p. 79)
Ink, 23¾ × 17″ (60.3 × 43.2 cm)
Collection Mr. and Mrs. James Foster,
Chicago

35. *Untitled*. 1953 (p. 80)
Ink, 18 × 24″ (45.7 × 61 cm)
Collection PaineWebber Group Inc.

36. *Untitled*. (1953) (p. 83)
Ink, 17⅞ × 23¾″ (45.4 × 60.3 cm)
Collection Dorothy C. Miller

37. Drawing related to *Zone (Drawing
No. 19)*. (1954) (p. 81)
Ink, 17⅞ × 24″ (45.4 × 61 cm)
Private collection, New York

38. *Drawing*. 1954 (p. 82)
Ink, 17⅞ × 23⅞″ (45.4 × 60.7 cm)
Collection Mr. and Mrs. Andrew Saul

39. *Head—Double View (Drawing
No. 20)*. 1958 (p. 84)
Ink, 20 × 24⅞″ (50.7 × 63.2 cm)
The Museum of Modern Art,
New York. Purchase

40. *Forms in Change*. 1958 (p. 85)
Ink, 18 × 23¾″ (45.7 × 60.3 cm)
Collection Roselyne and Richard Swig

41. *Last Piece*. (1958) (p. 86)
Gouache, 22 × 30″ (55.9 × 76.2 cm)
The Edward R. Broida Trust,
Los Angeles

42. *For M (Drawing No. 29)*. 1960 (p. 87)
Ink, 18 × 24″ (45.7 × 61 cm)
Collection A. J. Pyrch, Victoria, British
Columbia

43. *Sortie*. 1960 (p. 88)
Ink, 18½ × 23″ (47 × 58.4 cm)
Private collection, New York

44. *Untitled*. 1960 (p. 88)
Ink, 18 × 24″ (45.7 × 61 cm)
Estate of the artist, courtesy David
McKee Gallery, New York

45. *Drawing*. 1960 (p. 89)
Ink, 18¾ × 23⅞″ (47.6 × 60.7 cm)
Collection Mr. and Mrs. Donald Blinken

46. *Celebration*. 1961 (p. 89)
Ink, 25¾ × 30½″ (65.4 × 77.5 cm)
Courtesy David McKee Gallery,
New York

47. *Drawing*. 1961 (p. 90)
Ink, 26 × 40″ (66 × 101.6 cm)
Collection Juliet and Michael A.
Rubenstein

48. *Pleasures*. 1961 (p. 90)
Ink, 26 × 36″ (66 × 91.5 cm)
The Edward R. Broida Trust,
Los Angeles

49. *Pleasures I*. 1961 (p. 91)
Ink, 26⅛ × 35½″ (66.4 × 90.2 cm)
Estate of the artist, courtesy David
McKee Gallery, New York

50. *Woodstock Drawing*. 1961 (p. 91)
Ink, 18⅛ × 24″ (46.1 × 61 cm)
Collection Louis Bernstein and
Ruth Fischer

51. *Untitled*. 1962 (p. 92)
Ink, 26 × 39¼″ (66 × 99.7 cm)
Arthur Ross Foundation

52. *Untitled*. 1963 (p. 87)
Ink, 22 × 28″ (55.9 × 71.1 cm)
The Edward R. Broida Trust,
Los Angeles

53. *Departure*. 1963 (p. 93)
Gouache, 30 × 40″
(76.2 × 101.6 cm)
Estate of the artist, courtesy David
McKee Gallery, New York

54. *Untitled*. 1963 (p. 94)
Gouache, 30 × 40″
(76.2 × 101.6 cm)
The Edward R. Broida Trust,
Los Angeles

55. *Dark Form II*. 1963 (p. 95)
Gouache, 23 × 29″ (58.4 × 73.7 cm)
Estate of the artist, courtesy David
McKee Gallery, New York

56. *The Stone*. 1965 (p. 96)
Ink, 18 × 24″ (45.7 × 61 cm)
The Edward R. Broida Trust,
Los Angeles

57. *The Scale*. 1965 (p. 96)
Ink, 18 × 24″ (45.7 × 61 cm)
Private collection, New York

58. *The Hill*. 1965 (p. 97)
Ink, 17½ × 23½″ (44.5 × 59.7 cm)
Estate of the artist, courtesy David
McKee Gallery, New York

59. *Untitled*. 1965 (p. 97)
Ink, 18⅛ × 23¼″ (46.1 × 59.1 cm)
Estate of the artist, courtesy David
McKee Gallery, New York

60. *Full Brush*. 1966 (p. 98)
Ink, 18 × 23″ (45.7 × 58.4 cm)
Estate of the artist, courtesy David
McKee Gallery, New York

61. *Chair*. 1967 (p. 98)
Ink, 14 × 16½″ (35.6 × 41.9 cm)
Private collection, Woodstock,
New York

62. *Mark*. 1967 (p. 99)
Ink, 14 × 16½″ (35.6 × 41.9 cm)
Estate of the artist, courtesy David
McKee Gallery, New York

63. *Edge*. 1967 (p. 99)
Ink, 13½ × 16¾″ (34.3 × 42.6 cm)
Estate of the artist, courtesy David
McKee Gallery, New York

64. *Haven*. 1967 (p. 100)
Ink, 16 × 19¹³⁄₁₆″ (40.6 × 50.3 cm)
The Edward R. Broida Trust,
Los Angeles

65. *Form*. 1967 (p. 100)
Ink, 19 × 23″ (48.3 × 58.4 cm)
Estate of the artist, courtesy David
McKee Gallery, New York

66. *Untitled*. 1967 (p. 101)
Ink, 13¾ × 17⅛″ (34.9 × 43.5 cm)
Estate of the artist, courtesy David
McKee Gallery, New York

67. *Wave II*. 1967 (p. 101)
Ink, 14 × 16¼″ (35.6 × 41.3 cm)
Estate of the artist, courtesy David
McKee Gallery, New York

68. *Book*. 1968 (p. 102)
Charcoal, 17⅞ × 24″ (45.4 × 61 cm)
Private collection, New York

69. *Book*. 1968 (p. 102)
Charcoal, 17½ × 22½″
(44.5 × 57.2 cm)
Collection T. W. and S. J. Quirk,
Melbourne

70. *Car*. 1968 (p. 103)
Charcoal, 13 × 16″
(33 × 40.6 cm)
Private collection, Woodstock,
New York

71. *Ink Bottle and Quill*. 1968 (p. 103)
Charcoal, 13⅞ × 16⅛″
(35.2 × 41 cm)
Private collection, Woodstock,
New York

72. *Statement*. 1968 (p. 104)
Charcoal, 17½ × 23″
(44.5 × 58.4 cm)
Estate of the artist, courtesy David
McKee Gallery, New York

73. *City*. 1968 (p. 104)
Acrylic on board, 20 × 30″
(50.8 × 76.2 cm)
The Edward R. Broida Trust,
Los Angeles

74. *Head (Stranger)*. (1968) (p. 105)
Ink, 18 × 22½″ (45.7 × 57.2 cm)
Collection Janie C. Lee

75. *Untitled.* 1968 (p. 106)
Charcoal, 18 × 24″ (45.7 × 61 cm)
Estate of the artist, courtesy David
McKee Gallery, New York

76. *Group I.* 1968 (p. 106)
Charcoal, 18 × 24″ (45.7 × 61 cm)
Private collection, New York

77. *Untitled.* 1968 (p. 107)
Charcoal, 17⅞ × 22½″
(45.4 × 57.2 cm)
Private collection, New York

78. *Untitled.* 1968 (p. 109)
Charcoal, 17½ × 20½″
(44.5 × 52.1 cm)
Private collection, New York

79. *Untitled.* 1968 (p. 111)
Charcoal, 17½ × 23¼″
(44.5 × 59.1 cm)
Estate of the artist, courtesy David
McKee Gallery, New York

80. *Brushes in Can.* 1969 (p. 108)
Charcoal, 15⅞ × 20″
(40.3 × 50.7 cm)
Estate of the artist, courtesy David
McKee Gallery, New York

81. *Group.* 1969 (p. 108)
Ink, 16 × 19¼″ (40.6 × 48.9 cm)
San Francisco Museum of Modern Art.
In memory of Philip Guston's friend-
ship, gift of the Turnbull Foundation,
Paule Anglim, and William D. Turnbull

82. *Clock.* 1969 (p. 110)
Pencil, 14 × 18″ (35.6 × 45.7 cm)
Collection John Whitney, Jr.

83. *At the Table.* 1969 (p. 112)
Pencil, 14 × 16″ (35.6 × 40.6 cm)
Collection Phyllis and Ted Rosen

84. *City.* 1969 (p. 113)
Charcoal, 18 × 24″
(45.6 × 60.9 cm)
Australian National Gallery, Canberra

85. *The Law.* 1969 (p. 114)
Charcoal, 17⅞ × 14⅝″
(45.4 × 37.2 cm)
Private collection, New York

86. *Discussion.* 1969 (p. 115)
Charcoal, 23⅝ × 17¼″
(60 × 43.8 cm)
The Edward R. Broida Trust,
Los Angeles

87. Study for *Edge of Town.* 1969 (p. 116)
Charcoal, 17¼ × 24″
(43.8 × 61 cm)
Private collection, New York

88. *Untitled.* 1969 (p. 117)
Charcoal, 17¹⁵⁄₁₆ × 23¹⁵⁄₁₆″
(45.5 × 60.8 cm)
Estate of the artist, courtesy David
McKee Gallery, New York

89. *Untitled.* 1969 (p. 118)
Charcoal, 17¾ × 22¾″
(45.1 × 57.8 cm)
Private collection, New York

90. *Untitled.* 1969 (p. 119)
Pencil and colored pencil, 15⅜ × 20″
(39 × 50.8 cm)
Estate of the artist, courtesy David
McKee Gallery, New York

91. *Window.* (1969; dated on drawing
1970) (p. 120)
Pencil, 18 × 21½″ (45.7 × 54.6 cm)
Collection Mr. and Mrs. Harry W.
Anderson

92. *Wrapped.* 1969 (p. 121)
Charcoal, 17¼ × 21½″
(43.8 × 54.6 cm)
The Museum of Modern Art,
New York. Purchase

93. *Two Figures.* 1969 (p. 121)
Charcoal, 18 × 23⅜″
(45.7 × 59.3 cm)
Estate of the artist, courtesy David
McKee Gallery, New York

94. *Solitary II.* 1970 (p. 122)
Ink, 16⅜ × 21¼″ (41.6 × 54 cm)
Estate of the artist, courtesy David
McKee Gallery, New York

95. *Boots.* 1970 (p. 122)
Ink, 18 × 24″ (45.7 × 61 cm)
Collection Mr. and Mrs. Harry W.
Anderson

96. *Trip.* 1970 (p. 123)
Pencil, 13½ × 17″ (34.3 × 43.2 cm)
Collection Marianne and Jonathan
Fineberg, Urbana, Illinois

97. *Stranger.* 1970 (p. 124)
Ink, 18 × 24″ (45.7 × 61 cm)
Estate of the artist, courtesy David
McKee Gallery, New York

98. Study for *Sheriff.* 1970 (p. 124)
Ink, 17½ × 19½″ (44.5 × 49.5 cm)
Collection Hans Mautner

99. *Fever.* 1970 (p. 125)
Charcoal, 18 × 24″ (45.7 × 61 cm)
Private collection

100. *Street.* 1970 (p. 126)
Charcoal, 17⅞ × 23″
(45.4 × 58.4 cm)
Estate of the artist, courtesy David
McKee Gallery, New York

101. Study for *Cellar.* 1970 (p. 126)
Charcoal, 17¼ × 24″ (43.8 × 61 cm)
Collection Rick Meyerowitz,
New York

102. *Dawn.* 1971 (p. 127)
Charcoal, 19 × 24″ (48.3 × 61 cm)
Collection Stacey Moss

103. *Back View.* 1971 (p. 128)
Oil, 28⅞ × 34⅞″ (73.3 × 88.6 cm)
Estate of the artist, courtesy David
McKee Gallery, New York

104. *Farnesina Gardens, Rome.* 1971
(p. 129)
Oil, 29 × 40½″ (73.7 × 102.9 cm)
Collection Mrs. Semon E. Knudsen

105. *Roma.* 1971 (p. 130)
Oil, 28¼ × 40″ (71.8 × 101.6 cm)
Collection T. W. and S. J. Quirk,
Melbourne

106. *Roma II.* 1971 (p. 131)
Oil, 19½ × 27¾″ (49.5 × 70.5 cm)
Estate of the artist, courtesy David
McKee Gallery, New York

107. *Untitled.* (1971) (p. 132)
Oil, 30 × 40″ (76.2 × 101.6 cm)
Collection Mr. and Mrs. Alfred
Ordover, New York

108. *Untitled.* (1971) (p. 133)
Oil, 19⅝ × 27⅝″ (49.9 × 70.2 cm)
Estate of the artist, courtesy David
McKee Gallery, New York

109. *Cornered.* 1971 (p. 134)
Oil, 30¼ × 40⅛″ (76.9 × 101.9 cm)
Collection Michèle Cone

110. *Untitled.* (1971) (p. 135)
Oil, 27⅞ × 39¾″ (70.8 × 101 cm)
Estate of the artist, courtesy David
McKee Gallery, New York

111. *Untitled.* 1971 (p. 136)
Oil, 19¾ × 27½″ (50.2 × 69.8 cm)
Private collection, Pennsylvania

112. *Brick Wall.* 1972 (p. 137)
Oil, 21¼ × 29¼″ (54 × 74.3 cm)
Courtesy Langer & Co. Fine Arts,
New York

113. *Four Heads.* 1974 (p. 138)
Ink, 18 × 24″ (45.7 × 61 cm)
The Edward R. Broida Trust,
Los Angeles

114. *Smoking in Bed II.* 1974 (p. 139)
Ink, 19 × 24" (48.3 × 61 cm)
Collection Michèle Cone

115. *Message.* 1975 (p. 140)
Ink, 18⅞ × 25" (48 × 63.5 cm)
Estate of the artist, courtesy David
McKee Gallery, New York

116. *Untitled.* 1975 (p. 141)
Ink, 18⅞ × 25" (48 × 63.5 cm)
Estate of the artist, courtesy David
McKee Gallery, New York

117. *Rain.* 1975 (p. 142)
Ink, 19 × 24" (48.3 × 61 cm)
The Edward R. Broida Trust,
Los Angeles

118. *Web.* 1975 (p. 142)
Ink, 19 × 24" (48.3 × 61 cm)
Private collection, Woodstock,
New York

119. *Aftermath.* 1975 (p. 143)
Ink, 18 × 24" (45.7 × 61 cm)
Collection Raymond J. Learsy

120. *Web.* 1975 (p. 143)
Ink, 19 × 24" (48.3 × 61 cm)
Collection Mr. and Mrs. Harry W.
Anderson

121. *Head and Bottle.* 1975 (p. 144)
Ink, 19 × 24" (48.3 × 61 cm)
Collection Armando and
Gemma Testa

122. *Fist.* 1975 (p. 144)
Ink, 19 × 25" (48.3 × 63.5 cm)
Art Gallery of New South Wales,
Sydney

123. *Untitled.* 1975 (p. 145)
Ink, 17⅞ × 24⅜" (45.4 × 61.9 cm)
Private collection, New York

124. *Elements.* 1975 (p. 146)
Ink, 18½ × 24½" (47 × 62.2 cm)
Collection Terry Hunziker

125. Study for *Green Sea.* 1975 (p. 147)
Pencil, 13¾ × 16⅞"
(34.9 × 42.9 cm)
Estate of the artist, courtesy David
McKee Gallery, New York

126. *Untitled.* 1975 (p. 147)
Pencil, 14 × 16⅝" (35.6 × 42.2 cm)
Estate of the artist, courtesy David
McKee Gallery, New York

127. *Three Heads.* 1975 (p. 148)
Ink, 19 × 25" (48.3 × 63.5 cm)
Private collection

128. *Foot.* 1975 (p. 150)
Ink, 19 × 23⅞" (48.3 × 60.7 cm)
Estate of the artist, courtesy David
McKee Gallery, New York

129. *Untitled.* 1976 (p. 149)
Charcoal, 19 × 24" (48.3 × 61 cm)
Estate of the artist, courtesy David
McKee Gallery, New York

130. *Two Heads—Water.* 1976 (p. 151)
Ink, 18 × 24" (45.7 × 61 cm)
Courtesy Janie C. Lee Master
Drawings, New York

131. *Lower Level.* 1976 (p. 152)
Ink, 19 × 24" (48.3 × 61 cm)
Collection Celia Ascher

132. *Current.* (1976) (p. 153)
Ink, 19 × 24" (48.3 × 61 cm)
Estate of the artist, courtesy David
McKee Gallery, New York

133. *Hovering.* 1976 (p. 154)
Ink, 18³⁄₁₆ × 24¹⁄₁₆" (46.2 × 61.1 cm)
National Museum of American Art,
Smithsonian Institution, Washington,
D.C. Gift of Ruth and Jacob Kainen

134. *Untitled.* 1976 (p. 155)
Ink, 17⅞ × 23⅞" (45.4 × 60.7 cm)
Estate of the artist, courtesy David
McKee Gallery, New York

135. *Objects on Table.* 1976 (p. 156)
Ink, 19 × 24" (48.3 × 61 cm)
Estate of the artist, courtesy David
McKee Gallery, New York

136. Study for *The Wall.* 1976 (p. 157)
Pencil, 13½ × 16" (34.3 × 40.6 cm)
Estate of the artist, courtesy David
McKee Gallery, New York

137. *Palette.* 1976 (p. 157)
Ink, 19 × 24" (48.3 × 61 cm)
Collection Mrs. Keith S. Wellin

138. *Layers.* 1980 (p. 158)
Ink, 19 × 25¾" (48.3 × 65.4 cm)
Collection Brian and Lyn Hayden

139. *Untitled.* 1980 (p. 159)
Ink, 15¾ × 25¼" (40 × 64.1 cm)
Private collection

140. *Fault.* 1980 (p. 160)
Ink, 22⅞ × 28⅞" (58.2 × 73.4 cm)
Private collection, New York

141. *Dawn.* 1980 (p. 161)
Ink, 19⅞ × 29" (50.5 × 73.7 cm)
Estate of the artist, courtesy David
McKee Gallery, New York

142. *Untitled.* 1980 (p. 161)
Ink, 23 × 29" (58.4 × 73.7 cm)
Estate of the artist, courtesy David
McKee Gallery, New York

143. *Untitled.* (1980) (p. 162)
Ink, 23 × 29" (58.4 × 73.7 cm)
Private collection, New York

144. *Bombay.* 1980 (p. 162)
Ink, 21 × 29⅞" (53.3 × 74.8 cm)
Private collection, New York

145. *Untitled.* 1980 (p. 163)
Ink, 18 × 23⅛" (45.7 × 58.7 cm)
Collection Mr. and Mrs. Harry W.
Anderson

146. *Untitled.* 1980 (p. 164)
Acrylic and ink on board, 20 × 30"
(50.8 × 76.2 cm)
Private collection, New York

147. *Untitled.* (1980) (p. 165)
Acrylic and ink on board, 20 × 30"
(50.8 × 76.2 cm)
Private collection, New York

148. *Untitled.* (1980) (p. 166)
Acrylic and ink on board, 20 × 30"
(50.8 × 76.2 cm)
The Museum of Modern Art,
New York. Gift of Musa Guston

149. *Untitled.* (1980) (p. 167)
Acrylic and ink on board, 20 × 30"
(50.8 × 76.2 cm)
Private collection, Woodstock,
New York

150. *Untitled.* (1980) (p. 168)
Acrylic and ink on board, 20 × 30"
(50.8 × 76.2 cm)
Private collection, Woodstock,
New York

151. *Untitled.* (1980) (p. 169)
Acrylic and ink on board, 20 × 30"
(50.8 × 76.2 cm)
The Museum of Modern Art,
New York. Gift of Musa Guston

152. *Untitled.* (1980) (p. 170)
Acrylic and ink, 23 × 29"
(58.4 × 73.7 cm)
The Museum of Modern Art,
New York. Gift of Musa Guston

153. *Untitled.* (1980) (p. 171)
Acrylic and ink on board, 20 × 30"
(50.8 × 76.2 cm)
Private collection, New York

CHRONOLOGY

1913 June 27: Born Phillip Goldstein in Montreal, Canada, the youngest of seven children of Lieb and Rachel Ehrenlieb Goldstein. His parents, émigrés from Odessa, Russia, had settled in Canada about 1905.

1919 Family moves from Canada to Los Angeles.

1923 Father commits suicide.

1925 Begins to draw.

1926 His mother enrolls him in a year-long correspondence course offered by the Cleveland School of Cartooning, a gift for his thirteenth birthday.

1927 Enters Manual Arts High School, Los Angeles, where he becomes friends with Jackson Pollock. Frederick John de St. Vrain Schwankovsky, his art teacher there, introduces him to modern art, especially Cubism, and to Oriental philosophy and Theosophy.

1928 Wins a cartooning contest for teenagers sponsored by the *Los Angeles Times*.

1929 With Pollock, is expelled from Manual Arts for printing and distributing a "Journal of Liberty," a broadside critical of the faculty's "unreasonable elevation of athletic ability and the consequent degradation of scholarship." Never returns, and never completes any formal academic program.

First becomes aware of the Mexican mural movement, through the January issue of *Creative Art* magazine.

1930 Receives a scholarship to Otis Art Institute, Los Angeles, where he meets the artist and poet Musa McKim and the artist Reuben Kadish. Disappointed with the traditional curriculum, he leaves after three months. Draws constantly on his own, from Piero della Francesca, Paolo Uccello, and Masaccio.

Through Kadish, meets the Los Angeles painter Lorser Feitelson, who enables the younger artists to visit the Walter and Louise Arensberg collection of modern art. It is Guston's first encounter with the paintings of de Chirico and Picasso.

A drawing for *Conspirators* (p. 50) marks the first appearance of the hooded figure in his oeuvre.

Possibly visits Pomona College, Claremont, California, to observe José Clemente Orozco painting his mural *Prometheus*.

1931 Becomes increasingly involved in political issues and responsive to the Mexican artists' call to take up the social power of art: with Kadish, paints a series of fresco panels for the walls of the John Reed Club, a Marxist group. (The paintings, depictions of the events surrounding the Scottsboro Case and of Ku Klux Klan atrocities, will be destroyed during a police raid on the club in 1933.)

1932 David Alfaro Siqueiros is in Los Angeles, painting his controversial murals at Chouinard Art Institute and the Plaza Art Center (both destroyed).

Late 1932 (or early 1933): The first gallery exhibition of his work, Stanley Rose Bookshop, Hollywood.

1933 His work is presented in a museum for the first time, in the Annual Exhibition of Painters and Sculptors, organized by the Los Angeles Museum.

1934 Travels to Mexico with Kadish and Jules Langsner, a writer, where with Siqueiros's assistance, they receive an unpaid commission to execute a mural for Maximilian's palace in Morelia. The finished fresco, *Workers' Struggle for Liberty,* measures 1,024 square feet and is the subject of an article in *Time* magazine.

1935 Joins the Treasury Department's Public Works Administration and, with Kadish, receives a commission to create a mural for the City of Hope Medical Center, Duarte, California. Joins the mural division of the Works Progress Administration (WPA).

Begins using the name Philip Guston.

Winter of 1935–36: Moves to New York, rooming at first with Pollock, who had moved to the city in 1930.

Possibly sees de Chirico works on view at the Pierre Matisse Gallery, New York, from November to December.

1936 Works on cartoons for WPA mural commissions and meets other WPA artists, including James Brooks, Burgoyne Diller, Stuart Davis, and Willem de Kooning.

Views many exhibitions in New York galleries and museums, notably "Cubism and Abstract Art," at The Museum of Modern Art.

1937 Marries Musa McKim.

Exhibits mural studies in the temporary galleries of the Municipal Art Committee, New York.

1938 Receives a Treasury Department commission for a post-office mural in Commerce, Georgia: *Early Mail Services and the Construction of the Railroad.*

1939 Awarded a major mural commission for the facade of the WPA building at the New York World's Fair. The work, *Maintaining America's Skills* (destroyed 1940), wins first prize in a contest (based on a poll of visitors) sponsored by the American Society of Mural Painters.

Accepts a commission to execute a mural for the Queensbridge Housing Project in New York.

February–March: Sees an exhibition of Max Beckmann's art at the Buchholz Gallery, New York. May: Picasso's *Guernica* is on view at New York's Valentine Gallery. November–January, 1940: The Museum of Modern Art mounts a Picasso retrospective.

1940 Upon completing the Queensbridge mural, resigns from the WPA and moves to Woodstock, New York, intending to concentrate on easel painting.

1941 With his wife, executes decorative murals for three ships of the President Steamship Lines. The two also complete Treasury Department murals for the Forestry Building in Laconia, New Hampshire: *Pulpwood Logging* and *Wildlife in the White Mountains.*

Accepts a position as an associate professor of art at the State University of Iowa, Iowa City.

Completes his first mature canvas in a personal style, *Martial Memory,* one of many depictions of children at play in allegories of war.

1942 Executes his last mural, for the auditorium of the Social Security Building in Washington, D.C.

1943 His daughter, Musa Jane, is born.

Creates a series of gouaches for *Fortune* magazine illustrating military training (p. 57), and a group of drawings for the Naval Air Force (p. 56).

1944 A one-artist exhibition of his paintings and drawings takes place at the State University of Iowa. His work is included in the Annual Exhibition of Painting and Sculpture at the Pennsylvania Academy of the Fine Arts, Philadelphia.

1945 Receives first prize in the competition and exhibition "Painting in the United States," organized by the Carnegie Institute, Pittsburgh. Shortly thereafter he characterizes the prize-winning work, an atmospheric, painterly portrait titled *Sentimental Moment* (1944), as "too literal."

Midtown Galleries mounts his first New York one-artist exhibition.

Accepts the position of art instructor at Washington University, St. Louis, where he will teach for two academic years. Is strongly influenced by the Beckmann paintings that he views in local collections.

1947 Receives a Guggenheim Fellowship. Wins the Altman Prize from the National Academy of Design. Paints *Porch II* (fig. 7); the images of legs and nail-studded soles of shoes will reappear in the late figurative works.

Returns to Woodstock, where he becomes friends with Bradley Walker Tomlin.

Winter: In an intensive period of drawing, which produces the study for *Tormentors* (p. 59) and an untitled drawing (p. 60), begins experimenting with abstraction.

1948 Receives the Purchase Prize from the University of Illinois, Urbana, the Prix de Rome from the American Academy in Rome, and a grant from the American Academy of Arts and Letters.

Fall: Travels to Europe for the first time. Studies the art of Italy, Spain, and France. His stay in Europe (through fall 1949) coincides with a renewed focus on drawing. Works such as the Ischia landscapes (p. 63) evidence a further shift toward abstraction.

1950 Spring semester: Works as visiting artist at the University of Minnesota, Minneapolis.

Summer: Settles in New York City, where he participates actively in the Eighth Street Club. Develops friendships with Robert Motherwell and with the composers Morton Feldman and John Cage, who share his interest in Zen philosophy and Existentialism.

Fall: Holds the position of instructor of drawing at New York University (until 1958).

Draws copiously, now producing completely abstract works. Such compositions as *Small Quill Drawing* (p. 64) and *Autumn* (p. 66) evoke Oriental calligraphy in their masses of accumulated strokes.

1952 Peridot Gallery, New York, mounts an exhibition of his new abstract paintings and drawings.

Enters another period of intensity in drawing (through 1954). The work, including the drawing related to *Zone* (p. 81) and *Drawing* (p. 82), takes on "Mondrianesque" qualities: marks in grid-like compositions define rigorous structures.

1955 Joins the Sidney Janis Gallery, New York, which represents the Abstract Expressionists Pollock, de Kooning, and Mark Rothko as well. Exhibits regularly until 1961.

Focuses (through 1958) on paintings and a series of gouaches in which masses of brushstrokes coalesce into amorphous forms. Among these works are *To Fellini* (fig. 11) and *Last Piece* (p. 86).

1956 Several of his abstract paintings from 1951 to 1955 are shown in The Museum of Modern Art's exhibition "Twelve Americans."

1958 Is included in "The New American Painting," an exhibition organized by The Museum of Modern Art for presentation in Europe. Guston's art makes a strong impression on Georg Baselitz and other young European artists.

A new period of drawing begins. Works such as *Head—Double View* (p. 84) and *Forms in Change* (p. 85) suggest a dissatisfaction with abstraction, anticipating the landscape-inspired and figurative works to come.

1959 Receives a Ford Foundation grant and wins The Art Institute of Chicago's Flora Mayer Witkowsky Prize.

A large group of his paintings and drawings from 1949 to 1958 is included in the Bienal de São Paulo.

Gives up teaching (until 1973), except for slide lectures and seminars.

1960 Summer: Is one of four artists represented in the American Pavilion at the Venice Biennale. Travels in Europe for three months, stopping in Umbria to renew study of frescoes by Piero.

Drawings of this period incorporate landscape configurations and figurative elements. These include *Sortie* (p. 88), *Celebration* (p. 89), and *Pleasures* (p. 90).

1961 Is included in the exhibition "Modern American Drawing," organized by The Museum of Modern Art for presentation in Europe and Israel. The Dwan Gallery, Los Angeles, mounts the exhibition "Philip Guston/ Franz Kline."

1962 The Solomon R. Guggenheim Museum, New York, mounts a major retrospective of his art. The exhibition travels to Amsterdam, Brussels, London, and Los Angeles.

Leaves the Sidney Janis Gallery with other Abstract Expressionists in response to the gallery's exhibition "New Realists," made up of American Pop art.

1963 Produces a series of gouaches—including *Departure* (p. 93), an untitled work (p. 94), and *Dark Form II* (p. 95)—that move further toward figuration.

1964 Is represented in "An International Exhibition of Drawing" at Mathildenhöle, Darmstadt, and in "The American Contemporary Drawing," at The Solomon R. Guggenheim Museum.

1965 Executes a series of pen-and-ink drawings, among them *The Stone* (p. 96) and *The Scale* (p. 96), in which thin contour line is used to describe simple forms.

By the year's end, has stopped painting altogether and has devoted himself to drawing (through 1968).

1966 The Jewish Museum, New York, mounts the exhibition "Philip Guston: Recent Paintings and Drawings," transitional paintings, gouaches, and drawings from 1958 to 1965. The critical reaction is mixed.

Joins Marlborough Gallery, New York.

Initiates two major series of drawings, which will develop concurrently: throughout the next two years, he will produce hundreds of works, alternating "pure," reductive compositions, such as *Mark* (1967; p. 99) and *Edge* (1967; p. 99), with renderings of everyday objects, including *Book* (1968; p. 102) and *Ink Bottle and Quill* (1968; p. 103).

1967 His work is included in an exhibition organized by Morton Feldman, "Six Painters: Mondrian, Guston, Kline, de Kooning, Pollock, Rothko," at University of St. Thomas, Houston.

Moves again to Woodstock; becomes friends with the writer Philip Roth and the poet Clark Coolidge.

Continues drawing prolifically.

1968 Receives a second Guggenheim Fellowship.

Figuration predominates in his art, from this time until his death in 1980. Is increasingly disturbed by the Vietnam War and the civil strife in America: *Group I* (p. 106) and an untitled (p. 106) are among early examples of an outpouring of drawings that reestablish figuration in his oeuvre. Iconographic motifs include Ku Klux Klan hoods (in the studio as well as within cityscapes), comic-strip-style clocks, books, hands, brushes, and flatirons.

1969 Begins painting again, at first directly transposing single objects from the drawings onto small panels.

1970 Receives an honorary doctorate of fine arts from Boston University. Is elected a member of the American Academy in Rome.

October: Marlborough Gallery exhibits the figurative work of the previous two years. The critical reaction is generally negative.

Leaves for Italy after exhibition opens and spends the next nine months in Europe, his third stay.

1971 Artist-in-residence at the American Academy in Rome.

Initiates a sequence of more than one hundred oils and acrylics on paper—the Roma series (pp. 128-136)—that depict garden landscapes and excavation sites in Italy. Nail-studded soles of shoes and hoods appear prominently in the series, marking the last use of the hoods in his art.

End of summer: Returns to Woodstock.

1972 Is elected a member of the National Institute of Arts and Letters.

Leaves Marlborough Gallery.

1973 Becomes a professor of art at Boston University; teaches a graduate seminar three days each month (until 1978).

Exhibition "Philip Guston: Drawings, 1938–1972" at The Metropolitan Museum of Art, New York.

1974 Joins David McKee Gallery, New York.

Begins a series of drawings and paintings, including *Smoking in Bed II* (p. 139) and *Head and Bottle* (1975; p. 144), that employ the image of a bloated, one-eyed head.

1975 Receives the Distinguished Teaching of Art Award from the College Art Association.

Explores the theme of the deluge (through 1976) in such drawings as *Lower Level* (1976; p. 152) and *Current* (1976; p. 153). Also executes drawings (p. 146) in which objects from his studio are piled in heaps.

1976 His work is included in the exhibition "Drawings by Five Abstract Expressionist Painters," organized by the Museum of Contemporary Art, Chicago.

1979 Has a near-fatal heart attack; works very little.

1980 Receives Brandeis University's Creative Arts Award for Painting.

Executes a series of pen-and-ink drawings, including *Dawn* (p. 161) and an untitled (p. 161), that depict familiar motifs in tangled masses. A group of untitled acrylics (pp. 164–171) explores similar iconography.

May: A major retrospective of his work opens at the San Francisco Museum of Modern Art.

June 7: Dies of a heart attack, at Woodstock.

EXHIBITION HISTORY

The following list is limited to one-artist exhibitions; significant group exhibitions are noted in the Chronology.

The number of works on paper shown in the exhibition is cited when known. (In a few cases, the total includes works on board.) "Catalogue" indicates that a publication accompanied the exhibition; the book-length works among these are cited in full in the Selected Bibliography.

1932–33 Stanley Rose Bookshop, Hollywood, California.

1944 "Paintings and Drawings by Philip Guston," March 5–19, Iowa Union Lounge, State University of Iowa, Iowa City. 13 works on paper. Catalogue.

1945 "Philip Guston," January 15–February 3, Midtown Galleries, New York. 15 works on paper. Catalogue.

1947 "Philip Guston," April, School of the Museum of Fine Arts, Boston.

"Philip Guston," November 2–December 1, Munson-Williams-Proctor Institute, Utica, New York. 9 works on paper.

1950 "Philip Guston," April 10–May 12, The University Gallery, University of Minnesota, Minneapolis. 6 works on paper. Catalogue.

1952 "Paintings, 1948–1951, by Philip Guston," January 2–26, Peridot Gallery, New York. Portfolio of drawings. Catalogue.

1953 "Philip Guston: Paintings and Drawings," January 12–February 7, Egan Gallery, New York.

1956 "Recent Paintings by Philip Guston," February 6–March 4, Sidney Janis Gallery, New York. 9 works on paper.

1958 "Philip Guston: Recent Paintings," February 24–March 22, Sidney Janis Gallery, New York.

1959 "Recent Paintings by Philip Guston," December 28–January 23, 1960, Sidney Janis Gallery, New York. 8 works on paper. Catalogue.

1961 "New Paintings by Philip Guston," February 13–March 11, Sidney Janis Gallery, New York. 2 works on paper.

"Philip Guston/Franz Kline," April 3–29, Dwan Gallery, Los Angeles. 3 works on paper. Catalogue.

1962 "Philip Guston," May 3–July 1, The Solomon R. Guggenheim Museum, New York. Tour: Stedelijk Museum, Amsterdam; Palais des Beaux-Arts, Brussels; Whitechapel Art Gallery, London; Los Angeles County Museum of Art. 31 works on paper. Catalogue.

1966 "Philip Guston: Recent Paintings and Drawings," January 12–February 13, The Jewish Museum, New York. 43 works on paper. Catalogue.

"Philip Guston: A Selective Retrospective Exhibition, 1945–1965," February 27–March 27, The Poses Institute of Fine Arts, Rose Art Museum, Brandeis University, Waltham, Massachusetts. 2 works on paper. Catalogue.

1967 "Philip Guston," February 15–March 26, The Santa Barbara Museum of Art, California. 11 works on paper. Catalogue.

1969 "Philip Guston: Paintings and Drawings," October 4–30, Gertrude Kasle Gallery, Detroit. 14 works on paper. Catalogue.

1970 "Philip Guston," January 20–February 22, Jefferson Gallery, Beverly Hills, California.

"Philip Guston: Recent Paintings," October 16–November 7, Marlborough Gallery, New York. 8 works on paper. Catalogue.

"New Paintings: Philip Guston," November 14–December 13, School of Fine and Applied Arts Gallery, Boston University.

1971 "Philip Guston: Recent Work," August 1–October 3, La Jolla Museum of Contemporary Art, California. 12 works on paper. Catalogue.

1973 "Philip Guston: Major Paintings of the Sixties," March 10–April 7, Gertrude Kasle Gallery, Detroit. 11 works on paper. Catalogue.

"Philip Guston: Drawings, 1938–1972," July 11–September 4, The Metropolitan Museum of Art, New York. 20 works on paper.

1974 "Philip Guston: New Paintings," March 15–April 14, School of Fine and Applied Arts Gallery, Boston University. 8 works on paper. Catalogue.

"Philip Guston," November 9–December 12, Gertrude Kasle Gallery, Detroit. 11 works on paper.

"Philip Guston," November 15–December 18, David McKee Gallery, New York. 6 works on paper. Catalogue.

1975 "Philip Guston," February 17–March 29, Makler Gallery, Philadelphia. 11 works on paper.

"Philip Guston: Drawings for Bill Berkson's 'Enigma Variations,'" December 16–January 26, 1976, Gallery Paule Anglim, San Francisco. 15 works on paper.

1976 "Philip Guston: Paintings, 1975," March 6–April 10, David McKee Gallery, New York. Catalogue.

1977 "Philip Guston: Paintings, 1976," Part 1, March 18–April 8; Part 2, April 9–April 30, David McKee Gallery, New York. Catalogue.

"A Selection of Recent Works by Philip Guston," Summer, Achim Moeller Gallery, London. 16 works on paper.

1978 "Philip Guston: Major Paintings, 1975–76," September 29–November 2, Allan Frumkin Gallery, Chicago.

"Philip Guston: Drawings, 1947–1977," October 3–November 4, David McKee Gallery, New York. 56 works on paper. Catalogue.

"Philip Guston: New Works in San Francisco," December 21–January 21, 1979, San Francisco Museum of Modern Art.

1979 "David McKee Presents Works on Paper by Franz Kline/Philip Guston," July 21–August 18, Asher/Faure Gallery, Los Angeles. 18 works on paper. Catalogue.

"Philip Guston: Paintings, 1978–1979," October 6–November 10, David McKee Gallery, New York. Catalogue.

1980 "Philip Guston," March 8–May 4, Akron Art Museum, Ohio.

"Philip Guston," May 16–June 29, San Francisco Museum of Modern Art. Tour: Corcoran Gallery of Art, Washington, D.C.; Museum of Contemporary Art, Chicago; The Denver Art Museum; Whitney Museum of American Art, New York. 26 works on paper. Catalogue.

"Philip Guston: Recent Paintings," May 21–June 21, John Berggruen Gallery, San Francisco. Catalogue.

"A Tribute to Philip Guston: Paintings and Drawings from 1950 to 1980," October 11–November 12, David McKee Gallery, New York.

1981 "Philip Guston: 1980—The Last Works," March 21–May 24, The Phillips Collection, Washington, D.C. Tour: Cleveland Museum of Art; Museum of Art, Carnegie Institute, Pittsburgh; David McKee Gallery, New York. 31 works on paper. Catalogue.

"Philip Guston: New Lithographs," May, Gemini G.E.L., Los Angeles.

"Philip Guston: Sus Ultimos Años," October 16–December 20, Bienal de São Paulo. Tour: Museo de Arte Moderno, Mexico City; Centro de Arte Moderno, Guadalajara, Mexico; Museo de Arte Moderno, Bogotá, Colombia. 15 lithographs. Catalogue.

1982 "Paintings by Philip Guston," May 22–June 19, Asher/Faure Gallery, Los Angeles.

"Philip Guston," June 10–August 22, Montgomery Museum of Fine Arts, Alabama. 11 works on paper.

"Philip Guston: Lithographs," September 9–October 24, Yellowstone Art Center, Billings, Montana. 15 lithographs.

"Philip Guston: Paintings, 1969–1980," October 13–December 12, Whitechapel Art Gallery, London. Tour: Stedelijk Museum, Amsterdam; Kunsthalle Basel. 14 works on paper. Catalogue.

1983 "Philip Guston," January 23–February 16, Riva Yares Gallery, Scottsdale, Arizona.

"Philip Guston: Eight Lithographs," February, Gemini G.E.L., Los Angeles.

"Philip Guston: Paintings," October 8–November 5, David McKee Gallery, New York.

1984 "Philip Guston: The Late Works," August 17–September 16, National Gallery of Victoria, Melbourne, Australia. Tour: The Art Gallery of Western Australia, Perth; Art Gallery of New South Wales, Sydney. Catalogue.

"Philip Guston: The Last Works," October 12–November 25, Hayden Gallery, Massachusetts Institute of Technology, Cambridge. 36 works on paper.

1985 "Philip Guston: Small Works, 1968–69," April 4–May 4, David McKee Gallery, New York.

"Philip Guston: Drawings," June–July, Reconnaissance Gallery, Fitzroy, Victoria, Australia. Tour: Art Gallery of New South Wales, Sydney. 12 drawings.

1986 "Philip Guston," February 11–April 6, Greenville County Museum of Art, Greenville, South Carolina. Tour: North Carolina Museum of Art, Raleigh. 10 works on paper. Catalogue.

"Philip Guston: Works on Paper," September 5–October 4, Cava Gallery, Philadelphia. 10 works on paper; 10 lithographs.

1987 "Philip Guston: 'Roma,' 1971," October 10–31, David McKee Gallery, New York. 17 works on paper. Catalogue.

"Philip Guston: Early and Late Works," October 15–November 15, Schick Art Gallery, Skidmore College, Saratoga Springs, New York. 10 works on paper. Catalogue.

SELECTED BIBLIOGRAPHY

INTERVIEWS AND ARTIST'S WRITINGS

Berkson, Bill. "Dialogue with Philip Guston, November 1, 1964." *Art and Literature: An International Review,* Winter 1965, pp. 56–69.

Butterfield, Jan. "A Very Anxious Fix: Philip Guston." *Images and Issues,* Summer 1980, pp. 30–35.

Guston, Philip. "Piero della Francesca: The Impossibility of Painting." *Art News,* May 1965, pp. 38–39.

———. "Faith, Hope and Impossibility." *Art News Annual, 1966,* October 1965, pp. 101–03, 152–53.

———. "Philip Guston's Object: A Dialogue with Harold Rosenberg." In Sam Hunter, *Philip Guston: Recent Paintings and Drawings* (exhibition catalogue). New York: The Jewish Museum, 1966.

———. "Philip Guston Talking" (edited excerpts from a lecture given at the University of Minnesota, Minneapolis, March 1978). In Nicholas Serota, ed., *Philip Guston: Paintings, 1969–1980* (exhibition catalogue). London: Whitechapel Art Gallery, 1982.

Pring, Joan. Interview with Guston in his studio at 112 East Eighteenth Street, New York, on June 25, 1957. Transcript in the Archives of The Museum of Modern Art, New York.

Rosenberg, Harold. "Conversations: Philip Guston and Harold Rosenberg—Guston's Recent Paintings." *Boston University Journal,* Fall 1974, pp. 43–58.

Rosenberg, Harold, and Philip Guston. "On Cave Art, Church Art, Ethnic Art and Art." *Art News,* December 1974, pp. 36–41.

Stevens, Mark. "A Talk with Philip Guston." *The New Republic,* March 15, 1980, pp. 25–28.

MONOGRAPHS AND INDIVIDUAL-EXHIBITION CATALOGUES

Arnason, H. H. *Philip Guston* (exhibition catalogue). New York: The Solomon R. Guggenheim Museum, 1962.

Ashton, Dore. *Philip Guston.* New York: Grove, 1960.

———. *Yes, But...: A Critical Study of Philip Guston.* New York: Viking, 1976.

Buckley, John. Preface to *Philip Guston: The Late Works* (exhibition catalogue). Melbourne: National Gallery of Victoria, 1984. Essays by Edward T. Fry and Joseph Ablow. Includes reprint of "Philip Guston Talking" from Nicholas Serota, ed., *Philip Guston: Paintings, 1969–1980.*

Feldman, Morton. *Philip Guston: 1980— The Last Works* (exhibition catalogue). Washington, D.C.: The Phillips Collection, 1981.

Philip Guston (exhibition catalogue). New York: Marlborough Gallery, 1970.

Philip Guston (exhibition catalogue). New York: David McKee Gallery, 1974.

Philip Guston: Drawings, 1947–1977 (exhibition catalogue). New York: David McKee Gallery, 1978.

Philip Guston: "Roma," 1971 (exhibition catalogue). New York: David McKee Gallery, 1987.

Hopkins, Henry T., and Ross Feld. *Philip Guston* (exhibition catalogue). New York: Braziller; San Francisco: San Francisco Museum of Modern Art, 1980.

Hunter, Sam. Introduction to *Philip Guston: Recent Paintings and Drawings* (exhibition catalogue). New York: The Jewish Museum, 1966.

Recent Paintings by Philip Guston (exhibition catalogue). New York: Sidney Janis Gallery, 1959.

Serota, Nicholas, ed. *Philip Guston: Paintings, 1969–1980* (exhibition catalogue). Essay by Norbert Lynton. London: Whitechapel Art Gallery, 1982.

Storr, Robert. *Philip Guston.* New York: Abbeville, 1986.

BOOKS AND GROUP-EXHIBITION CATALOGUES

Ashton, Dore. *The New York School: A Cultural Reckoning.* New York: Viking, 1973.

Barr, Alfred H., Jr. Introduction to *The New American Painting: As Shown in Eight European Countries, 1958–1959* (exhibition catalogue). New York: The Museum of Modern Art, 1958

Baur, John I. H. *Nature in Abstraction: The Relation of Abstract Painting and Sculpture to Nature in Twentieth-Century American Art* (exhibition catalogue). New York: Whitney Museum of American Art, 1958.

Berkson, Bill. *Enigma Variations.* Bolinas, Calif.: Big Sky, 1975. Cover and drawings by Guston.

Feldman, Morton. *Six Painters: Mondrian, Guston, Kline, de Kooning, Pollock, Rothko* (exhibition catalogue). Houston: Art Department, University of St. Thomas, 1967. Text reprinted as Feldman, "After Modernism," *Art in America,* November/December 1971, pp. 68–77.

Kashdin, Galdys Shafron. "Abstract Expressionism: An Analysis of the Movement Based Primarily on Interviews with Seven Participatory Artists." Ph.D. dissertation, Florida State University, 1965.

Kokkinen, Ella. *Drawings by Five Abstract Expressionist Painters: Arshile Gorky, Willem de Kooning, Jackson Pollock, Franz Kline, Philip Guston* (exhibition catalogue). Cambridge, Mass.: Hayden Gallery, Massachusetts Institute of Technology, 1975.

Miller, Dorothy C., ed. *Twelve Americans* (exhibition catalogue). New York: The Museum of Modern Art, 1956.

Sandler, Irving. *The New York School: The Painters and Sculptors of the Fifties.* New York: Harper & Row, 1978.

ARTICLES

Ablow, Joseph. "The Nature of Identity: Metamorphosis of an Artist." *Bostonia Magazine,* April/May 1986, pp. 14–19.

Albright, Thomas. "Philip Guston: 'It's a Strange Thing to Be Immersed in the Culture of a Painting.' " *Art News,* September 1980, pp. 114–16.

Alloway, Lawrence. "Notes on Guston." *Art Journal,* Fall 1962, pp. 8–11.

Aronson, David. "Philip Guston: Ten Drawings." *Boston University Journal,* Autumn 1973, p. 21.

Ashton, Dore. "The Age of Lyricism." *Art and Architecture,* March 1956, pp. 14–15, 46.

———. "Philip Guston: The Painter as Metaphysician." *Studio International,* February 1965, pp. 64–67.

———. "An Evolution Illuminated: New York Commentary." *Studio International,* March 1966, pp. 112–13.

Baker, Kenneth. "Art: Guston's Bleeding French Fries." *Boston Phoenix,* April 2, 1974, section 2, p. 13.

———. "Philip Guston's Drawing: Delirious Figuration." *Arts Magazine,* June 1977, pp. 88–89.

Barker, Walter. "Painter and His Identity: Spontaneity and Contemplation in Philip Guston Show." *St. Louis Post-Dispatch,* February 13, 1966.

Berkson, Bill. "Philip Guston: A New Emphasis." *Arts Magazine,* February 1966, pp. 15–18.

———. "The New Gustons." *Art News,* October 1970, pp. 44–47, 85.

Brach, Paul. "Looking at Guston." *Art in America,* November 1980, pp. 96–101.

Feldman, Morton. "Philip Guston: The Last Painter." *Art News Annual, 1966,* October 1965, pp. 97–100.

Finkelstein, Louis. "New Look: Abstract-Impressionism." *Art News,* March 1956, pp. 36–39, 66–68.

Gopnik, Adam. "The Genius of George Herriman." *The New York Review of Books,* December 18, 1986, pp. 19–28.

Grillo, Jean Bergantini. "Guston: A Maverick at Sixty." *Boston Phoenix,* November 23, 1970, pp. 20–21.

Hagberg, Marilyn. "Guston's Political Hoods." *San Diego Magazine,* August 1971, pp. 20, 22, 24, 28.

Hakanson, Joy. "Guston's World of Paradox." *The Detroit News,* November 17, 1974.

Holmes, Mary. "Metamorphosis and Myth in Modern Art." *Perspective,* Winter 1948, pp. 77–85.

Hughes, Robert. "Ku Klux Komix." *Time,* November 9, 1970, p. 38.

Hunter, Sam. "Painting by Another Name." *Art in America,* December 1954, pp. 291–95.

———. "Philip Guston." *Art International,* May 1962, pp. 62–67.

Kachur, Lewis. "Philip Guston." *Arts Magazine,* January 1981, p. 9.

Kingsley, April. "Philip Guston's Endgame." *Horizon,* June 1980, pp. 34–41.

Kramer, Hilton. "A Mandarin Pretending to Be a Stumblebum." *New York Times,* October 25, 1970, section B, p. 27.

Laporte, Paul M. "Painting, Dialectics, and Existentialism." *Texas Quarterly,* Winter 1962, pp. 200–24.

Larson, Kay. "Painting from Ground Zero." *New York Magazine,* July 20, 1981, pp. 58–59.

Lynton, Norbert. "London Letter." *Art International,* February 25, 1963, pp. 69–70.

Moser, Joann. "Forum: Philip Guston's 'Hovering.'" *Drawing,* March/April 1988, p. 132.

O'Connor, Francis V. "Philip Guston and Political Humanism." In Henry A. Millon and Linda Nochlin, eds., *Art and Architecture in the Service of Politics.* Cambridge, Mass.: MIT Press, 1978.

O'Hara, Frank. "Growth and Guston." *Art News,* May 1962, pp. 31–33, 51–52.

"On a Mexican Wall." *Time,* April 1, 1935.

Orton, Fred, and Gavin Bryars. "Morton Feldman: Interview." *Studio International,* November/December 1976, pp. 244–48.

Perreault, John. "Art." *The Village Voice,* November 5, 1970, p. 26.

———. "Guston Winds." *SoHo News,* July 8, 1981, p. 51.

Raleigh, Henry P. "Image and Imagery in Painting." *Art Journal,* Spring 1962, pp. 156–64.

Ratcliff, Carter. "New York Letter." *Art International,* July/August 1977, pp. 73–74.

Rickey, Carrie. "Dreaming with His Eyes Open: Philip Guston, 1913–1980." *The Village Voice,* June 23, 1980, p. 73.

———. "Gust, Gusto, Guston." *Artforum,* October 1980, pp. 32–39.

Rosenberg, Harold. "The American Action Painters." *Art News,* December 1952, pp. 22–23, 48–50. Reprinted in Rosenberg, *The Tradition of the New,* New York: Horizon, 1959.

———. "Liberation from Detachment." *The New Yorker,* November 7, 1970, pp. 136–41.

Rosenblum, Robert. "Varieties of Impressionism." *Art Digest,* October 1, 1954, p. 7.

Schipper, Merle. "Kline and Guston: Phases of Drawing." *Artweek,* August 11, 1979, pp. 1, 16.

Schjeldahl, Peter. "Self-Abuse on Parade." *The Village Voice,* July 15, 1981, p. 72.

Seitz, William. "The Relevance of Impressionism." *Art News,* January 1969, pp. 28–43.

Smith, Roberta. "The New Gustons." *Art in America,* January/February 1978, pp. 100–05.

Steinberg, Leo. "Month in Review: Fritz Glarner and Philip Guston Among 'Twelve Americans' at The Museum of Modern Art." *Arts Magazine,* June 1956, pp. 42–45. Reprinted in Steinberg, *Other Criteria: Confrontations with Twentieth Century Art,* New York: Oxford University Press, 1972.

Wohl, Hellmut. "Philip Guston and the Problems of Painting." *Harvard Art Review,* Spring/Summer 1967, pp. 28–30.

Yau, John. "Philip Guston, David McKee Gallery." *Artforum,* January 1988, pp. 114–15.

Zaller, Robert. "Philip Guston and the Crisis of the Image." *Critical Inquiry,* Autumn 1987, pp. 69–94.

FILMS

Philip Guston: A Life Lived, 1913–1980. New York: Michael Blackwood Productions, 1980.

The New York School. New York: Michael Blackwood Productions, 1973.

LENDERS TO THE EXHIBITION

Art Gallery of New South Wales, Sydney
Australian National Gallery, Canberra
The Solomon R. Guggenheim Museum, New York
The Museum of Modern Art, New York
National Museum of American Art, Smithsonian
Institution, Washington, D.C.
San Francisco Museum of Modern Art
Whitney Museum of American Art, New York

Mr. and Mrs. Harry W. Anderson
Philip Anglim
H. H. Arnason
Celia Ascher
Dore Ashton
Leonard and Stephanie Bernheim
Louis Bernstein and Ruth Fischer
Mr. and Mrs. Donald Blinken
The Edward R. Broida Trust
Michèle Cone
Charles Craig
Mr. and Mrs. Lee V. Eastman
Marianne and Jonathan Fineberg
Mr. and Mrs. James Foster
Estate of Philip Guston
Brian and Lyn Hayden
Terry Hunziker
Mrs. Semon E. Knudsen
Raymond J. Learsy
Janie C. Lee
Hans Mautner
Rick Meyerowitz
Dorothy C. Miller
Edward Miller
Stacey Moss
Mr. and Mrs. Alfred Ordover
A. J. Pyrch
T. W. and S. J. Quirk
Phyllis and Ted Rosen
Arthur Ross Foundation
Juliet and Michael A. Rubenstein
Mr. and Mrs. Andrew Saul
Roselyne and Richard Swig
Armando and Gemma Testa
Mrs. Keith S. Wellin
John Whitney, Jr.
Mr. and Mrs. Craig P. Wood
Seven anonymous lenders

Langer & Co. Fine Arts, New York
Janie C. Lee Master Drawings, New York
David McKee Gallery, New York
PaineWebber Group Inc., New York